SHAHEED NICK MOHAMMED

THE
(Dis)information Age

THE PERSISTENCE OF IGNORANCE

PETER LANG
New York • Washington, D.C./Baltimore • Bern
Frankfurt • Berlin • Brussels • Vienna • Oxford

Library of Congress Cataloging-in-Publication Data
Mohammed, S. Nick.
The (dis)information age: the persistence of ignorance /
Shaheed Nick Mohammed.
p. cm. — (Digital formations; v. 79)
Includes bibliographical references and index.
1. Information society. 2. Ignorance (Theory of knowledge).
3. Disinformation. 4. Propaganda. 5. Information technology—
Social aspects. 6. Communication.
I. Title.
HM851.M64 303.48'33—dc23 2011046450
ISBN 978-1-4331-1502-8 (hardcover)
ISBN 978-1-4539-0534-0 (e-book)
ISSN 1526-3169

Bibliographic information published by Die Deutsche Nationalbibliothek.
Die Deutsche Nationalbibliothek lists this publication in the "Deutsche
Nationalbibliografie"; detailed bibliographic data is available
on the Internet at http://dnb.d-nb.de/.

The paper in this book meets the guidelines for permanence and durability
of the Committee on Production Guidelines for Book Longevity
of the Council of Library Resources.

Table of Contents

Acknowledgments

All scholarly work is inevitably indebted to the works that have preceded them. The present book is no exception. Many pioneers of Information Age analysis have crafted invaluable conceptual structures upon which our understandings of the present age depend. At the outset the author acknowledge the debt of gratitude we all owe to these many great scholars.

The author would also like to thank the series editor, Professor Steve Jones, for his important guidance in development of the final manuscript.

Preface

While walking through the publishers' row at a conference in Singapore I could not help but be struck by the sheer volume of books on various aspects of the Information Age. Despite the existence of several authoritative analyses of various dimensions of the present technology-driven and communication-oriented Information Age, there appears to be a continuing appetite for deconstructing the ever-changing set of social and technical circumstances that characterize our modern age.

Partly driven by the evolution of technologies, access to them and the multiplicity of uses (both intended and unintended) to which these are put, any analysis of the Information Age is scarcely complete when it must yet again be redefined.

Yet, an emerging set of assumptions have evolved with these analyses. These assumptions of the necessarily liberating, democratizing and beneficial qualities of information and communication technologies continue to be insufficiently addressed. Particularly problematic is the notion that these technologies and their popular modes of usage necessarily lead to a more informed public. This notion mandates a more careful look at the question of ignorance and how both established and emergent communication technologies (and use modalities) may actually support long traditions of ignorance.

The multiple titles with some variant of the term Information Age on the lists of various publishers prompted me to ask why there were not more titles on the dis-informing power of modern mediated communication. It was not so much that scholars were not interested in this topic—many have been skeptical of utopian ideas surrounding the Information Age. It may be more about the danger of appearing cynical by associating our Information Age technologies with the spread and support of ignorance. Yet, in myriad ways, this seeming paradox of increasing ignorance amidst increasing information may well be one of the defining issues of our time—one which the present work attempts to bring to more widespread scrutiny and understanding.

1

Introduction

Water, water, everywhere,

Nor any drop to drink

(Coleridge, 2006 [1798])

The concept of the "Information Age" is central to modern thinking. It pervades not only media and communication studies but also much of sociological investigation, business, marketing and even public policy. Almost two decades into the public dissemination of Internet technology, the common social assumption is that we are squarely situated within the Information Age and that everything has changed because of it (Castells, 2000; Haddon & Paul, 2001). Further, it is widely and uncritically accepted that the assumptions of the Information Age have become part of society to the extent that they largely determine not only our collective futures but also our individual aspirations (Winston, 1998).

However, on closer examination, much of the actual research and thinking does not support the hype and assumptions surrounding the presumed Information Age. The availability of measurably higher quanta of information in most dimensions of modern life has not necessarily led to fundamental social change on the scale of the transitions to and from the stone age, the bronze age, the iron age or even the industrial revolution (Castells, 2000; Drucker, 1999).

Nor indeed does the hype of the Information Age hold true for the vast majorities of the world's population (Wresch, 1996). While global entities and their informationized cultures spread ever more widely, the one-sided nature of the exchange usually favors the purveyors of information (such as marketers and advertisers for global corporations) over the consumers. Many of the world's rural poor are only participants in the global information as audiences for increasingly penetrative international marketing or political ideas. In many cases, vast masses of the rural poor are simply spectators, unable to purchase the marketers' wares. These are the rural poor who may see Nike ads but who

may only be able to wear a Nike shoe as a second- or third-hand product or as a donation from an international charity.

Most of us in the industrialized West are unlucky enough to suffer the constant assault of information (Lukasiewicz, 1994). Worse, we are required by social and other pressures to conform to each new norm of information usage whether it be e-mail or Twitter or Facebook. College professors are increasingly pressured to maintain Facebook pages and some studies have suggested benefits of such use. Yet Barber and Pearce's (2008) research indicated that professors' Facebook use is associated with students perceiving them as having decreased credibility, competence and attractiveness while Mazer, Murphy, & Simonds (2007) warned about possible negative associations between Facebook use and professor credibility.

This is a skeptical, and perhaps cynical, view of the Information Age. It is one that runs counter to the currents that make our assumptions seem natural when they may be both misplaced and manipulated. The call here is not one to simply doubt the assumptions of the Information Age, but rather to be vigilant about the several concepts that we are called on, and expected to believe and accept in our modern age.

The choice to focus on the persistence of ignorance is directly related to the discourse of informationization and the presumed enlightenment associated with new information technologies that predominate in the literature. To argue that the Information Age enables the spread of ignorance just as much as it enables the spread of knowledge is not mere delicious irony, but rather something of a reality check to the broad-brush sweeps of ideas about the Information Age.

In a time when many information consumers perceive of themselves as immune to manipulation because of the number of information options available to them, it is valuable to consider the extent to which very old ideas such as wartime propaganda might not only exist, but also flourish in the Information Age. Johansen and Joslyn's (2008, p. 604) research, for example, concluded that "a misinformed public was the norm" in the run up to the Iraq War when the media were guilty of propagating several patently false ideas that garnered support for the government's position. Even more disturbing is the fact that Johansen and Joslyn (2008) found that audience members were not insulated from this propaganda even by the traditional filter of higher educational status which has been thought to be an insulating factor against misinformation and propaganda. This means that we are all somewhat vulnerable to disinformation and that we may all be complicit in the persistence of ignorance despite our pretentions to education, expertise, or tech-savvy.

2

Ignorance in Context

Philosophers, teachers, researchers and others have spent a good portion of the efforts towards human development dealing with questions about knowledge. What is it? How is it acquired, spread, preserved? We have asked fundamental questions about the nature of knowledge and the nature and extent of knowing. Knowledge has been an important part of many religious traditions, particularly as the key issue over which (some interpretations suggest) Adam and Eve fell from God's grace in the Garden of Eden. Some scholars have cited eighteenth-century philosopher Immanuel Kant's ideas about the political implications of knowledge stemming, in part, from his famous definition of enlightenment (as quoted in translation by Cronin [2003, p. 51]) as follows:

> Enlightenment is the human being's emergence from his self-incurred minority. Minority is the inability to make use of one's own understanding without direction from another...

Any blanket endorsement of Kant's broader views on enlightenment must, however, be tempered by a knowledge of his early views on a major facet of ignorance that will occupy our attention in the present discussion—namely the manifestation of ignorance in the form of racism. It is somewhat ironic that ideas about knowledge and enlightenment should be adopted from Kant. Though much of the analysis of Kant's work suggests that he valued personal freedom and considered slavery something of a legal paradox, closer examination suggests that this reasoning may have (at least at one time) applied only to

those members of his own perceived ethnic group. According to Kleingeld (2007, p. 576):

> When he started his theoretical work on the concept of race, Kant had already expressed on several occasions his views on the inferiority of nonwhites. One of the most notorious examples is his remark... that the fact that a negro carpenter was black from head to toe clearly proved that what he said was stupid... Kant's focus was on features such as skin color, facial traits and hair structure. But he also added comments, such as that blacks are lazy and that Native Americans have a "half extinguished vital energy, " and remarked on their respective usefulness as slaves...

Perhaps the relevance of examining Kant in the context of epistemology and knowledge emerges in the perception that his views evolved into something more akin to seeing race as a matter of physiological difference with no bearing on one's freedom (Kleingeld, 2007).

While serious philosophical and scholarly attention may be afforded questions of knowledge, far less attention has been paid to the question of ignorance, except as a counter to the need for knowledge. Smithson (1985, p. 151) contended that "ignorance is a neglected topic in the study of social life." Keefe (2007) observed that "philosophical discussions concerning ignorance arc few and far between." However, this is not to say that such discussions do not exist, nor does it suggest that they are historically absent. Socrates, for example, was quoted in Diogenes Laertius' *Lives of Eminent Philosophers* as saying "I know nothing except the fact of my ignorance" and that "there is only one good, knowledge, and one evil, ignorance." The philosophical implications of both Socrates' knowledge and his ignorance are still discussed in modern times by scholars such as Austin (1987, p. 23) who distinguished between the so-called Socratic Paradox involving wrongdoing as ignorance and a more general question of the Socratic conception of ignorance posed thusly:

> If Socrates' wisdom consists in knowing that and what he does not know, in particular that he knows nothing, then how does he know that he does not know what he does not know?

Keefe pointed to further historical context such as the work of James Ferrier, a Scottish philosopher of the 1800s who described ignorance as an imperfection in an intelligent being and who is thought to have first used the term "epistemology" to refer to the study of knowledge and knowing. Notably, it would be more than a century before the notion of an epistemology of ignorance would take hold—as we shall discuss later. Keefe also compares Ferrier's ideas about ignorance with those of St. Thomas Aquinas, who briefly mentioned ignorance as a state of privation in his *De Malo*, but Keefe empha-

sized the brevity of analyses of ignorance in the literature overall. Harding (2006) pointed out that both Sigmund Freud and Karl Marx theorized ignorance, with Freud emphasizing the deliberate suppression of unresolved childhood issues and Marx focusing on "the role of bourgeois interests in shaping what does and doesn't count as good science and as legitimated knowledge" (p. 24). Roberts and Armitage (2008, p. 336) traced the modern sense of the term *ignorance* to a 1615 play by George Ruggles entitled *Ignoramus*, noting as well that several other senses of the word persist including the notion of ignorance as being discourteous or rude.

Where we speak of knowledge as light, we describe ignorance as a kind of darkness. We see it as dangerous though benign. According to Smithson (1993, p. 136), "traditionally, ignorance is treated as either the absence or the distortion of true knowledge, and uncertainty as some form of incompleteness in information or knowledge." From this general perspective, ignorance is inadequately perceived as an active threat, a deliberate political tool, or a moral danger—all of which it can be in the proper context. Proctor (2008, p. 2), in fact, suggested that: "ignorance has many friends and enemies, and figures big in everything from trade association propaganda to military operations to slogans chanted at children." Despite which, Ungar (2008, p. 301) noted that ignorance is "a serious social problem with potentially deadly consequences" which "remains relatively unrecognized." He contextualized this claim of deadly consequences with reference to events such as the 2003 U.S.-led invasion of Iraq:

> That American policy makers were clueless about the realities there is apparent in their failure to recognize the longstanding rift between Sunni and Shia Muslims. Unfamiliarity and obliviousness were augmented by a lack of Arabic-speaking experts and closure to outside experts who warned about the problems of administering the country. If ignorance in these instances involves oversights that were not inevitable, the attempted use of conventional forms of military intelligence to combat the insurgency entails embedded ignorance and uncertainty. (Ungar, 2008, p. 306)

In the world of the early 21st century, modern society focuses largely on information and knowledge as the basis for innovation, development, commerce and prosperity. We pay much less attention to the influence of ignorance, which is often perceived as naturally and inevitably being destroyed by the constant and rapid advance of knowledge. However, Rescher (2009, p. 4) identified the growth of information with the persistence of ignorance, suggesting that: "One of the most obvious sources of ignorance is the sheer volume of factual information," with any individual being unable to make sense of more than "an insignificant fraction of it." That is to say, more information may be less informing and more conducive to the persistence of

ignorance or its promotion. Ungar (2008, p. 301) similarly suggested that "cascading increases in knowledge are accompanied by a persistent undertow of ignorance."

While Rescher (2009) refrained from suggesting a taxonomy of ignorance in light of the breadth of the concept, Smithson (1989) in fact described such a taxonomy two decades earlier that included the following categories:

1. Things we are aware we do not know (simple or humble ignorance)
2. Things we think we know but do not (i.e., ignorance based on error)
3. Things we are not aware that we know (intuition)
4. Things we are not supposed to know (taboo knowledge)
5. Things we find too painful to know (willful suppression of unpleasant knowledge)
6. Things we are not aware that we do not know

Citing what she and others have termed the epistemology of ignorance, Tuana (2006, pp. 3-13) echoed Smithson's taxonomy in her "modes of ignorance" which included:

1. knowing that we do not know yet not caring to know
2. not even knowing that we do not know
3. not knowing because privileged others do not want us to know
4. willful ignorance

Taken together, these various dimensions suggest that simple definitions of ignorance (such as, for example, a lack of knowledge) are inadequate for understanding the concept. Ignorance is variously perceived as a failure to acquire knowledge, the inadequacy of such knowledge or its unavailability, a resistance to knowing or a failure to recognize a lack of knowledge. Ignorance has even been conceived as having a relationship with spiritual existence and standing—conceived as a kind of darkness which enlightenment or knowledge is capable of lifting. At the same time, ignorance has been protected by religious thought as many traditions acknowledge the existence of various classes of "forbidden" knowledge. However construed, ignorance has always been part of the human condition.

Rescher (2009) outlined several prime sources of ignorance including:

1. the unavailability of concepts (which are often discovered later)
2. the use of statistics—which hides specific information within what Rescher calls a "statistical fog"
3. simple chance
4. the effects of time in which knowledge is lost to natural process of decay
5. the suppression of knowledge either by failure to reveal it or by active efforts to hide it

He also argued that presumption in the absence of information is a natural human process and that we often make presumptions to fill in knowledge gaps that we find troubling. Proctor (2008) made a fundamental distinction between such ignorance as a passive construct (a native state borne of innocent lack of knowledge) and ignorance as an active construct or even a strategic ploy, something cultivated, designed or manipulated for profit or other advancement of particular groups. The second of these two perspectives is more frightening, but may also be increasingly widespread.

Ungar (2008) argued that ignorance, while not a new phenomenon, "was largely unremarkable and tolerated as more or less inevitable until the relatively recent advent of the so-called Information Age." While there may be some debate on this point, the question that does emerge today is whether the Information Age will fundamentally alter the reality of ignorance in its many forms, leave ignorance untouched as an inevitable human state, or—what is more intriguing—foster ignorance as an increasingly important facet of the power relations of information. The possibility exists that in a flood of information, we may drown in ignorance.

According to Brown (2008, pp. 166–167), information for the sake of social control or what he calls "knowledge for power" increases ignorance which, in turn, partly explains humanity's "current and growing dysfunctional relationship with life and the world." Among the varieties and manifestations of ignorance being generated by the pursuit of knowledge, Brown (2008, p. 167) cited the tendency to be unreflective about "ethical, metaphysical, and theological assumptions," the complication of choices as to social and scientific directions, a lack of perception and concern for the consequences of the application of such knowledge and the displacement by Western science of other perspectives such as those of traditional peoples.

The dominant ideas about ignorance suggest that it is a natural state, one for which a person may be forgiven in the absence of knowledge or access to knowledge. We rarely conceive of humans as being ignorant by choice, particularly because we recognize that knowledge and information are not resource neutral. The time spent acquiring information or knowledge is time that could be spent acquiring food resources, for example. Though by this reasoning, the more readily or cheaply information is available, the less excusable is ignorance. Yet, as we will see later, it is becoming increasingly evident that in the context of widely available knowledge, many choose (or default to) ignorance.

Popular conceptions of ignorance tend to focus on comfortable stereotypes of non experts who lack knowledge of simple and presumably widely known facts. Supported by repeated surveys as well as anecdotal evidence, the

idea of a general population that is lacking in basic knowledge has developed credibility in recent years. The images of befuddled respondents to simple general knowledge questions on Jay Leno's *Jaywalking* segments may not be statistically representative of the general population. However, scientific studies such as those by the Pew Research center have consistently found lacunae in the public knowledge of basic facts about government and social issues. So consistent are the findings that in a 2007 Pew survey (The Pew Research Centerfor the People and the Press, 2007) researchers found that Americans had not improved their general knowledge of national and international affairs in the period 1989–2007 despite the explosion in information and news sources available over that time. Despite the vast availability of information, the survey found that few respondents were able to answer a majority of questions such as the name of the vice president or the Speaker of the House of Representatives or the name of the Russian president:

> Eight people out of the 1,502 respondents answered all 23 questions correctly. At the other end of the spectrum, five people failed to answer a single question correctly... Using a common school grading scale in which 90% correct is the minimum necessary to receive an A, 80% for a B, 70% for a C, 60% for a D and less than 60% is a failing grade, Americans did not fare too well. Fully half would have failed, while only about one in six would have earned an A or B. (The Pew Research Centerfor the People and the Press, 2007, p. 4)

As notable as this persistence of ignorance might be among the general population, well-recognized experts are also culpable of deficiencies—albeit in more specialized fields. Lewis (2000) pointed out that the general population is woefully uninformed about global realities despite a widespread and increasing focus on globalization in its many forms. Of greater concern, however, are signs of ignorance (in both its passive and active dimensions) among scholars of globalization and global studies. He noted (2000, p. 623), for example, that Samuel Huntington (1996) touted the superiority of the West over Islamic civilization based on the West's multiplicity of languages—apparently missing the fact that Turkey, Indonesia and Pakistan, among others are predominantly Islamic nations with diverse languages. He also pointed to a kind of willful historical ignorance among scholars of international economics and politics who consistently ignore the legacies of colonialism and other forms of domination as factors in the realities of underdevelopment in many Third World countries. In such contexts we must allow for the possibility that these particular claims by learned scholars are not so much reflections of knowledge deficiencies but rather indications of willful disinformation or deliberate ignorance calculated to generate support for particular viewpoints in the face of alternative and competing explanations.

THE USES OF IGNORANCE

Ignorance, conceived as a social phenomenon, is not without its uses. Townley (2009) called for a revaluation of ignorance, noting its importance in areas such as education where an answer might be withheld from a class to encourage problem solving. Such a positive function of ignorance might be contrasted with the negative functions of knowledge including the development of lethal weapons or other destructive technologies. Townley (2009) suggested, more generally, that the emphasis on knowledge production and acquisition can also form part of oppressive established patterns of social dominance and exploitation. Moore & Tumin (1949) suggested that ignorance plays a number of important (though not always positive) roles in society. Ignorance, in their view, is a factor in such domains as the preservation of social hierarchy since some groups or classes hold power through privileged access to information and knowledge. They also associate ignorance with the reinforcement of traditional values, maintaining competition, preserving stereotypes and even in allowing open-ended incentives (such as the promise of unspecified wealth or profits) to be effective. They noted (p. 795) that "the difference reduces to one where the maintenance of ignorance institutionalizes old problems and the acquisition of knowledge makes continuous the introduction of new problems" and concluded that "ignorance must be viewed not simply as a passive or dysfunctional condition, but as an active and often positive element in operating structures and relations."

Intolerance as Ignorance

Those concerned about the active and practical uses of ignorance have noted how ignorance is used as a tool to perpetuate prejudice, hate and mutual distrust. Wallis (1929, p. 804) described the relationship between ignorance and insular prejudice in the following terms:

> Ignorance stays at home and hangs up heavy curtains which exclude the light of the larger outside world; if it ventures abroad it wears tinted glasses, so that the world without shall lose its distracting contrasts; and if the ruthlessness of facts smashes the goggles, ignorance retires to the seclusion of her own dark chamber... The overvaluation of our social group, and the corresponding undervaluation of others, is due in large part to a failure to understand the inner content and meaning of life in other groups.

While mutual ignorance in its simple passive sense may well be a source of distrust among groups, the more important context in the Information Age is ignorance as an active and continuous process of construction of the "other." Chew (2001, p. 1) has argued that what he termed "murderous regional

tensions" are often founded on "reciprocal ignorance" derived from ancient (though durable) ideas. In the sense of both Tuana's (2006) notion of willful ignorance and Rescher's (2009) notion of suppression of knowledge either by failure to reveal it or by active efforts to hide it, intolerance and hate are manifestations of ignorance that remain critically important as active processes in the Information Age. Edward Said in 2001, for example, challenged Huntington's Clash of Civilizations thesis, characterizing the mutual and cultivated distrust between particular segments of humankind as a Clash of Ignorance (Said, 2001). Attempts by autocratic or repressive regimes to deny access to information also demonstrate the uses of ignorance. When protestors took to the streets of Cairo in January, 2011, the government responded by shutting down Internet and cell phone service, an attempt to impose a kind of ignorance on the public.

This active dimension of ignorance is an important one, and has been identified in past work on the subject. Smithson (1985, p. 151), for example, warned that "it is not sufficient to conceive of ignorance as merely neglect or distortion" adding that "ignorance, like knowledge, is socially constructed and negotiated." Tuana (2004, p. 2) called ignorance "a practice with supporting social causes" and Bishop and Phillips (2006, p. 181) similarly noted that "beyond being the necessary condition for 'knowledge' *per se*, ignorance, therefore, can be seen as productively producing power in and of itself." From this perspective, ignorance warrants interrogation as a social phenomenon not only in the context of knowledge and information dynamics, but in its broader (related) context of social power relations including politics, prejudice, stereotypes and hate.

IGNORANCE AS A CONSEQUENCE OF THE INFORMATION AGE

According to Smithson (1993, p. 134), the technological and intellectual developments of recent decades are linked with the flourishing of ignorance as well as concern about its spread. He argued, for example that rapid expansions in the volumes of scientific research has led to "an increasingly rapid turnover of what constitutes established scientific knowledge or truth, and a burgeoning quantity of scientific literature and information" meaning, in turn, that "scientific and technical knowledge has a shorter half-life" with scientists now being more likely to see the certainty of their ideas overturned in their own lifetimes. For Smithson, this results in a sort of uncertainty or ignorance in the knowledge base of the scientist.

Also concerned about the persistence of scientific ignorance, Ravetz (1993) suggested that the ignorance of scientific ignorance (or what he termed ignorance-squared) is not new—having existed since the founding of modern

science. He suggested (1993, p. 157), however, that such ignorance is increasingly untenable in the modern Information Age, calling it unsustainable and something that "may very well become destructive to the continued progress of science." Smithson (1993, p. 134) also connected scientific hyperspecialization (and his perceived merging of science with government and business) to the spread of ignorance, noting in particular what has been termed the "politicization of uncertainty" in which

> interest groups selectively manipulate uncertainty (or ignorance) about scientific matters to their own ends. Such manipulations take two forms: one is the valuation of ignorance (e.g.,, What should scientists find out about next? What is the importance of not knowing about X?), and the other is its assessment (i.e., To what extent are we unsure of X? How much disagreement among scientists is there about it?).

Were such phenomena limited only to the scientific community, the concern over the spread and persistence of ignorance might be relegated to a parochial matter, of concern only to those actively involved in science. However, in broader public debates including that over stem cells, bio-engineering and numerous other areas, various interest groups exploit this facet of ignorance for political and other reasons.

More generally, factors such as increasing information flows and increasingly short information half-lives also exist outside of the scientific community, leading to widespread uncertainty and ignorance supported not so much by narrow interest groups, but rather by the still-emerging information capitalism which focuses on the commercial potential of information regardless of whether it is particularly useful. Such a claim, while relatively rare in discourse of the modern hyper-mediated (and hyper-commercialized) public sphere, does rest on some empirical support. Segev and Ahituv (2010, pp. 30-31), in their study of search engine queries found that much information seeking in developed nations eschewed political and economic topics in favor of a much narrower range of commercialized interests including entertainment:

> Popular search queries in these countries were relatively homogeneous... and concentrated mainly on entertainment. The narrow range of information uses in some developed countries... matches the increasing Internet commercialization and the dominance of popular channels, which have reinforced highly concentrated Internet traffic... Dominant and popular Web sites continuously customize information and advertisements for the specific interests of their users, reinforcing a narrow range of information uses in favor of commercial and popular content... The high degree of entertainment-related search queries and the narrow range of popular searches and the very specific queries in the United States, Canada, and Australia

reflect this trend, suggesting that information in these countries is highly customized, popularized, and commercialized.

Thus while flows of information may be voluminous, the variety of information is low and focused on topics that are commercially oriented and distracting rather than inquiring in nature. While information choices are free and personal, they are also heavily and increasingly influenced by commercial interests and the overriding capital focus of the modern Information Age.

THE FALLACY OF INFORMATION ERASING IGNORANCE

One of the underlying assumptions about the dynamic between information and ignorance is that the one replaces the other. The provision of information is almost by definition, the removal of ignorance. While this may be true in some instances, it is a naïve perspective rooted in highly traditional information-poor contexts.

With each source of information that becomes available, the forces of ignorance become active. While media and technology have long been associated with cultural and social change, part of that dynamic involves new sources of information often being met with sources of disinformation. Johannes Gutenberg provides an early example of this interplay through his contribution to printing in Europe. Briggs and Burke (2002) suggested that Gutenberg's connection with printing came somewhat obliquely but was related to his jeweler's skills with metals. He did not invent printing, as impressions were commonly made using woodblocks in Europe well before his time—though this method was fairly limited in the number of impressions possible before softening and deterioration of the blocks. Additionally, the Chinese had already developed both ceramic and metal moveable type, by some accounts since the 11th century. Gutenberg succeeded in integrating press technology—similar to the kind used for pressing olives—with impression plates composed of individual metal letters, thereby creating a more efficient and ultimately cheaper method of producing printed texts. Drucker (1999, p. 4) characterized these innovations as "the first of the technological revolutions that created the modern world," arguing that

> the printing revolution swept Europe and completely changed its economy and its psychology... In its first fifty years printing made available—and increasingly cheap— traditional information and communication products. But then, some sixty years after Gutenberg, came Luther's German Bible—thousands and thousands of copies sold almost immediately at an unbelievably low price. With Luther's Bible the new printing technology ushered in a new society. It ushered in Protestantism, which conquered half of Europe and, within another twenty years, forced the Catholic Church to reform itself in the other half. Luther used the new medium of print deliberately to

restore religion to the center of individual life and of society. And this unleashed a century and a half of religious reform, religious revolt, religious wars.

Notably, the Church was not simply a victim of printing technology in all of this, but also actively engaged in printing and distributing its messages to sway public opinion. The widely distributed "blue library" comprised Church-produced pamphlets and other writings extolling the importance of not just faith but also obedience to Church doctrine. While some (for example Cook, 1995) have argued for a somewhat more tempered view of Gutenberg's contribution, the use (and misuse) of printing press technology certainly had wide and varied impacts on European culture and eventually on the history of the world (Briggs & Burke, 2002). Given the nature of the changes, some have espoused the view that Gutenberg's improvements to printing were more revolutionary than today's Internet or satellites.

When the networked technologies of the Internet began to spread beyond the limits of the military and government institutions, scholars, technology theorists and policy makers began to perceive a democratizing potential for these tools. For the first time, information consumers would become information producers who could "talk back" to the media. This was not the first time a set of new media technologies had been touted this way. Popularization of home video and the new accessibility of relatively low-cost video cameras prompted the hope that they would spawn a new group of movie producers who would rival the power of Hollywood and express a greater diversity of viewpoints. Ouellette, for example (1995, p. 33) wrote:

> The popularization of the camcorder points to an important contradiction in media monopoly under capitalism. The economic interests of the culture industries have not prevented the development of equipment which might pose a significant challenge to dominant media institutions.

While there was no overwhelming democratic movement in video or through Internet content, more subtle changes have more recently evolved with information consumers becoming simultaneous producers through social media including YouTube and Facebook. Many journalists reporting on democracy movements in the Middle East during 2011 went as far as dubbing the changes in Egypt, for example a Facebook revolution. While this may overstate the role of technology in general and unduly glorify a specific technology, it does express an idea that is relatively common when dealing with new technologies.

In Europe of Gutenberg's time, printing was similarly influential, widely diffused and co-opted by powerful forces. Bearing in mind Cook's (1995) caveat that the actual diffusion was perhaps significantly slower and less

widespread than many historians have admitted to, it is still true that the availability of reading materials at lower costs enabled the improved spread of information and encouraged literacy, and literacy encouraged learning (however gradually these processes may have evolved).

THE UNEQUAL BATTLE BETWEEN IGNORANCE AND KNOWLEDGE

Despite the insistence that we are steeped in the Information Age, ignorance not only persists, but also prevails. Ehrlich and Ehrlich (1996, p. 25) noted that "in the United States today, a surprising number of people believe in horoscopes, 'out–of–body' experiences, the magical powers of crystals, and visitors from space."

A long tradition of ignorance-based social norms has created a modern society where established scientific fact is forced to "debate" with superstition and fanciful suppositions. This is partly due to the entrenchment of ignorance under umbrellas such as "tradition," "heritage," "religion," and "culture." Disinformation that can be protected under one or more of these intellectual preserves, acts powerfully against scientific knowledge and information, which, even today, has to struggle for moral ground. Evidence of this is widespread but comes most clearly into focus when clear scientific information faces off against long-held cherished religious beliefs.

In 1925 (admittedly, a few years before the start of our present Information Age) the U.S. State of Tennessee prosecuted and convicted high school teacher John Scopes for teaching evolution in his classroom. Scopes' teaching of evolution contravened Tennessee's Butler Act of 1925 that made it illegal to teach evolution in relation to humans or to teach any theory that denied the Biblical account of the creation of humankind.

The repeal of Tennessee's Butler Act in 1967 did not end the debate. In numerous school districts across the United States, this debate continues today in the midst of our "Information Age." According to Ehrlich and Ehrlich (1996, p. 25):

> Our society is also witnessing a resurgence of creationism... religious doctrine is creep-
> ing back into school science curricula as legislators and local school boards pressure
> teachers to give equal time to the teaching of creationism and to characterize evolu-
> tion as an "unproven" theory.

Thus, in an age where both the scientific community and the society at large have access to verifiable, replicable, and rigorously reviewed scientific evidence of inherited traits, mutations and selection through successive generations of numerous organisms, where genetics has led to both cloning and genome mapping, evolution is called theory while many still afford

creationism the status of accepted truth. Perhaps sensing the futility of the traditional insistence of a divine being bringing all creation into being over a week or so, several intellectual twists have been employed to protect the well-cherished creation myth.

One such twist is found in the concept of Biblical Time or Genesis time. Since scientific time-dating of both earthly and cosmic objects calls into question the time scale for creation as presented in the traditional Judeo-Christian and Islamic religious accounts by pointing out that the age of many everyday geological and cosmic objects pre date the biblical account of creation by at least several billion years. Religious apologists such as Gerald Schroeder (1997) have argued that because time and the earth had not yet been created, the Biblical account of creation references a much grander scale of time. While typical of the techniques used to attempt to bolster un-science in the Information Age, this Biblical time approach pales in scope and vehemence when compared with the Intelligent Design movement.

Intelligent design provides us with an opportunity to distinguish between relatively innocuous traditional beliefs such as creationism (with a literal interpretation of the religious account) and much more virulent and deliberate assaults on science couched in novel and convenient fabrications of ignorance. The Intelligent Design movement clearly articulated its dis-informative intentions in its writings, well encapsulated in a publication called "The Wedge" (Center for the Renewal of Science and Culture, 1999). Published by the disingenuously titled organization The Discovery Institute, and authored by the equally deceptively titled Center for the Renewal of Science and Culture, this report does little to either promote discovery in the scientific sense or to renew science and culture. In fact, the "wedge" methodology is aimed at the overthrow of science (what it calls "materialism") through strategies of writing and publicity, opinion making and confrontation.

Several conservative media outlets have waved this banner of Intelligent Design in past years and school board confrontations have been couched in terms of a "debate" between the teaching of evolution and the teaching of intelligent design. Part of the deception has been to pass off intelligent design as a synonym for religious creationism and then to portray school boards as anti religious for refusing to allow it to be taught.

There are several reasons why we can characterize this "debate" as little more than a promotion of ignorance and un-science. Perhaps the most important is the scientific denialism inherent in intelligent design. According to "The Wedge" document (Center for the Renewal of Science and Culture, 1999, p. 5): "If we view the predominant materialistic science as a giant tree, our strategy is intended to function as a 'wedge' that, while relatively small can

split the trunk when applied at its weakest points." Intelligent design also fits quite well into the categorization of types of ignorance mentioned before. In fact, Scott and Branch (2002) specifically noted that intelligent design has been characterized as an argument arising out of ignorance since an intelligent cause or designer is assumed when explanations cannot be found. In elevating either creationism or intelligent design to the status of debate with evolution, a false impression of equality is given to the two sides.

As theory, Darwin's body of work has grown well beyond initial propositions and has matured in scientific terms to the point where further questions that test the boundaries of extant theory must be asked (i.e., the seeds of paradigm shift in Kuhnian terms), but none of that is to validate any of the specious claims against the validity of a theory that has stood up to scientific scrutiny and yielded thousands of peer-reviewed studies that support its tenets. As a rhetorical device, reference to Darwin's body of work as either a "theory" or "just a theory" belies popular ignorance about the role of theory in the scientific process. It simply furthers ignorance when proponents of ID or creationism suggest that these are somehow on par with evolution and natural selection as scientific theories to be debated. That the "debate" between the two is both successfully promoted by proponents of creationism and ID (using the media technologies of the Information Age) and repeatedly reported in the mass media in the frame of a valid debate, suggests that the Information Age is equally apt to be clouded with disinformation. The result in this case is a persistent belief that evolution is a dodgy concept that is not only unconvincing but is spread by being forced on society. Comfort (2008, p. 8), who called evolution a "Fairy Tale for Grownups" characterized the persistence of this notion over some fifty years in the following manner:

> In 1982 a Gallup Poll asked Americans if they believed that God created mankind. An amazing 82 percent said that they believed He did. Thirty-five years later, in 2007, the same question was asked, and 81 percent said they thought that God created man. So despite more than fifty years of school children and television viewers being force-fed evolution, belief in the theory increased only 1 percent. It seems that the average American isn't easily fooled.

Lest the impression be given that this is a strictly American phenomenon, it is worth noting that in other places, the influence of cultural and religious superstitions are even more firmly embedded in the persistence of ignorance. In Kuwait, for example, Ministry of Education regulations routinely prohibit depictions of dinosaurs in books used for pre school and elementary classes, a rule not without precedent in the region. Burton (2010) investigated the content of Saudi textbooks, finding that at least one of the biology texts openly

derided Darwin and his body of work, calling it deviant and contrary to reason. Burton noted (2010, p. 26):

> As might be expected, the rest of the textbook, which focuses on descriptions of the various kingdoms of organisms, makes no further mention of evolution, but includes more Qur'an verses as relevant to certain groups of animals. With only this exposure to biological evolution in their public education, Saudi students may enter science programs in domestic and foreign universities.

The Information Age privileges scientific information and technological advancement largely to the exclusion of other ways of seeing the world. In this context, it is also important to note that it would also be a kind of ignorance to completely and automatically dismiss all dimensions of religious thought or similar philosophies. Moral guidance, notions of social equity, generosity, charity, forgiveness and other benefits of religious thought remain as important to human society in the Information Age as in ages past (and, some would argue, even more so). However, the social role of religion as a primary determinant of information has necessarily changed. As later chapters will examine, this role has varied over the history of humankind and continues to evolve along with new information technologies.

SCIENCE AND INFORMATION

Science is often seen as the antithesis of ignorance, associated, as it is, with knowledge and investigation. Since unscientific ideas have been associated with ignorance, it is also necessary to interrogate the concept of science—and to ask whether science itself can be capable of fostering ignorance.

Thomas Kuhn (1962) in *The Structure of Scientific Revolutions* has presented modern society with several important perspectives that clarify our approaches to science. Among these concepts, Kuhn emphasized that science is a human endeavor, influenced in part by the politics of what scientists operating under a particular paradigm consider acceptable. The changes to scientific paradigms over time are wrought not simply by the gathering of more and more information within a specific paradigm, but also by innovations and by questioning of the prevailing and dominant concepts of the current science.

Scientific endeavor as a human undertaking, is fundamentally imperfect and continually improving. There is no such thing as science in an absolute sense, but, as Kuhn suggests, a continually evolving set of concepts of science—each replacing its predecessor with improved ideas and understanding of the world around us. Information is thus a component of science, a necessary, but not a sufficient part of knowledge. Such a view of science also allows us to conceive of good science and bad science at several levels. Good science may

be that science which employs sound methods, or reveals truths that are important to the human condition. Bad science may be science that is unsound in its methods, or even science that is methodologically sound but applied to nefarious or unethical uses.

While the modern social information mechanisms have become purveyors of science to the broader society, this in itself has not necessarily improved the social spread of scientific knowledge—or thwarted the spread of bad science. Of particular interest here are cases in which good scientific information is misrepresented to the public, scientific debate is characterized as a failure of the scientific method or bad science is promoted through the hype-inducing conduits of the networks.

Autism

For several years, a growing number of parents in the United States and elsewhere have resisted routine vaccination of their children. For many, the choice has to do with a perception that vaccines in general and the MMR (measles, mumps and rubella) vaccine in particular are associated with the spread of the condition known as autism. The diagnostic criteria for autism are laid out at section 299.00 of the Diagnostic and Statistical Manual of Mental Disorders (DSM-IV) and include, *inter alia*, impairments in social interaction and communication as well as repetitive fixated behaviors. On February 28, 1998, the *Lancet* (volume 351, number 9103) published an article by Wakefield and eight other authors entitled "Ileal–lymphoid–nodular hyperplasia, non-specific colitis, and pervasive developmental disorder in children." The study itself concluded (p. 641) that the authors "did not prove an association between measles, mumps, and rubella vaccine and the syndrome described (autism and bowel disease)" and even suggested that a "genetic predisposition to autistic-spectrum disorders is suggested." However the study did raise several questions about possible associations between the vaccine and autism, and then combined with publicity over the lead author's testimony in legal suits attempting to hold vaccine manufacturers responsible for autism in children.

The spread of these ideas led to a broad public acceptance of a direct causal effect between the MMR vaccine and autism (not just the study's autism/bowel disease syndrome)—evinced by both drop-offs in vaccination rates and increases in disease incidence in the United States and the United Kingdom (The CNN wire staff, 2011). Perhaps more relevant to the discussion of the persistence of ignorance is the extent to which this particular piece of disinformation took hold. The relatively specific and circumspect pronouncements of the study morphed with each web posting and online discussion into

a general association between autism and vaccination which became deeply entrenched in the popular imagination. So deeply established was this false association that even the retraction of the study in 2010 and several findings of unethical conduct against the lead author were not enough to dissuade those already convinced. In January 2011, almost a year after the retraction of the study, a poll of Americans found that about half of those surveyed still suspected that there was an association between vaccinations and autism (Gardner, 2011).

Global Warming

The concept popularly known as "global warming" aptly demonstrates the interplay of forces of information and disinformation in the present Information Age. However, the debate over global climate change has raged over many decades. Palfreman (2006, p. 28) traced the debate back more than 150 years to Victorian scientists who raised questions about the earth's temperature, specifically mentioning John Tyndall who concluded that while nitrogen and oxygen had no effect on retaining heat, carbon dioxide acted as a blanket or greenhouse, trapping heat in the atmosphere.

Starting out as a question of purely scientific speculation, this Victorian debate evolved over the years into one about whether human impact on the environment is responsible for changes in global climate conditions. One such measure is the overall temperature of the global system which has been measured as rising somewhat over the current measuring period, leading to the use of the term global warming. At the level of everyday ignorance, this term allows commentators on mass media and in the blogosphere to claim at every cold spell that the notion of "global warming" is unfounded. In this way a simplistic and erroneous view of global climate change is popularized. Global climate change is a much more complicated area of scientific inquiry that includes both increases and decreases in temperature as well as several other factors. However, the question of global climate change is still an open one—debated within scientific circles where data are repeatedly presented, interpreted and questioned. At the center of this debate is the question of whether the observed changes in the earth's climatic conditions are temporary fluctuations within the various cycles of climatic and natural changes or markers of the permanent impact of human activity.

The public debate, however, is deficient on the science and its implications both in tone and in fact. Contributing to the deficiencies is a systematic failure of journalistic coverage of this and other scientific issues. Palfreman (2006) concluded from several prior studies of media coverage of scientific issues that journalists contribute to distortion of scientific issues by making

scientific errors, focusing on the human-interest side of stories rather than the scientific issues and by an insistence on "balanced" coverage in which equal prominence is given to unscientific opposing views. Carvalho (2007, p. 237) took this analysis further, arguing that journalism is tinged with ideological factors in three ways: 1) how facts are interpreted including what is considered factual and how much space is granted to various claims, 2) the determination and acceptance of experts who are featured by the media and 3) the interpretation of implications of scientific issues.

Outside of its primary scientific concerns, the politics of the debate also include partisanship alignment in the United States. While liberal politician and former U.S. Vice President Al Gore has championed the cause, conservative commentators have taken to outright denial of the concept of global climate change, and further, to denial of any tenets of conservationism as threats to industry and free enterprise. Schmidt (2010, p. A537) described the media debate in the following terms:

> Skeptics in the media (typically conservatives) deride global warming as a monumental hoax, while those who believe in the evidence for human-induced climate change (typically liberals) accuse the skeptics of being industry-funded hacks.

An example of this kind of partisan analysis could be found in a December, 2010 editorial from the *Washington Times* (The Washington Times 2010) which argued:

> Now the so-called "scientific community" of global-warming alarmism predicts the heating of the planet will produce "extremes" that include colder winters and warmer winters. It's a self-proving "scientific" theory: Regardless of what happens, even if it gets colder, it's proof of global warming... It's also definitive proof that the purveyors of this hokum are not doing real science. It's one thing to credit a fairy tale to stimulate the imagination of young children. It's another to use a fairy tale to enact socialist policies designed to give Washington bureaucrats more control over our lives and the economy.

There are deeper implications of this mindset which hail back to certain religious ideals about human dominion over the natural environment, but to stay with the question of political commentary, conservative commentators take the very existence of scientific debate as evidence of the falsehood of the concept of global climate change. The issue, however, is a broader one, which involves question about science and the interplay of the forces of information and disinformation.

Piltz (2008, pp. 74–75) suggested a direct and deliberate political effort to obfuscate the science of climate change in the interests of industrial powers, noting:

> In 1998, a "Global Climate Science Communication Action Plan," developed at the American Petroleum Institute (the leading trade association and lobbying arm of the U.S. oil industry) by industry representatives and political operatives with advocacy groups, laid out a media relations campaign in which contrarian scientists would be recruited, trained, and deployed to promote an air of scientific uncertainty about global warming... It wasn't necessary for them to "win" the debate about the reality of anthropogenic global warming; rather, it was necessary only to create the appearance of a deeply divided science community, thus helping to dissipate the will to action among political leaders and the public.

Piltz (2008) further argued that the ascension of prominent petroleum interests to positions of power in later years led to the success of this strategy.

Fault for the characterization of environmental concerns as political may fairly be laid at the feet of politicians and commentators who openly deny even the most obvious evidence of destruction of the natural environment and depletion of natural resources—frequently at the behest of powerful corporate interests—the most common perpetrators. Yet, environmental "activists" may be equally guilty of politicization in their rhetoric including various over-reaching conclusions from the science and activities such as eco-terrorism evident both in the United States and abroad. From this perspective, ignorance abounds on both ends of the political spectrum.

Within this volatile debate, any failure of the science of global climate change provides fuel for the debate and comfort to those that would deny the importance of the issue. This has culminated in mass media and online discussions in recent years of the "hockey-stick" graph describing an above-normal acceleration in global temperatures in the most recent centuries. The specific debate in scientific circles is quite technical, having to do with particular protocols used in estimating global temperatures over thousands of years and featured reviews and counter reviews of data. As Sheppard (2011), has noted, the politicized debate that followed involved active strategies on the part of conservatives to characterize this as a revelation that the entire scientific enterprise of investigating climatic and other changes was in fact a hoax.

PORTRAYALS OF THE SCIENTIST AND THE ACADEMIC

The roles of both mass and electronic interpersonal media in portrayals of science and scientists have become increasingly important in the Information Age. In this regard Mccann-Mortimer, Augoustinos and Lecouteur (2004, p. 413) wrote:

Recent research has emphasized the increasing importance of the media's role in disseminating science news, and in shaping public understandings of science... It is widely accepted that science journalism acts as a gatekeeper between scientists and the general public, and that science news may be reified or challenged according to the particular "framing" employed by the science writer.

Rather than demanding engagement from the popular imagination, however, the complexities of actual scientific debates and controversies are all too frequently ignored in mass media and other common expressions of Information Age discourse, swept over by broad brushes of generalizations and ignorance. Despite the increasingly broad availability of information on many scientific and intellectual issues with the evolution of the technologies of the Information Age, popular media often portrays the pursuit of such knowledge and those involved in such pursuits in pejorative terms.

Gregory (2007), for example, argued that both expectations and practice of education in the United States are conditioned by popular media portrayals of educators and the education process despite a lack of attention to such portrayals in academic circles. In analyzing these representations, Gregory (2007, p. 13) noted:

> The content of these images is almost always as corrosive as acid to any real-life student's notions of the hard work, self-discipline, repetitive practice and powers of attention required for getting a real education. The images of education in movies and television hammer home that the real reason for being in school is to have fun, fun, fun; that academic classes are about as tasty as walnut shells; and that teachers—a generally contemptible tribe of aliens—are either out-of-touch nerds, supreme egoists, disgusting lechers, out-of-fashion uglies, or vicious bullies who focus on the helplessness of students with sadistic delight. In many education narratives, teachers care only about petty power, petty ego, petty grades, petty rules, and petty indulgences.

Educators and educated persons including scientists face negative stereotypes in the media of the Information Age even outside the context of the classroom. From the Professor on *Gilligan's Island* to Ross from *Friends* and the team from *The Big Bang Theory*, academics and scientists are portrayed as socially inept, disconnected, naïve, distracted and unrealistic in their outlooks and aspirations. Flicker (2003) and Haynes (1994) noted the associations of scientists with madness and obsession, their relative unattractiveness and their potential for harm in pursuit of their objectives while Haynes (2003, p. 243) asserted that "according to the media, Victor Frankenstein is alive and well, preparing polio viruses for germ warfare, delivering genetically engineered vegetables, cloning sheep, cows, human babies, and anything you care to nominate." With the comic bumbling of *Third Rock's* Dick Solomon and the manic ravings of Doctor Emmett Lathrop "Doc" Brown (in *Back to the Future*)

as well as the *Paper Chase's* austere and aloof Professor Kingsfield, the learned and the academic are objects of both ridicule and fear, cast as both inferior and even dangerous (Losh, 2010) despite their learned status. For Gregory (2007), this is at once part of a long tradition of representations and a continuing conditioning of expectations against knowledge, learning and those who choose to be educated or to become educators. Haynes (2003, p. 244) identified a continuing tradition of such portrayals from the early days of Western literature with the emergence of seven interrelated (but predominantly negative) stereotypes of the scientist or academic as follows:

1. the "evil alchemist"
2. the "noble scientist" as hero or savior of society
3. the "foolish scientist"
4. the "inhuman researcher"
5. the "scientist as adventurer"
6. the "mad, bad, dangerous scientist"
7. the "helpless scientist," unable to control the outcome of his or her work

In their study of six Hollywood films from the 1960s, Terzian and Grunzke (2007, pp. 416-417) concluded that these films projected "multiple images of the American scientist as an intellectual who is precariously stationed on the margins of acceptable cultural parameters, often socially inadequate and not practically intelligent," a figure that is alternately mocked and feared. They also concluded that films such as *The Nutty Professor* and *The Absent Minded Professor* view the scientist as socially and otherwise awkward despite being able to challenge the very laws of nature. Taken further, films such as *Dr. Strangelove* portrayed scientists as a threat to the very survival of mankind.

The image of the scientist, researcher or academic, while part of a long tradition that has embodied both reverence and ridicule, has not demonstrated improvement in an age where knowledge and information are supposedly elevated to a higher social status. Thomas and Holderman (2008, pp. 25-31), analyzing modern offerings in media representations of intellectuals argued:

> Particularly since the second half of the twentieth century, our culture—and, thus, its mythology and prominent stories—is basically anti-intellectual. In other words, traditional intellectuality has, increasingly, become devalued and discouraged... Throughout all popular media and genres—in or out of the academy—intellectuals are typically life's losers. Although research shows that rich people are invariably portrayed as significantly less congenial or happy than others, or that criminals and "bad guys" ultimately suffer negative consequences, there seems to be no other identifiable group... depicted as more discontented and deluded than intellectuals.

While much of the research in this area suggests a particular U.S. bias for the technically proficient over the academic or theoretically insightful scientist, there is also need for a distinction to be made between the scientific pursuit of information and the more mundane pursuit of information. Thus in the Information Age, the scientist or researcher who generates, interprets and applies scientific data is not necessarily more valued than the paparazzi who generate information in the form of scandalous photos of celebrities or the e-mail list marketer who mines, compiles and sells e-mail addresses for profit.

3

The Information Age in Perspective

The Ministry of Truth—Minitrue, in Newspeak—was startlingly different from any other object in sight. It was an enormous pyramidal structure of glittering white concrete, soaring up, terrace after terrace, 300 metres into the air. From where Winston stood it was just possible to read, picked out on its white face in elegant lettering, the three slogans of the Party:

WAR IS PEACE
FREEDOM IS SLAVERY
IGNORANCE IS STRENGTH

(Orwell, 1949, p. 2)

In 1913—at the tail end of the Industrial Revolution, French poet Charles Péguy said the world had changed less since the time of Jesus Christ than in the previous thirty years. The exuberance and exaggerations of the Information Age are, therefore, not unique. Nor indeed are the problems of the information or the social responses to its changes. Floridi's (2009, p. 154) perspective is somewhat typical of the widely accepted tropes of suddenness, revolution and inevitability that one may find even in critical discourses on the Information Age described in the following terms:

The almost sudden burst of a global information society, after a few millennia of relatively quieter gestation, has generated new and disruptive challenges, which were largely unforeseeable only a few decades ago... The information revolution has been changing the world profoundly, irreversibly, and problematically since the fifties, at a breathtaking pace, and with unprecedented scope, making the creation, management, and utilization of information, communication, and computational resources vital issues.

TECHNOLOGICAL REVOLUTIONS

Cook (1995, p. 63) argued that despite the widespread perception that we are always in the midst of some kind of technological revolution and ascribe historical and social importance to them, we lack what he calls "substantive

discussions as to what exactly a technological revolution is." He further pointed to the perceived obviousness of these revolutions, writing:

> In fact, we refer to them as though their nature were obvious. We make use of histori-
> cal examples to characterize the appearance of exciting new technologies and to pre-
> scribe ways for dealing with their "impact." And we make these comparisons and
> prescriptions with such alacrity as to suggest that an explication of what we take the
> form of a technological revolution to be is simply unnecessary. (Cook, 1995, p. 63)

He is among others who have suggested that these predispositions and assumptions lead to distorted perceptions of both the history of technology and their social impacts.

Information Revolution, Information Age

The very pervasiveness of the notion of a still emergent Information Age makes it difficult to step outside its guiding assumptions. The more that we live these assumptions, the harder it becomes for us to question whether an Information Age is truly upon us. For many of us, it seems an undeniable fact, difficult to question because we are inextricably caught in the web of interdependent information technologies that define our age. The person who e-mails, texts, and manages their bank accounts using these technologies is likely to perceive them as natural parts of modern life. The person who has little or no access to these technologies, draws water from a well, and lives a rural agricultural existence in a developing country may have a slightly different perception.

There are several instances, for example, of the rollout of mobile phone technologies in rural areas of developing countries—bringing phone service to places where governments had never been able to run traditional wired land line telephone networks. A mobile phone in such a person's life may indeed add tremendous convenience, but the person may not perceive it and its interdependent technologies as marking a separate age or even a fundamental change in lifestyle. Winston (1998, p. 2), characterizing the concept of an Information Revolution as mere hyperbole, argued that a historically conscious viewpoint "reveals the 'Information Revolution' to be largely an illusion, a rhetorical gambit and an expression of technological ignorance" despite the fact that, as he contended, "the popular literature on these matters and the media resound with visions of techno-glory or apocalypse, the same set of phenomena being the source for both styles of pontificating."

Mosco (2004) has argued that the hyperbole surrounding many of the claims of the Information Age cannot be substantiated by empirical evidence—among them the claim of technology as an agent of social change and trium-

phal pronouncements such as Francis Fukuyama's (1989) notions of the "end of history" and Cairncross' (1997) notion of the "death of distance" (examined in further detail later in the present work). Mitroff and Silvers (2008) took this question of hyperbole somewhat further, suggesting a connection between misguided Information Age concepts and particular types of intellectual errors. Of particular interest to the present discussion are their Type 4 errors that involve efforts to precisely solve the wrong problems, which, one might argue, constitute a form of ignorance. They argued that the much-touted Information Age provides the means to cultivate misguided and dangerous conceptions of the socially acceptable in the service of what they characterize as "Sociopathic Capitalism." They included in the scope of their explanation such widespread and diverse phenomena as the establishment of healthcare as a commodity, the acceptance of the right of huge corporations to make vast profits by exploiting consumers (and the environment) as well as government abuse of information to promote wars fought by the children of poor families.

In developing their notion of what they characterize as a misguided shift in social priorities associated with the Information Age, Mitroff and Silvers (2008) also suggested that the error of solving the wrong problems may not be limited to the influence of Information Age technologies or data. In addressing this issue they also inevitably end up questioning the existence of such errors in traditional thinking, noting, for example that popular religious traditions are anachronistic, aimed at concerns of long-past societies and, beyond just being irrelevant in the modern age, they perpetuate a tendency to solve the wrong problems.

Despite such dire evaluations, the question of whether an Information Age is upon us is so overwhelmingly decided in the popular culture that it seems counterintuitive to question whether we are actually in such an age. Yet the evolution of the idea has been part real technical evolution and part academic and popular hype. The notion of an Information Age suggests the level of human advancement associated with movements from the stone age to the iron age and so on. Several questions remain as to whether the present "Information Age" marks an advancement of the same scale or whether we are actually looking at incremental advancements to technology that have made life more convenient but have not fundamentally transformed human society on a global scale. The debate becomes all the more interesting when as Webster (2002, p. 22) pointed out: "the closer one looks at what is meant by 'information,' the more awkward does it seem to find a precise and unambiguous definition." Since, as Webster claimed, there are well over 400 definitions of information, it may be foolhardy to settle on one, and in the present analysis the term is used as loosely as possible (following the lead of Daniel

Bell, 1973) to refer to any quantum of data including message both meaning-
ful and otherwise, whether measurable or not.

The definitional and nomenclatural problems do not end there. While the
two terms are used interchangeably in the vernacular, there is some distinction
in the literature between the concept of Information Age and the concept of
Information Society, the former referring to the technological developments
associated with the Information Revolution and the latter referring somewhat
more specifically to the conditions of society that devolve from those develop-
ments. Both Castells (2000)and Webster (2002) appeared to favor the use of
the term "Information Age" while cautioning against the use of the term
"Information Society."

Frank Webster (2002, p. 23) suggested that an Information Society can be
defined in terms of technological innovation and diffusion, occupational
change, economic value, information flows, the expansion of symbols and
signs and changes in the ways in which life is conducted because of informa-
tion. Despite this definition, Webster also cautioned that the concept of
Information Society "is of little use to social scientists, and still less to the
wider public's understanding of transformations in the world today" (2002, p.
22). This warning has less to do with the idea of the transformative power of
information and more to do with caution about making sweeping social
claims, especially in a world where tremendous variations exist in access to and
diffusion of Information Age technologies. Trying to resolve this distinction is
neither productive to the present analysis nor properly within its scope. Yet, a
return to some of the precedents of both terms may aid in understanding the
evolution of the general idea of the Information Age. A reasonable place to
embark is with the work of Machlup and his ideas about the information
economy.

MACHLUP AND THE INFORMATION ECONOMY

Fritz Machlup (1962) wrote *The Production and Distribution of Knowledge in
the United States*. This work marked a fundamental shift in thinking about the
Information Age and the beginning of widespread reference to something
called the "information economy." Machlup's central thesis was that the U.S.
economy was gradually moving away from production of physical goods. He
suggested that this traditional focus of the economy was being gradually
replaced by an emphasis on the creation and provision of information-based
services. Machlup (and, later, his students) sought to demonstrate this shift
through measurement of the contribution of various sectors to the national
economy. They showed that an increasing proportion of the value of the U.S.

economy was accounted for by so-called "knowledge industries" which, over time, were eclipsing the traditional production of material goods.

Critics of Machlup's work have argued that the emerging value of "knowledge industries" had more to do with an ever-widening definition of what constituted information jobs. They suggested that the value of information jobs was shown to increase because Machlup and company were simply including more and more jobs under the heading of information jobs and more and more industries under the heading of "knowledge industries." Despite these criticisms, the concept of the "Information Age" began to emerge and become popular, especially in the context of developments in computer technology around the same time.

COMPUTERS, NETWORKS AND THE INFORMATION AGE

The development of computer technology and networks were among the most important factors that both drove and symbolized the social transformations associated with the Information Age. Computer networks were already being discussed in technical circles when the launch of the Soviet satellite Sputnik (on October 4, 1957) prompted the United States to respond in part with an agency for technological knowledge and innovation—the Advanced Research Projects Agency (ARPA) under the Department of Defense (DOD). It was at this agency that the concept of computer-based networks developed into the reality of networks.

J. C. R. Licklider was an influential scientist of his time who had an interest in computers and information processing. While he was with a technology firm called Bolt Beranek and Newman (BBN) during the late 1950s the National Council on Library Resources asked him to investigate the ways in which computer technology might be used to address the growing amount of information available to humankind. Having already spent some time on this issue, he became the head of two programs at ARPA in 1962.

Soon after he arrived at ARPA, he began to form contractual relationships with large universities and research institutions such as Stanford, UCLA and Berkeley who were involved in studying and developing computer technology. The stories of how and why computers were networked are, like so many other historical records, contested and varied despite (and sometimes because of) the availability of several sources of information. According to some sources, Licklider wrote to the participating institutions, which he termed the Intergalactic Computer Group, to propose a network:

> In 1963, Lick wrote a memo to members of the Intergalactic Computer Group making a case for standardization among the various computer systems used by members of the group. Lick wanted the researchers to be able to build upon each others' work.

Their physical distances from each other and incompatible computer systems made this difficult. If the various computers could be connected researchers could easily communicate data between them. Lick was proposing a network. (Griffin, 2000)

Other sources credit Robert Taylor, the director of ARPA's Information Processing Techniques Office with an even more mundane genesis to the modern computer network. Taylor coauthored a 1968 paper entitled "The Computer as Communication Device" in the journal *Science and Technology* (1968) with J. C. R. Licklider and had a similar interest in networking computers. However, the story goes, often quoted directly from Taylor, that the impetus to form the first network was much more pragmatic than any grand notion of advancing human knowledge. Taylor and others have recounted his frustration at having access to several large and powerful computers but having to change seats every time he wanted to move from one to the other. According to Marion Softky (2000) writing in the *Almanac* newspaper:

About 1966, Mr. Taylor recalls, his office in the Pentagon had a terminal connected to time-sharing community at MIT, a terminal connected to a different kind of computer at the University of California at Berkeley, and a third terminal to the Systems Development Corp. in Santa Monica. "To talk to MIT I had to sit at the MIT terminal. To bring in someone from Berkeley, I had to change chairs to another terminal," he says. "I wished I could connect someone at MIT directly with someone at Berkeley. Out of that came the idea: Why not have one terminal that connects with all of them?"
"That's why we built ARPAnet," he says.

Regardless of the motives and whether they were noble or self-interested, the ARPANet became a reality and by the turn of the decade of the 1970s the computer networking genie was out of the lamp. Computer technologists and other specialists working with (and around) Arpanet and university projects created small communities in the 1970s and '80s which included the very successful Usenet and its newsgroups as well as the MUDs (multi-user dungeons) and MOOs (multi-user dungeons—object oriented) of the early 1990s.

Even before users outside of the military and large research universities had access to what we know today as the Internet, a particular flavor of geek was already dabbling in connecting computers across distances and enabling users to share messages. These dabblers, some with establishment connections—others simply hobbyists and techies—were a breed apart from normal humans of their day. The messages about networked technologies and the promises of digital computing spread among them with a palpable promise of fruition. They had access to computers, and some had even actually sent messages over great distances using telephone lines and early modems. This

core of sysops, hackers and cybergeeks lived mainly on the outside of the main ARPA-based systems. However many had deep ties and contacts with related projects or big computer firms that were connected through contracts to the hub of ARPA's digital communication efforts.

These "users" found both the technical ability to transmit messages through computers and the social need to do so. Pretty soon they were using rudimentary modems to shovel data from one set of computers to another (often on "borrowed" telephone lines and time). The inception of the first network outside the ARPA official system is associated with the work of Duke University grad students, Tom Truscott and Jim Ellis in 1979 that led to creation of the Usenet. Using a "store and forward" model for messages, and then a discussion forum for what became known as Newsgroups, the Usenet evolved into a relatively social, though initially quite specialized and unintentionally restricted, network. The restrictions had more to do with technical aptitude and access than with formal bars to entry. Computer literacy required real effort. Commands had to be mastered, complex instructions issued in the proper order and numerous entered for even the simplest of computer messages to be exchanged. By the late 1980s, this would begin to change with the popularization of the personal computer, first mass marketed by IBM in 1983—yet even as the Usenet flourished, it did so among those with the technical ability and dedication to learn how to use the network and its associated technologies.

Early information systems such as Compuserve and America Online and electronic bulletin board systems (BBS) of the late 1980s and early 1990s foreshadowed the development of online communities that would later become possible with the rapid public and international diffusion of Internet technologies. A hybrid kind of community would sometimes form among BBS users. In the late 1980s and early 1990s popular BBS operators were known to host picnics and other events where users, many of whom had only communicated online before, would have a chance to meet. Some BBS providers were in it primarily for the money and the events could sometimes feel like a big marketing ploy, but the experience of meeting virtual contacts had a particular novelty for most people involved in this early form of digital community. In the case of BBS communities, other users were not primarily friends, family and coworkers but like-minded computer communications enthusiasts—constituting what some have called a community of interest. With the rapid diffusion of personal computer technologies and Internet connectivity starting in the early 1990s, large corporate interests and telecommunication companies began to provide connectivity in a manner that quickly made the BBS communities unnecessary. Though some persisted for a while, many others simply

hung up their modems. A small number of larger BBS operators made the switch to being Internet Service Providers especially in rural areas and developing nations where telecoms were slow to expand.

These communities, from Usenet enthusiasts to BBS users were among the few who experienced many of the possibilities and challenges of the digital Information Age before these became everyday realities for the rest of modern society. On a broader scale, the social evolution into an information-based reality through digital technologies becoming part of everyday life would be somewhat more gradual. Part of this evolution involved what some have characterized as a movement away from an emphasis on industrialization towards an emphasis on information.

DANIEL BELL AND POST-INDUSTRIALISM

Daniel Bell is frequently credited with the popularization (if not the origin) of the concept of post-industrialism—essentially the idea that modern society has evolved away from a focus on industrial production and (by implication) toward a focus on information as the primary locus of production and economic activity. Like Malchup before him, Bell argued that the emerging predominance of service and information-based activity in the modern economy marked a fundamental shift in the nature of society away from the industrial character spawned in previous centuries and toward a more intellectually based, knowledge-centered existence. Bell (1973, p. 14) defined post-industrialism in terms of five central social characteristics: (1) an economy based on services rather than material production, (2) predominance of professional and technical jobs, (3) theoretical knowledge as the source of innovation and policy (4) a technological and future- based orientation and (5) decisions guided by what he termed "intellectual technology." Veysey (1982, p. 49) defined the concept in the following manner:

> Post-industrialism refers to the period in the evolution of an already economically developed society that follows the largest leap of industrial growth and is marked by a relative decline in the importance of the manufacturing sector, by widespread affluence and leisure, by a high degree of dependence upon technology, and by a relative emphasis on one's role as a consumer, rather than as a worker, as compared with all previous historical eras.

He also noted in offering the definition that despite its popularization by Bell, the basic idea behind post-industrialism had been articulated much earlier (in the 1950s) by economists such as John Kenneth Gailbraith. Gilliam (1982) suggested that though widespread and well debated, the post-industrialist perspective gained popularity partly due to the stature of Bell

himself as a famous and controversial scholar. At about the same time, other scholars were declaring the death of the post-industrial concept (Veysey, 1982).

NORA, MINC AND L'INFORMATISATION DE LA SOCIÉTÉ

Not all contributions to thought on the Information Age have originated with scholarly debate. Some have originated in more worldly pursuits such as the crafting of public policy. Fitting this description is the report by Simon Nora and Alain Minc in 1978 entitled *L'information de la Société* (often translated as the Computerization of Society) submitted to French President Valery Giscard d'Estaing. This document is credited with introducing such concepts as "telematique" which was seen as a kind of national resource of telecommunications and information (Nora & Minc, 1978; Rheingold, 1993). The Nora and Minc contribution included forecasting massive social change as a result of the spread of computing power and networking. Such change included shifts in both the flows of communication and the nature of conflicts—which, they suggest would become increasingly centered on issues of culture rather than physical resources. They predicted a possible shift from the elite use of computing and information resources to mass availability as well as a shift from industrial production to information-based society.

Outside of some passionate debates on whether "telematique" is properly translated as "telematics" and other similar concerns, the Nora and Minc report has been most directly criticized for its parochialism because of its focus on the need to protect French national sovereignty by urging national control of the convergence of information and telecommunications—particularly with regard to the then emerging power of the IBM corporation in France and elsewhere. Ithiel de Sola Pool (1981, p. 353) for example, accused the report of having an "authoritarian fundament" and demonstrating "unresolved ideological conflicts."

MANUEL CASTELLS AND THE INFORMATION AGE

For many scholars and other commentators, the defining statement of the modern Information Age is Manuel Castells' trilogy entitled *The Rise of the Network Society, The Power of Identity and End of Millennium* published as volumes of The *Information Age: Economy, Society and Culture*. Castells (2000, p. 1) described the Information Age in revolutionary terms, calling it "a technological revolution, centered around information technologies" which, he contended, "began to reshape, at accelerated pace, the material basis of society." He made the connection, as well, between this revolution in information technologies and the globalization of economies suggesting that they have

become "globally interdependent, introducing a new form of relationship between economy, state, and society..." (Castells, 2000, p. 1). He addressed the hype of social change to some extent, arguing that while "prophets of technology preach the new age" others "indulge in celebrating the end of history, and, to some extent, the end of reason, giving up on our capacity to understand and make sense, even of nonsense" (Castells, 2000, p. 3). Whereas a substantial part of the Information Age hype necessarily centers on the relationships between society and technology, Castells (2000, p. 5) invited a much more nuanced view predicated on a "complex pattern of interaction" between the two, suggesting that "technology does not determine society. Nor does society script the course of technological change, since many factors, including individual inventiveness and entrepreneurialism, intervene in the process of scientific discovery, technological innovation, and social applications..." Included in the factors intervening between technology and society for Castells are capitalist dictates and motives. He argued (2000, p. 18) that "the information technology revolution was instrumental in allowing the implementation of a fundamental process of restructuring of the capitalist system from the 1980s onwards," and that "informationalism is linked to the expansion and rejuvenation of capitalism, as industrialism was linked to its constitution as a mode of production" (2000, p. 19).

Castells' broad and comprehensive examination of myriad aspects of the Information Age included economic, political, public policy, and even urban planning concepts that aptly demonstrated the impact of global communication technologies. Yet, it also included several warnings about the propensity to overextend perceptions of the impact of those technologies and to thoughtfully consider the many ways in which social change is wrought. It is within this set of cautionary notes that the present analysis resides—adding the idea that these technologies, for all their informative roles, may also prove to be dangerously dis-informing.

CAIRNCROSS AND THE DEATH OF DISTANCE

Frances Cairncross (1997) suggested that the concept of distance was being eroded by the ever-expanding influence of Internet-connected new media especially with regard to the changes in commerce wrought by these developments. She argued that, in the future, anyone with a credit card and a telephone could become part of the new economy. This bold claim seems less radical in retrospect particularly with the global reach of the Internet and the expansion of e-commerce on the Net in recent years.

The claim seems even stronger in light of Cairncross' important distinction between digital and physical products. She distinguished between

products that have a physical form and those that are purely digital in nature. Digital products such as music or movie downloads conform neatly to the concept of the death of distance because they incur no (or negligible) transportation expenses. Additionally, they never wear, and are replicable for little or no marginal cost. More information products are becoming more completely digital even today—witness the still nascent market for digital books, for example. All of which seems to bear out the argument that distance is indeed dead.

Yet, the sweeping claim that distance is dead does not hold true. Distance is still very much a factor in real life. Cairncross wrote her book in 1997 when the price of a gallon of gasoline averaged $1.24. Subsequent upward trends in international oil prices made transportation expensive again and distance once again had to be recognized as a continuing and important part of production, distribution and consumer costs. Fuel surcharges were being charged directly on shipping invoices while fuel and other distance costs once again began to drive consumer costs upward.

Thus despite great advances in e-commerce, distance still matters because we live in a real world where real goods still need to be moved to physical locations for flesh-and-blood consumers. So while we can purchase a digital music download and imagine that there are no physical components to the transaction, we still require physical devices to enable us to obtain and use the product. Our computer or music player still must be delivered to us on a truck or driven home from the store. The physical components required to create those devices also had to be shipped, often all over the world, to enable their production. The finished products were then placed on ships, trains, and trucks (all incurring both distance and associated costs) before the products were available to consumers.

Cairncross' prediction that anyone with a credit card and a telephone could be part of the global economy suggested that the Information Age has ushered in (or will eventually create) an age of open global trade. In response to this well-meaning but specious assertion, we may consider the "Cuban Cigar" exception. The case of the Cuban Cigar is only one of many examples of the complexity of human geopolitical relations and how they resist the perceived utopian global virtual and free economy. No kind of credit card or telephone or Internet connection can allow someone in the United States to purchase Cuban cigars. Old and deeply rooted prejudices and conflicts inform and maintain legal restrictions such as the U.S. embargo on trade with Cuba. Technological advances, the Information Age and the (real or imagined) death of distance have not changed that reality.

Cairncross' early analysis of the Information Age and the consequent information economy presupposed the development of a borderless world predicated on the interconnectivity of the emerging networked technologies. Yet, Carey (2005, p. 453) argued that this techno-deterministic view of automatic "debordering" turned out to be only partly true, writing:

> Every fundamental change in technology—whether the invention of written literacy or of printing or the telegraph or whatever—every fundamental change in the system of production, dissemination and preservation of culture simultaneously borders and deborders the world. It was a widespread notion in the 1990s that Internet technology was a force in globalization, creating borderless worlds and borderless communities, borderless organizations and borderless politics. There is truth in that generalization. But what is equally true, is that as one set of borders, one set of social structures is taken down, another set of borders is erected.

Hafez (2007, p. 175) similarly argued that "(m)edia systems are firmly in the grip of nation-states" with media globalization being a far more modest process with a slower pace than is generally assumed. While the hindsight advantage of these later authors must be taken into consideration, so too must their willingness to break with the orthodox and prevailing wisdom on the matter of the global scope and the presumed economic impact of Information Age assumptions.

Cairncross' insightful but excessive pronouncements about the death of distance can be placed in context using what we might call the robot perspective. Before the idea of the Information Age began to dominate the discourse on social development, there were several other contenders. One of the most important of these was what we might term (in hindsight) the robot perspective, demonstrated in popular views of the future like *The Jetsons* and *Westworld*. In these and many other 1950s, '60s and '70s portrayals of the future, robotic (android) technologies and automated services would dominate our social existence. We created vision of the future with personal robot assistants and mechanized service devices. This was before the notion of virtualization became possible. Thus we were previously concerned with making physical motion easier and relieving physical effort in our daily lives. The notion of the virtual began to shift the emphasis of both our science fictions and our lived realities. Our robots have now turned into automated information retrieval and access tools. Our Westworld experiences are now developed online and through game consoles in virtual form.

Yet our physical needs and realities have not changed so radically as to allow them to be addressed by virtual technologies. Despite the fact that the digital networked technologies of today bring us the ability to communicate more easily and cheaply, enable software and documents to be exchanged

almost effortlessly and even enable medical professionals to perform tele-surgery, the fundamental need for the physical and the consequent reality of this thing called distance remain with us. The surgery that takes place via distance must still use physical tools if there is any hope of addressing the patient's problems and creating helpful changes. Eliminating the need for the surgeon to travel to the site is certainly a great leap forward, but it takes away neither the persistence of the physical nor the costs associated with distance. While information improves our lives in many ways, it does not substitute for physical needs and certainly does not eliminate them.

It is also interesting to note that robots have in fact seen their own developments over the past decades. The context of robotic devices has shifted to the realm of industrial production rather than in domestic and everyday life. Thus we might imagine our futures as virtual but the physical robots that we imagined in the 1950s, '60s and '70s are building our physical goods and loading them on trucks to be shipped to us.

Cairncross' early analysis reflected a particularly economic view of the new media (or distance reducing) technologies and their social impacts. Economic analyses of this and other revolutions are perfectly valid and often well-substantiated perspectives. Yet they are often predicated on a particular paradigm of value. Within that paradigm, value is measured in terms of material wealth, largely to the exclusion of other conceptions of value that may exist. Within this paradigm, the Information Revolution and the Industrial Revolution are comparable in terms of the monetary potential that each allowed to be realized. The importance of the Information Age, therefore, lies more clearly in the potential for creation of material wealth by strategies of informatization than in the potential for other changes such as improvements in social equity, the promotion of peace and understanding or the development of solutions to non monetary social problems.

THE REVOLUTIONARY CONTEXT

Management guru Peter Drucker (1999) is among those who have argued that the modern Information Age (and specifically its manifestation in e-commerce) has completely eliminated geography. Yet, he noted that this would not be the first time that society's "mental geography" has undergone an adjustment. In Drucker's argument, the previous distance-shattering revolution was the industrial revolution in which the railroad transformed society to the extent of changing the very perception of geography. Drucker (1999, p. 49) argued:

> Almost everybody today believes that nothing in economic history has ever moved as fast as, or had a greater impact than, the Information Revolution. But the Industrial Revolution moved at least as fast in the same time span, and had probably an equal impact if not a greater one.

Common to many analyses of the Information Age and the Information Revolution are comparisons with previous changes in human society. Castells, for example, also compared the Information Age revolution to previous ones. He wrote (2000, p. 30):

> Information technology is to this revolution what new sources of energy were to the successive industrial revolutions, from the steam engine to electricity, to fossil fuels, and even to nuclear power, since the generation and distribution of energy was the key element underlying the industrial society.

One of the messages of the comparisons is that no matter how exciting, fast-paced or transformative the technical and social revolution of one's day, there is a chance that similarly paced, and equally transformative experiences have excited generations past. With regard to certain social and technical changes such as the popularization of printing in fifteenth-century Europe and the spread of telegraph technology, there are sound arguments for the position that these developments were equal to, if not greater than modern digital, global information systems in terms of their social impact (for example, see Briggs and Burke 2002 and Drucker, 1999).

Another important bit of context concerns the purported revolutionary character of Information Age media technologies. The discourse of revolution in information technology is inseparable from the discourse of revolution surrounding the Information Age. Assumed revolutionary processes or at least revolutionary potential is part of the hype that leads to uncritical assumptions about the Information Age and its social impacts. Carey (2005, p. 446), for example, pointed out that early thinking about the Internet uncritically stressed its revolutionary nature, noting:

> The consensus was that the Internet was the greatest revolution to occur since the invention of printing. This innocent comparison was made without the writer asking any questions about what the invention of printing actually involved and what the consequences were, both good and bad, that appeared in its aftermath. While there was an allusion to the past, there was no attempt to locate printing or the Internet as historical phenomena.

While later work has indeed attempted to engage both the critical and historical dimensions, the discourse of revolution persists. However, Latzer (2009) reminded us that technological change can be radical or incremental

and can be sustaining or disruptive. In many cases new media technologies have demonstrated such multiple tendencies with changes that can be characterized as evolutionary rather than revolutionary, and improvements that have sustained rather than overthrown older technologies. Despite these realities, hype tends to drive hype, and as Svennevig and Firmstone (2000, p. 583) noted:

> Technology itself may well be neutral, but in the hands of "converts to the cause," a social expectation can be established. This in turn may influence people just as readily as a technology itself might. For example, if businesses—more precisely put, the people who make corporate decisions—come to believe that the future lies in one technological direction rather than another, then this can have a direct effect on the individual.

In light of these properties of technology as well as their propensity to evolve into popularity, and even be replaced Peters (2009, p. 13) called for a broader view of new media technologies that looks beyond the novelty of particular media forms while addresses the context of media history as a whole, suggesting that "new media need to be understood not as emerging digital communication technologies, so much as media with uncertain terms and uses." The uncertainty of technological change is not a new phenomenon, nor is the social dislocation and resistance associated with such uncertainty. Society has seen this before, manifest in such movements as the Luddite labor uprisings.

NED LUDD AND THE INDUSTRIAL REVOLUTION

Emerging social transformations usually take hold over a long period of time. Despite revolutionary notions, most such transformations are neither sudden nor universally accepted. This is as true of the Information Age as it was of the Industrial Revolution, where, despite massive social and technological change, transformations were often gradual, socially dislocating and even sometimes resisted. The fashionable transformations of this or previous ages have often faced resistance from those who stood least to benefit from them. Today, we call people who refuse to be wired and resist being swept up in the trends of information "Neo-Luddites." While the predominant sense of this term today describes someone who is averse to new technologies or fails to adapt to them, its implications run somewhat deeper relative to questions of social change, technology, and economic power relationships. This Information Age reference hearkens to the realities of social and technological change in a much earlier time of social transformation—the Industrial Revolution.

The Luddites came to prominence in the early 1800s when the introduction of mechanization during the Industrial Revolution combined with the

effects of a period of war, economic turmoil and high food prices, leading to widespread layoffs of laborers and other hardships. Displaced workers became disgruntled and vented their rage against the machinery they perceived as denying them employment, taking a figure known as Ned Ludd for their "leader." Manuel (1938, p. 184) recounted the most famous of the Luddite uprisings in the following terms:

> From March, 1811, through January, 1812, Nottinghamshire was the center of an organized movement of masked and armed workmen, who would appear in small bands on the same night over a large area, destroy stocking-frames, terrify the manufacturers, and bewilder the authorities... In February, 1812, a law pronounced death as the sentence for machine-breaking. Ned Ludd, from whom the rioters took their name, was either a whipped apprentice who had demolished a frame in vengeance, a mythical leader of Sherwood Forest, or a maniac who made a practice of wrecking machines.

Manuel noted, despite a historical emphasis on the events in England, that the ideas of resistance to technological displacement of labor were not limited to Nottinghamshire or even to England, arguing that the movement spread to France. There, a number of philosophers had already been questioning the exuberance over and social acceptance of the spread of mechanization, lamenting its dire consequences for the working classes. According to Sale (2006, p. 71):

> Great forces were at work creating this transformation: powerful manufacturing and financial interests; aristocratic landowners and speculators; government stalwarts both political and bureaucratic; it is hardly any wonder that the men who were whirled and whipped around at the bottom of this maelstrom chose to resist. Resisting a maelstrom, especially one that represents the future, may be futile. But resist it they did.

History does not specifically identify the real person behind the character Ned Ludd. He is variously described as a captain (or some other authority figure) who came to notice when he destroyed a weaving-frame (one of the earliest of the mechanizations in the Industrial Revolution) after being abused by his employer. Some accounts even refer to Ludd as a king of some sort, though these accounts do not explain how Ludd was supposed to be employed in a menial job if he was of noble origin. Jones (2006) suggested that the title may have derived from deliberately provocative (and openly seditious) signatures used on letters written by the Luddites to industrialists and authorities of the time. According to Simms (1978, p. 169):

> The historical basis for a captain, lieutenant, or king Ludd are, of course, nonexistent. The stories of an imbecile, child, or enraged cropper of a generation previous

to the rebellion who became notorious for his machine breaking can also be discounted as a wishful euphemism; even the OED remarks that this type of explanation "lacks confirmation." Etymologies hint at some probable alternative derivations, but most lack persuasiveness in terms of the popular acceptance and use of the Ludd myth.

Apart from being absent from the actual protests and riots, the Ned Ludd character (whether fictional or real) also perhaps pre dated the era of these activities by some forty years or so. Navickas (2005, p. 281) placed the protest movement in greater historical context by pointing out that they took place not just during the Industrial Revolution but also at a time of economic hardships, writing:

> Its participants were often workers who felt that innovating manufacturers were threatening their livelihoods by introducing into their factories cropping or shearing frames or powerlooms during the period of economic distress of 1811-13. On the other hand, it has been recognized that the situation encompassed a much wider scope of action and participation. Methods of protest included food riots and threatening letters to magistrates and manufacturers.

Doutwaithe (1999) has argued that the Luddite movement, despite its radical and subversive approach was in fact correct in its interpretation of the impact of technological transformation. Prior analyses of the Information Age have also noted the relevance of earlier concerns about technology and social change to the modern social transformations associated with new media technologies. Ling (2009, p. 2) for example, asserted:

> When thinking about the founding of sociology, a theme that ran through the work of for example, Weber, Durkheim, Tonnies, Simmel, Marx, Compt and the others, is the impact of industrialization on the social fabric. These scholars, each in their own way, dealt with this central issue. These early social scientists were confronted with the reformulation of major social institutions. If we think of a simple list of major institutions such as the family, the church, the city, education and working life, the industrial revolution (both the transition to steam and later, the transition to electrical production) witnessed dramatic changes in these institutions.

He went on to argue that the modern discussions of technology must necessarily grapple with the same issues and even more profound changes in society including deleterious ones.

The modern neo-Luddite movement (discussed at some length in Jones' (2006) *Against technology: from the Luddites to Neo-Luddism*) is one site for the evolution of such discourse. The label includes those persons with simple reservations about technological dependence, philosophers and scientists with moral and social concerns. However, as Jones (2006) was careful to note, the

list of those identifying with the historical (or romanticized) Luddites also includes extremists who seek to counter the overwhelming assumptions of technological necessity with violence including the "Unabomber" Ted Kaczynski and the eco-terrorists known as the Earth Liberation Foundation (ELF). Thus it becomes necessary to establish, without equivocation, the caveat that neo-Luddite ideas, like any other philosophy, can be used for productive analysis as well as for destructive dogma and actions.

While many analyses have looked at the social implications of modern Information Age technologies, some scholars remind us that this is a problematic area of analysis since the technologies themselves can often be both the source of the change and the source of the problems. Sholle (2002), for example, argued that a continuing techno-centric view of these problems privileges the role of technology as not only the cause but also the inevitable solution to society's ills. In this view, the very social construction of technology allows for these instruments of social change to be viewed as benign and culturally neutral—dependent completely on the use-choices made by users rather than bringing their own biases to the social mix. Such a view of technology fails to question the need for technological solutions, assuming instead that technological approaches are automatically capable of solving all problems—even those that may be created by technology.

Technology, however, is not value neutral and can be heavily loaded in terms of the social and cultural values it embodies—a perspective that was evident in the philosophy of the original Luddites. According to Sale (2006, p. 69) the Luddites were "one of the first to recognize that technologies are not neutral, but value-laden, and that society must have a say in the values desired in technology." The focus on information in modern technological efforts, for example, is at once symptom and cause of a cycle of innovation that favors the social value that is increasingly placed on information. The cultural value of technologies and (increasingly) information technologies are also a matter of some concern to scholars and policy analysts. This is not a completely new concern since the cultural biases of technology transfer have, for some time, been major issues—particularly for the emerging economies of developing nations in an area of analysis sometimes called technology transfer. This particular area of study has looked at the processes involved in the adoption of technologies from developed nations by developing nations. Hill, Loch, Straub and El-Sheshai (1998), in their study of cultural values in technology transfer from developed nations to Arab countries, asserted, for example, that the technologies themselves were laden with the values of the source countries and tended to impart those values to the target nations through the transfer process. There are numerous dimensions to this cultural load, from the modes

of use to the application of the technologies, to the dependence created through the need for service, support and parts from the source nations. As information technologies come to dominate the global economy, nations on the receiving end of technology transfer may well be concerned about the social and cultural implications of these technologies. Sarukkai (2008, p. 37) made the explicit connection between the cultural content of technology and the tropes of colonialism, writing of "the creation of an image of technology, exhibited most prominently in the colonial discourse as an 'objective' parameter to compare different cultures," adding (p. 37):

> Such comparison was useful in the project of colonization and even today is paramount to the creation of hierarchies of societies based on technological development. Thus, developed countries are those which are far more advanced technologically in comparison to lesser developed countries. For technology to function in this role, it has to be culture-neutral. For, it is by being outside the ambit of the influence of culture that it can be used to compare and rank different cultures. This kind of "objectivization" of technology has played an important role in making technology seemingly neutral to culture.

Brown (2008, p. 175) supported this notion that technological determinism of knowledge and power tend to sustain the politics of exploitation and domination, writing that "the conception of knowledge as power also leads to ignorance," demonstrated, for example, by "the conceit that we of the industrialized West have a true understanding of the world," which in turn leads to "the view that our ways of knowing and doing are superior to those of 'backward' traditional people." Among the costs of this kind of ignorance, suggested Brown, is the loss of lifestyles and philosophies that may well be superior to our own, particularly in terms of their respect for and ability to coexist with the natural world.

THE (DIS)CONNECTED

Even if we concede that the world at large is faced with growing volumes of (and traffic in) information with seemingly greater and greater emphasis being placed on the information components of economic and social activity, the notion of an Information Age depends on who and where you are. William Wresch (1996) developed this argument in his book *Disconnected: Haves and Have-nots in the Information Age*. Citing groups such as the so-called "Bushmen" of Namibia, Wresch argued that not all groups in the global society experience greater information volume or traffic.

In fact, Wresch demonstrated that several groups are increasingly marginalized by being excluded from interlinking with the global information technol-

ogies. He argued (1996, p. 12) that: "the disconnected will fare far worse than their predecessors in previous revolutions. The gap between the rich and the poor, the knowing and the ignorant, will be larger, the room along the margins far smaller." Aguolu (1997, p. 25) echoed similar fears, suggesting:

> The developing countries may remain... for a long time, excluded from the global information village because of their state of underdevelopment and lack of basic technological infrastructures which the modern paraphernalia of information hardware and software needs to function. For these countries, the "Information Age" may continue to be a mirage unless they are able to break the vicious circle of underdevelopment, obtain access to the world's store of knowledge available in various media, and use the knowledge to effect speedy development.

A series of U.S. government reports in the late 1990s and early 2000 addressed gaps in access to information technologies (which were collectively referred to as the Digital Divide) that were perceived to be barriers to the inclusion of Americans in the digital Information Age. As the reports progressed it became evident that those gaps were closing over time in the United States with diverse forms of access becoming available (including access at schools and libraries) as well as with the rollout of broadband technologies including DSL and Cable Modems (Mohammed, 2007). However, where the access and use gaps have been closing in the U.S. among various socioeconomic groups, concerns about an international Digital Divide persist.

In both the domestic and international manifestations of the Digital Divide, the main issue is one of access—with the implicit assumption that access to the technologies associated with the Information Age would automatically lead to engagement with the technologies, and that engagement would be typical of the established uses of those technologies. However, the mere availability of technologies does not mean that they will be used or that they will be used in a manner consistent with the Information Age paradigm. Castells (2000) warned that the very concept of something called an Information Society in any global sense is flawed because different countries have taken different approaches to information technologies and because tremendous social differences persist with relation to their impacts. He argued (Castells, 2000, p. 20) that "while capitalism's restructuring and the diffusion of informationalism were inseparable processes on a global scale, societies did actually react differently to such processes, according to the specificity of their history, culture, and institutions."

Lukasiewicz (1994) further warned that many developing countries have been apt to adopt technologies more for their trappings and the appearance of Westernization rather than their appropriateness to their local contexts:

Such symbols of western affluence as airports and airlines, office towers, large scale industrial complexes, sophisticated weapons and telecommunications are popular with Third World countries but may only marginally influence their industrialization and economic development. Over-impressed with technical possibilities, Third World governments excelled in extravagant, excessive, or inappropriate applications of technology, or deployment of technologies which their societies are not ready for or capable of adopting.

Despite the possibility of some snobbery in the assessement above, and the use of loaded terms such as "Third World," the point is still a valid one with reference to Information Age technologies and their acquisition. Developing nations are faced with an overwhelming current of thought that suggests exclusion from these technologies will mean continued poverty and further underdevelopment. For example, Gutterman, Rahman, Supelano, Thies & Yang (2009) suggested that efforts to adopt the technologies of the Information Age can enable positive and sustainable development. They cite among these, Brazil's efforts to distribute computers in public schools and train teachers in information technology, Bangladesh's community-based ICT facilities called "Gonokendros," Malaysia's Smart School project and even Rwanda's "e-education" initiative.

On the other hand, many developing nations are unable to shoulder the financial burden of implementing the technologies including vast capital outlays for the supporting infrastructure (that could often be spent on more urgent needs such as food and healthcare) and the sometimes tenuous social relevance of the technologies to their societies as presently structured. Pillsbury & Mayer (2005) suggested that despite the many advantages of new media technologies (even at the level of using e-mail instead of international telephone calls) international donors have balked at the idea of funding new media in countries where basic needs for food and water have not been met or where the requisite support elements such as electric power are not present. Yet, the need to be connected to the international new media systems continues to be perceived as important in these societies. Pillsbury & Mayer (2005, p. 363) quoted an African NGO leader as saying "If you are not connected, you do not exist."

PHILOSOPHY OF THE INFORMATION AGE

The emergence of Information Age discourse as a primary focus of both academic analysis and social reality demands the development of philosophical approaches. These must be broad enough to span the various dimensions of a phenomenon both global and personal. Floridi (2009, p. 154) argued for a philosophy of information that includes both "the critical investigation of the

conceptual nature and basic principles of information, including its dynamics, utilization, and sciences" as well as "the elaboration and application of information-theoretic and computational methodologies to philosophical problems." Not the least of reasons for such a philosophy is what Floridi (2009, p. 157) perceived as an identity crisis of sorts resulting from the evolution of the Information Age and its practices:

> The problem caused by the dephysicalization and typification of individuals as unique and irreplaceable entities starts eroding our sense of personal identity as well. We become mass–produced, anonymous entities among other anonymous entities, exposed to billions of other similar inforgs online. So we self-brand and re-appropriate ourselves in cyberspace by blogs and Facebook entries, home pages, YouTube videos, and Flickr albums. We use and expose information about ourselves to become less informationally indiscernible.

Others have placed greater emphasis on the need for Information Age philosophies to address broad transformations of entire societies and cultures. Castells (2000), for example, is among those who have associated the globalization of information technologies and networks with processes of cultural erosion and abrasion. Briggle and Mitcham (2009, p. 171) linked this concern over culture directly to the issue of philosophizing information, arguing:

> It is widely maintained that the contemporary world is experiencing an ongoing cultural change, made both distinctive and far-reaching by the centrality of information and information technologies. We suggest that this raises two issues. One concerns whether it is possible to speak of "information culture" as a distinctive kind of culture. This notion of "information as culture" raises another issue concerning "culture as information"—that is, whether culture itself constitutes a special kind of information.

Canadian scholar and once-popular media guru Marshall McLuhan earlier saw fundamental cultural change on a global scale as a potential result of emerging media technologies. The extent of McLuhan's continuing influence beyond his time and into more modern phases of the Information Age may be seen in *Wired* magazine's use of the following quote in their first issue in 1993:

> The medium, or process, of our time—electric technology—is reshaping and restructuring patterns of social interdependence and every aspect of our personal life. It is forcing us to reconsider and re-evaluate practically every thought, every action, and every institution formerly taken for granted. Everything is changing—you, your family, your neighborhood, your education, your job, your government, your relation to "the others." And they're changing dramatically (McLuhan & Fiore, 1967, pp. 6-10).

Working in the pre-Internet but post-satellite era, McLuhan focused on the electronic nature of emerging communication forms and their global scope. Much of McLuhan's work inquired into the nature of mass media forms and their relationships with the messages that they transmitted. However, beyond the specific issues of media and messages, McLuhan's greater contribution may have come in his interrogation of the social impacts of technological developments. While not explicitly attempting to build a theory of the Information Age, McLuhan was one of the few thinkers who analyzed the social context of media while also moving beyond the specific context of each media form. His views of media as extensions of the human faculties (McLuhan, 1964) and his broader view of media to include a wide variety of forms (clothes, clocks, speech, writing, the electric light) paved the way for broader conceptualizations of the social roles of information.

Yet, for all the celebration of McLuhan's "prophetic" pronouncements and his laying the groundwork for analysis of a digital age which would not exist for the public until many years hence, the guru who launched "probes" rather than publishing theories was not without his detractors in his day and even today. Condemned in his own time for his anti-intellectual stance and his lack of rigor, McLuhan still draws criticisms such as Tomaselli and Shepperson's (2010, p. 52) assertion that: "McLuhan's 'probes' permit the making of large truth claims without substantiation."

More critical perspectives on Information Age philosophies have also emerged, particularly within the broad context of Marxist conceptions of class and power relations. Concerns over the practices of surveillance that are typical of the pervasive and networked information technologies in the Information Age have brought the work of Michel Foucault into particularly sharp focus. Foucault saw power as exercised in part through surveillance and conditioning. His most famous analogy in this regard is that of the prison structure known as the Panopticon—a structure that allows to prison authorities exercise power through the habituation of constant surveillance, which leads to self-conditioned repression among the prisoners. For several authors in the 1990s, the networked Information Age technologies threatened to amplify Foucault's Panopticon into an even more powerful tool of surveillance and dominance, spreading power not only over the visual spectrum but also through digital data (De Landa, 1991; Poster, 1990).

Specifically analyzing Foucault's relevance to the information society, Willcocks (2006, p. 277) has suggested that society has been moving from disciplinary societies to what Deleuze (1995) has termed "control societies" noting:

These no longer operate by, for example, physically confining people but through continuous control and instant communication enabled by developments in material technology. In this rendering, what has been called information society can also be read as control society. If this is correct, then Foucault's power/knowledge, discourse, biopower, and governmentality remain as thoroughly applicable concepts, as Foucault intended them.

Thus, for adherents, the broader questions of information and power which pervade Information Age discourse may find perspectives within Foucaultian analysis despite a lack of specific reference to information and communication technologies. The same may, of course, be said of Marxist analysis which can only be something of a tradition brought to the wider social and political contexts of modern information systems rather than a precise analytical tool for understanding either information technologies or their effects.

4

Information Age Paradoxes

The modern Information Age, even if taken at face value, provides examples of several self-contradictions. It is an age where information is at once freely available and completely inaccessible (as noted above in examples of the Digital Divide). It is an age of science and reason in which unreason and superstition are spread by the very same information technologies that define it as scientific, an age of increasing information accompanied by increasing ignorance, and one in which several paradoxes have emerged to challenge traditional and accepted concepts about the social roles of information, knowledge and ignorance.

INFORMATION (OVER)LOAD AND THE INFORMATION IMPACT PARADOX

The ability to process information is as important as how much information one is exposed to. In the modern globalized media environment, people linked to the networks of communication are bombarded with information. The fundamental question remains whether this increased flow of information necessarily results in a more informed populace. Despite the widespread assumption that it does, scholars have made several arguments that associate increased information with reduced knowledge. These arguments are often predicated on various notions of what is widely termed "information overload."

Although the term "information overload" denotes one of the most commonly perceived Information Age paradoxes, Bawden and Robinson (2009, pp. 182–183) noted that "there is no single generally accepted definition of information overload" but that it is "usually taken to represent a state of affairs where an individual's efficiency in using information in their work is hampered by the amount of relevant, and potentially useful, information available to them." They called the information overload concept perhaps the most familiar of the "information pathologies" typical of the modern age, and further noted (2009, p. 183):

The feeling of overload is usually associated with a loss of control over the situation, and sometimes with feelings of being overwhelmed. In the extreme, it can lead to damage to health. Various psychological conditions have been described associated with this, such as continuous partial attention, a focus on being "in touch" and "connected" which results in stress, and attention deficit trait, a distractability and impatience due to too much mental stimulus.

Though a seemingly simple idea, the information overload concept has evolved over several decades with influences from several areas including management, policy studies and consumer research (Malhotra, 1982) among others and has taken on several dimensions in recent decades. More than just a description of information volumes, the notion of information overload (or what Malhotra, Jain and Lagakos [2009, p. 27] termed "the information load paradigm") involves ideas about the debilitating effects of information. At some points in its history, information overload has been associated with ideas about the numbing physiological and psychological effects of sensory overload. The emerging body of information overload literature similarly suggests that too much information can negatively affect information processing, decision making, and everyday life. The most common conceptualizations of information overload relate to ideas popularized by Alvin Toffler (1970) but many of the key ideas in this area originated somewhat earlier, in studies often predating the Information Age. Malhotra, Jain and Lagakos (1982), for example, traced ideas about information overload to work on statistical theory in the 1930s (Wherry, 1931) and 1940s (Wherry, 1940) as well as investigations into the human capacity for information processing and clinical psychology in the 1950s and 1960s (Bartlett & Green, 1966; Kelly & Fiske, 1951; Miller G. A., 1956; Quastler, 1956).

Bawden and Robinson (2009) traced the idea even further back to the work of Georg Simmel at the turn of the twentieth century and even as far back as the Biblical book of Ecclesiates 12:6 which states "of making many books there is no end; and much study is a weariness of the flesh." They noted that the Royal Society's influential Scientific Information Conference of 1948 was already explicitly expressing concern over the difficulties of dealing with the proliferation of information. They placed the mechanization and computerization of information in the 1950s and 1960s as central to the recognition of information overload as a problem and noted (2009, p. 183) that "by the 1990s, information overload began to be referred to as a major problem, in the business world as much as in academia and the professions, and even more so with the influence of new technologies..."

Studies such as Klapp's Essays on the Quality of Life in the Information Age (1986) have provided some empirical evidence for the existence of information

load. There is, as well, a wide popular acceptance of the notion of information overload and the almost commonsense notion that most everyday users of information in modern industrialized societies suffer from its various manifestations. Despite this broad acceptance, some have questioned the validity of the information load and information overload concepts—particularly as articulated in the popular imagination. Tidline (1999, p. 486), for example, has argued that "popular and scholarly attention confirms information overload as a recognized and resonant cultural concept that persists even without solid corroboration," suggesting that "information overload can be viewed as a myth of modern culture."

Wurman, Leifer, Sume and Whitehouse (2001, p. 1) noted that "We still use centuries-old languages to communicate, and we do not speak in the zeroes and ones of binary language." While somewhat overstated, their argument is that widespread literacy, media choices, and audience discrimination all mean that the modern consumer of information is not necessarily inconvenienced by the unprecedented volumes of information since "accompanying the explosion of information has come an explosion of means to handle the increased information" (Wurman, Leifer, Sume, & Whitehouse, 2001, p. 2). Bauer (1996) took a somewhat different approach, suggesting that the increasing specialization of knowledge combined with the increased volume of information means that knowledge in some areas precipitates ignorance in others, leading to what he termed a "knowledge-ignorance paradox" (p. 39).

Comparatively speaking, the cultural impact of our vast information flows may actually be relatively small compared to information flows in the earliest days of the information revolution. The German villager in the 1450s who encountered a mass-printed Gutenberg page was probably more influenced by its message than users today might be by the multiple messages they receive. Drucker (1999, p. 50) argued that "like the Industrial Revolution two centuries ago, the Information Revolution so far... has only transformed processes that were here all along" and goes on to argue that "the real impact of the Information Revolution has not been in the form of 'information' at all" but rather in the "routinization" of traditional processes. To illustrate his argument, he cited a lack of change in the way that major decisions in business and government are made.

The concept of increased information load leading to decreased comprehension is well-known in communications literature (Carver, 1973; King & Behnke, 1989; King & Behnke, 2000). Load involves not only the volume of information available but the consistency of information and valence toward that information (how much information on an event that an individual exposes himself/herself to). Lukasiewicz (1994, p. 121) has examined similar

ideas with reference to the spread and processing of scientific knowledge and suggested what he has called the "degree of grasp" as the ratio of what we are capable of understanding (a fixed amount) over the exponentially expanding quota of information available for processing. The rapidly expanding denominator in this measure suggests an equally rapid erosion of the degree of grasp. Thus as load increases, in any of its dimensions, our relative level of ignorance also increases. Though, in practical terms, we are only really inconvenienced if the precluded information would have been potentially useful to us.

Whether it is the routinization of traditional tasks, the persistence of traditional patterns of language, or the creation of a crisis of meaning, there exist bases upon which the assumption of information impact may be questioned. This is not to deny that greatly increased information flows and access may provide tremendous benefits, but to question the prevailing assumption that they necessarily do so. As Wilson (1995) suggested, the vast flows of messages that reach us each day may contain little by way of useful information and may actually leave us more confused than informed. Thus the information impact paradox may reflect not only the lack of impact of increased information flows but also their negative impact.

THE INSULARITY PARADOX

McLuhan's (1964) Global Village concept was an important precursor to the later development of widely accessible global media. McLuhan foreshadowed many concepts that are now quite familiar to modern industrialized (and some would say informationized) society. Among these was the notion of what he characterized as automated information retrieval in which queries from anyone would be submitted and processed through major libraries of information to yield custom reports. Pronounced during the 1960s, a time when the notion of global media involved the ability to view satellite-relayed broadcasts and make (expensive) long-distance phone calls, the idea of the Global Village was at once fanciful and intriguing. It would continue to be echoed for decades, and then, with the arrival and widespread diffusion of truly global communications media, the village became something of a reality. Morrow (1989, p. 41), for example, wrote that "the village has indeed become global—Marshall McLuhan was right." Yet, there was not an extensive McLuhanesque detribalization or re-tribalization as some might have expected. The evidence pointed to a global village that, though connected, remained fragmented. What was more, the globally connected villagers began to reassert the same old parochial and tribal tendencies to which humankind had become comfortably accustomed.

Alexander Halavais (2000) pointed out that pages on the World Wide Web were more likely to link to other sites in their own countries than to other countries (except for the United States which dominates content on the Web). Following a survey of 4,000 websites, Halavais argued (2000, p. 7) that "although geographic borders may be removed from cyberspace, the social structures found in the "real" world are inscribed in online networks." This continuation of local linkages challenged the assumption that the global technologies of the Information Age necessarily resulted in a global scope of reference, providing evidence, instead for highly local networks on the global platform (Davies & Crabtree, 2004). Androutsopoulos (2006, p. 526), for example, found that even diasporic websites were "decidedly local" in character with "transnational diaspora" appearing "unimportant in user discussions." These local networks on the global network are often virtual communities that emanate from traditional physical communities. Anyefru (2008), for example, illustrated the development of the Anglophone Cameroon identity on the Internet that embraces views and expressions that are suppressed within physical Cameroon. Tynes (2007) similarly described the Internet success of the Sierra Leone diaspora in the form of the "Leonenet" despite the strife in Sierra Leone itself. The paradox, then, is one of a global medium being effectively related to local spaces (even by those who are themselves removed from those spaces).

Insularity and the Other

The mass media of the modern age has made communications among different groups and nations much easier than in previous generations. Questions remain about whether this increased ability to communicate has been accompanied by commensurate developments in willingness to communicate and attitudes about the now ever-present other. Shenk (1997, p. 125) suggested that new media technologies encourage "a cultural splintering that can render physical communities much less relevant and free people from having to climb outside their won biases, assumptions, inherited ways of thought." Aiding this paradoxical process of Information Age insularity is traditional media's ever-closing scope of reference. Claude Moisy (1997, pp. 78-79) former Chairman and General Manager of the Agence France-Presse wrote in 1997:

> For decades now, hazy-eyed apostles of the communications revolution have prophesied about the coming of a world without boundaries where everybody will know everything about everybody else. Since knowing is understanding, we were all going to share our worries and unite in alleviating them... So much for the dream. A careful analysis of the current exchange of foreign news around the world reveals an inescapable paradox. The amazing increase in the capacity to produce and distribute news

from distant lands has been met by an obvious decrease in its consumption. This is certainly true for the United States, but it appears that the same phenomenon exists, to some degree, in most developed societies."

What Moisy was pointing to was precisely the paradox of decreasing information about "the other" in the face of both the abundance of such information and ease of access to it. Despite some rebounding of international coverage after September 11, 2001, and during the initial stages of military action in Iraq and Afghanistan, U.S. media coverage of international affairs continues its steady decline. Remarkable events such as the uprisings in Tunisia and Egypt and the Japanese Tsunami of 2011 may cause occasional spikes in international news, but there is little by way of serious coverage, particularly of non-disaster international issues. Outside of traditional mass media, Shapiro (1999, p. 25) noted that the Internet simultaneously provides the user with the means to access and learn about the other, and the ability to isolate oneself from external ideas and people:

> The ability... to endlessly filter and personalize information means that, more than ever before, we can also build virtual gated communities where we never have to interact with people who are different from ourselves.

Castells (2000, p. 3) argued that the Information Age is characterized in part by its focus on identity as an early and pre-eminent organizational principle suggesting that "in a world of global flows of wealth, power, and images, the search for identity, collective or individual, ascribed or constructed, becomes the fundamental source of social meaning." He defined identity as "the process by which a social actor recognizes itself and construes meaning primarily on the basis of a given cultural attribute or set of attributes, to the exclusion of a broader reference to other social structures" (Castells, 2000, p. 22).

Despite the global reach of the Information Age technologies, or perhaps because of it, Castells suggested that identity clashes rather than conciliations abound in a context of fading social institutions and even declining importance of the traditional nation-state. Castells (2000, pp. 3–4) went further than Moisy and others who simply suggest that the globalized Information Age isolates—he implicated the nature and processes of the Information Age (with its emphasis on identity) in not just isolationism but also in the alienation of the "other" and in creation of fear and suspicion, writing:

> People increasingly organize their meaning not around what they do but on the basis of what they are, or believe they are... Our societies are increasingly structured around a bipolar opposition between the Net and the self... In this condition of structural

> schizophrenia between function and meaning, patterns of social communication become increasingly under stress. And when communication breaks down... social groups and individuals become alienated from each other, and see the other as a stranger, eventually as a threat...

He further suggested that notions of a global information society are thus intrinsically bound up with violent identity clashes including the rise of American militia, the perceived and real global Islamic/Christian contentions and even the Hutu/Tutsi genocide.

Notions of "the other" have also been bound up in the coverage of international affairs by the American media, which has frequently resorted to the lens of Huntington's (1996) Clash of Civilizations in reporting about news from the Middle East. Seib (2005, p. 76) has argued, however, that with overall decreases in international coverage in U.S. media (half to a quarter of the levels seen as recently as the 1980s),

> it is difficult for Americans to make knowledgeable judgments about the existence of civilization-related clashes if the public knows little about the civilizations in question... News coverage is a significant element in shaping the public's understanding of international events and issues. Aside from their occasional spurts of solid performance, American news organizations do a lousy job of breaking down the public's intellectual isolation.

The additional dimension of globally connected informal and social media in the modern information landscape makes it possible (in theory—at least) for more people to access information about events in other nations than would have been possible in the pre-Internet era. Here the question is one of agenda setting and the framing of news. Given the possibility of accessing news from all over the world—and allowing for the selection biases created by language barriers, users will gravitate to the stories or issues that are placed on the agenda either by traditional mass media or by prominence on social media (often resulting from initial media coverage). Meraz (2009) found evidence for continuing (though diminishing) influence of traditional media sources on the focus of some blogs, for example—with the caveat that the traditional media now constitute one of several influences on the informal and social media forms. Still, many stories that are underreported by mass media remain in relative obscurity such as various humanitarian crises in Chechnya and Darfur as well as political crises in Tibet and Nepal. Seib (2005, p. 78) concluded that "in this age of globalization, when the news media's view of the world could and should become ever broader, intellectual isolationism has taken hold, at least in journalism and presumably in other fields as well." During the Spring of 2011 political uprisings in Egypt and other countries in North Africa and

the Middle East did percolate through social media, but generally to small groups of academic elites and diaspora members until the situation turned visually appealing and dramatic enough for the traditional mass media to dispatch crews.

Scholarly and popular debate about the level of cultural exchange in the Information Age also focuses on issues such as global dominance of Western developed nations and the presumed cultural erosion of less powerful nations. However, some perspectives within this debate also suggest that audiences worldwide are active participants in both consuming information from other cultures (including but not restricted to developed Western nations) and in adopting influences from "the other." Among these active participant perspectives may be found the work of Kraidy (2005), who has argued that audiences develop hybrid identities based on the dynamic relationship between their own cultures and the influences from outside that are readily accessible via modern media.

THE DEMOCRATIZATION PARADOX

Albert Einstein commented in 1949:

> Under present conditions private capitalists inevitably control, directly or indirectly the main sources of information (press, radio, education). It is thus extremely difficult, and indeed in most cases quite impossible, for the individual citizen to come to objective conclusions and to make intelligent use of his political rights. (1949, p. 13)

The later advent of masses of information and ready access to participatory media seemed, therefore, to be custom made for the promotion of democracy, so often predicated on the existence of an informed electorate. Wilson and Peterson (2002, p. 450) recounted:

> Through most of the 1980s and 1990s, the conviction was widespread that the growing and evolving communications medium comprising inter-networked computers would enable the rapid and fundamental transformation of social and political orders. Much of the early literature surrounding the Internet regarded the new technology as revolutionary...

In one of the foundational works on virtual communities in the Information Age, Howard Rheingold (1993) was among those voices touting the democratizing potential of the Internet and its potential to revamp political participation. This seemed a natural extension of the ability of the new media technologies to bring people and groups together while subverting political restrictions of the real world. Bryan, Tsagarousianou, & Tambini (1998, p. 5) wrote:

New media, and particularly computer-mediated communication, it is hoped, will undo the damage done to politics by the old media... New media technology hails a rebirth of democratic life... new public spheres will open up... technologies will permit social actors to find or forge common political interests.

Such a view also belied some exuberance surrounding the technologies in their infancy as well as a networked ethic among the early enthusiasts. The Internet had, after all, emerged from an elaborate network—not just of computers—but also of people from different interest groups who collaborated in a spirit of openness to develop its technologies. Even early offshoot user groups such as those on the Usenet were also part of organized, relatively well-enlightened and collective-minded user communities who perhaps experienced more democratic participation in their online worlds than in their real ones. For these reasons, others such as Keohane and Nye (1998, p. 82) suggest that those making predictions about the inherent democratic potential of the Internet "moved too directly from technology to political consequences without sufficiently considering the continuity of beliefs, the persistence of institutions, or the strategic options available to statesmen." Wilson and Peterson (2002, p. 462) similarly concluded:

The revolutionary claims made for the Internet and the communications media it supports have faded in recent years. The realization has grown that though online communication may happen faster, over larger distances, and may bring about the reformulation of some existing power relationships, the rapid and fundamental transformations of society that some foresaw have not come to pass.

Andrew L. Shapiro (1999, pp. 14-15) called the claim that the Internet is inherently democratizing "wrong," classifying it as a dangerous and empty truism, suggesting that while "the Internet does have strong democratic proclivities" it may "suppress as well as promote democracy." Shapiro's observation of the Internet's propensity to suppress democracy, hints at perhaps the great paradox of Information Age democratization—the emergence and persistence of global information monopolies.

Global Information Monopolies

Much scholarly and popular debate focuses on the emergence of vast multinational information corporations and their purported negative effects on everything from traditional cultures to the development of national media industries. Whether or not all of the perceived negative effects of globalized corporate media corporations are likely (or even probable), the scope and power of commercial and monopolistic interests are thought to militate

against the democratizing potential of new media (Leaning, 2009; Bagdikian, 2004).

Cleveland (1985, p. 188) contended that "Once information [could] be spread fast and wide—rapidly collected and analyzed, instantly communicated, readily understood by millions—the power monopolies that closely-held knowledge used to make possible were subject to accelerating erosion." However, instead of a broad diffusion of information power, the Information Age has seen a reconsolidation of power. The powerful corporate interests who already control traditional media sources such as television and film have consistently invaded and come to dominate virtual spaces once these develop to the point of popularity. The commercialization of the World Wide Web was accompanied by the increasing dominance of corporate content not just from media corporations but also from traditional retailers and other advertisers. Facebook and Twitter are becoming similarly colonized with corporate voices increasingly controlling the virtual spaces with content and advertising. Even without making a value judgment on this phenomenon (i.e., allowing that corporate content is not necessarily a bad thing), the potential for individual expression to the mass that would be necessary for democratic potential to be realized is seriously compromised.

As noted in an earlier section, neither the advent of the home video camera nor the diffusion of the World Wide Web ultimately resulted in the assumed democratization of media production. However, the possibility of democratized, user-based media content has once again been raised with the popularization of social media and the increasing use of user-generated content such as videos on YouTube or what is now being termed "prosumption" after Tofler's (1980) earlier coinage. Manovich (2009, p. 321), however, warned of critical blindness to the continuing presence of corporate forces at play even where production seems to be in the hands of the users:

> In celebrating user-generated content and implicitly equating user generated with alternative and progressive, academic discussions often stay away from asking certain basic critical questions. For instance, to what extent is the phenomenon of user-generated content driven by the consumer electronics industry—the producers of digital cameras, video cameras, music players, laptops, and so on?

Moreover, he also implicated the corporate forces embodied in the social media networks themselves, asking: "to what extent is the phenomenon of user generated content also driven by social media companies themselves, who after all are in the business of getting as much traffic to their sites as possible so they can make money by selling advertising and their usage data?" (Manovich, 2009, p. 321).

Outside of social media, some still see globalized corporate media influences as intrusive and disruptive forces on domestic media production as well as on local cultures (Croteau & Hoynes, 2003). Cultural conservatives in many countries do not cherish The Information Age, seeing it as symbolic of invading foreign culture. This (somewhat flawed) view also suggests that the modern globalized mass media tend to further marginalize traditional cultures, languages and native groups associated with them. In this way, these forces of the Information Age are seen as inherently undemocratic in denying the voices of such groups. According to this view, the steamroller effect of the global multinational information giants not only denies the voices of local cultures but it also effectively suppresses their expression to the global audience, leaving the global audience perpetually ignorant of anything other than the culture and ideas deemed most commercially viable by the information corporations.

The contention that the information technologies are a potentially democratizing force in the Information Age is often still touted with reference to extreme and repressive regimes that are threatened by the pervasive power of the Internet and other new media technologies. The idea here is that despots can be overthrown by the collaborative force of people connected by the new technologies. There are some heartening instances that keep this idea alive, though Wilson and Peterson (2002, pp. 451–452) argued that "the optimistic notion that the Internet would inform and empower individuals worldwide, while subverting existing power structures, may underestimate the power of states to control information access"—a concept to which we will return later in the present discussion.

On the (Same Old) Campaign Trail

A kind of democratic use has evolved in the form of political campaigns online. Dalsgaard (2008) pointed out that social networking sites have been used with some success to mobilize supporters and raise funds in recent campaigns. He noted the role of Barack Obama's site my.barackobama.com in the 2008 election cycle. In an analysis of voting patterns, Tolbert and McNeal (2003) found that in the 1996 and 2000 U.S. presidential elections, Americans who had access to the Internet and online election news were significantly more likely to vote than those who did not. While these elements of mobilization and awareness certainly bode well for the notion of Information Age democracy, they have not necessarily signaled any major changes in terms of the prevailing power structures—particularly in the manner that money and influence come to bear on elections in the United States. Also, Morozov (2009) urged caution in overemphasizing the influence of Information Age technologies in Obama's victory, writing that:

Obama's use of new media is bound to be the subject of many articles and books. But to claim the primacy of technology over politics would be to disregard Obama's larger-than-life charisma, the legacy of the stunningly unpopular Bush administration, the ramifications of the global financial crisis, and John McCain's choice of Sarah Palin as a running mate. Despite the campaign's considerable Web savvy, one cannot grant much legitimacy to the argument that it earned Obama his victory.

Democracy to the Oppressed

More importantly, perhaps, the technologies of the Information Age have not led to massive and sweeping changes among the oppressed in despotic and repressive regimes as imagined by techno-determinists. Davis (2009, p. 12), for example, credited Twitter with helping to "foment revolt in Iran" in 2009, a charge that was also echoed by Teheran officialdom. The New York Times Magazine reported that after the August 2009 suppression of protests, Iranian officials had "accused Western governments of using online social networks like Twitter and Facebook to help execute a 'soft coup'" (Shachtman, 2009, p. 62), an accusation with some basis since U.S. interests were involved in enabling access to the social networking technologies for Iranians.

Baumann (2009, p. 1) described the Western fascination with the Iranian protests and what he characterizes as something of a "groupthink" about the events:

> It's the enduring image of the summer in international politics, the mob of Iranian students taking to the streets... The video of a young woman's death, circulated widely on Twitter and YouTube, swept through the Western imagination... Seemingly overnight, the Western media were consumed with talk of a "Twitter Revolution," spreading hope that the Internet (and social networking in particular) would bring democracy to autocratic states the world over.

Despite such widespread attestations to (and presumed agreement on) the power of Facebook, Twitter and blogs and with specific reference to the Iranian protests in 2009, Afshari (2009, p. 854) contended that the role of the technologies was less of a technology-driven revolution and more of an expression of overwhelming social discontent:

> Commentators have often marveled at the activities of Iranian bloggers during and after the June election. It is called a "Twitter Revolution." It was no revolution, however defined. The noticeable "social-networking" was a collection of individuals sharing news, views, and images. They gathered by the thousands mainly through cell phone connections and word of mouth.

Mozorov (2009) also warned that Information Age technology is no different from media of the past in offering both threat and opportunity to repressive regimes, pointing out:

> The Soviets did not ban radio; they jammed certain Western stations, cracked down on dissenting broadcasters at home, and exploited the medium to promote their ideology. The Nazis took a similar approach to cinema, which became a preferred propaganda tool in the Third Reich... Chinese authorities are notorious for creating and operating the so-called Fifty Cent Party, a squad of pro-government online commentators who trawl the Web in search of interesting political discussions and leave anonymous comments on blogs and forums. Similarly, the Russian government often relies on private Internet companies, such as the prominent New Media Stars, which happily advance the government's views online.

Mozorov elsewhere (quoted in Baumann, 2009) noted that Iranians were mostly flocking to the Internet to download pornography, unavailable in that country ruled by hard-line Shia' theocrats.

THE UNSCIENCE PARADOX

An earlier section examined the strategic spread of what I have termed "unscience" in the form of Intelligent Design. The broad diffusion of this and other equally specious ideas via both the traditional mass media and new media technologies gives rise to what might be termed an unscience paradox which eschews scientific knowledge, a foundation of the Information Age, in favor of random, incorrect and often dangerous anti-scientific or pseudo-scientific information. The popularity of un–science is a direct result of the availability and relative ease of access to information that characterizes the Information Age combined with a lack of information gatekeeping to weed out the useless or dangerous material. Many individual information consumers are not equipped to evaluate technical, medical or scientific pronouncements and claims. Given the vastness of our information resources, there is little chance that any individual could be equipped to evaluate all such information. The result is that many information consumers give equal weight to the incorrect and dangerous as to the scientific and sound. Worse, since scientific information is heavily controlled by systems of peer review, ethical and legal restrictions, it may easily lag behind more popular and less stringently controlled information. Add the profit motive to this equation and one ends up with a recipe for sales of everything from Acai Berries and Noni Fruit to Glucosamine and Chondroitin. The paradox is that the Information Age embraces un-science in place of the science that, arguably, made such an age possible.

Science Fact, Science Fiction and Miracles

Feder (1984, p. 526) sounded an early alarm about the spread of pseudoscientific ignorance via modern mass media, writing in 1984:

> A number of television programs regularly present extremely questionable and, at best, unverified claims as fact. Supermarket tabloids announce miraculous cures for cancer, an imminent invasion from outer space, the discovery of living sauropods, and the excavation of flying saucers from beneath Egyptian pyramids. Bookstore stalls are filled with pseudoscientific works that purport to "prove" all sorts of nonsense. Newspapers print regular astrology columns.

In the evolving Information Age, the situation has not improved but rather worsened over the years, and the coming of the Internet has hastened this decline into ignorance. Archaeology.org (Romey, 2003), for example, lists some of the websites spreading pseudoscientific disinformation including sites that attempt to "prove" the "presence of dinosaurs in the Bible..." the idea that ancient Egyptian, Greek, and Mesopotamian religions were "exploded planet cults" and that tale of Sodom and Gomorrah derives from a nuclear attack in 2024 B.C.

The "scientific" community and in particular, elements of the most popular social sciences, have done themselves no favors in recent decades by self-indulgent approaches to communication with the wider public. Information and communication technologies quickly spread the rash of often meaningless and frequently overstated research that characterizes much of social science. Lukasiewicz (1994, p. 26) argued that much of the research in social science is quite pointless, necessarily inaccurate and guilty of inflating its own importance through the use of pompous language:

> With exactness, verifiability, and predictability being largely out of reach of the social sciences, it has been possible to maintain unreasonable or even absurd views with impunity, to supply information that the recipient wants to hear and to seek a scientific aura through verbal innovation which amounts to no more than the deliberate use of an obscure jargon.

Beyond social science, even "hard science" has had troubles that have been multiplied by rapid information sharing and rampant distortion (both deliberate and otherwise) made possible by Information Age media technologies. On December 26, 2002, Brigitte Boisselier, the director of a company named Clonaid called a press conference in Hollywood, Florida, to announce that a small and hitherto relatively unknown group called the International Raëlian Movement (of which Clonaid was a subsidiary) had successfully cloned a human being, whom they had named Baby Eve. Ingram-Waters (2009, p.

295) noted that the scientific community was immediately skeptical of the claims:

> From the beginning of the Raëlians' public claims to clone humans, scientists dismissed the group's efforts as those of "cult scientists" who could not possibly achieve success with the intricate laboratory processes of human cloning. Very few scientists allowed that the Raëlians, or anyone persistent enough with access to some equipment, eggs, and surrogates, might actually achieve human cloning.

What Ingram-Waters' assessment missed is the fact that many of the world's major media forces were either present at the ceremony or carried some kind of coverage of the event. With little evidence to back up these claims and a dodgy background in both science and religion, the Raëlians had managed to spread their disinformation globally just for the asking and were aided and abetted by the mainstream global media. However, she did point out that the group's membership has grown since the publicity.

In this bizarre case, the spectacular nature of the claim along with the public outcry and scientific consensus that was brought to bear on the story helped to put the story into context. Soon, everyone recognized this for the hoax that it was. The issue remains, however, that the Raëlians human cloning story is being replicated every day in our Information Age. Disease cures and therapies ranging from the real and effective to the dodgy and plain false are announced on the World Wide Web as well as on traditional media (where they should really know better).

As early as 2001, the U.S. Federal Trade Commission (FTC) had starting clamping down on companies making fraudulent health claims on the Internet, many promising to cure AIDS and various cancers. The Aaron Company of Palm Bay, Florida, even claimed that its product Colloidal Silver could cure 650 diseases, AIDS and cancer among them (Sullivan, 2001). The American Dietetic Association (ADA) has been among those voicing concerns at the level of misinformation and disinformation regarding health, particularly on the Internet. In a position statement in 2002, the association (Ayoob, Duyff, & Quagliani, 2002, p. 262) noted that the Internet had emerged as "a major source of health and nutrition information" and warned:

> Sites featuring sound science-based content coexist with sites containing questionable, inaccurate or alarming information promoted by individuals and groups espousing unscientific views.

They warned of a "rapid and widespread dissemination of false nutrition and health-related stories via the Internet. Recent examples of these unfounded "urban health myths" are that bananas from Costa Rica carry flesh-

eating bacteria, and that the sweetener aspartame causes numerous ills such as multiple sclerosis and lupus" (Ayoob, Duyff, & Quagliani, 2002, p. 262).

The ADA did not lay the blame for misinformation only with the World Wide Web, suggesting that traditional media were also involved in the business of misinformation:

> Too often the popular media capitalize on preliminary research data in an effort to enhance audience and readership ratings. Promoters quickly turn legitimate research findings into sales pitches, products, and services... In addition, news reports on food and nutrition rarely provide enough context for consumers to interpret the advice given. Frequently absent are details about how much more or less of a food to eat, how often to eat a food and to whom the advice applies. (Ayoob, Duyff, & Quagliani, 2002, p. 263)

The spread of fanciful disinformation in search of profit has not gone away with repeated crackdowns and position statements from established scientific bodies, but rather has repeatedly resurfaced—in more sophisticated form each time. For example, starting around 2008 and continuing for several months, every other pop-up and sidebar advertisement on the Web featured some exhortation to try açai berry products. No doubt many thousands of people already had bottles of these products in their homes when the Federal Trade Commission announced a crackdown on fraudulent claims related to the berry in August 2010. At a press conference on August 16, 2010, the FTC announced action against Internet marketers of açai berry weight-loss pills and "colon cleansers" who promised not only weight loss, but also hinted at curing cancer (Federal Trade Commission [FTC] Office of Public Affairs, 2010).

This particular form of unscientific disinformation extends beyond simple quackery such as the sale of dubious herbal remedies. Since the present Information Age is also marked by a prevalence of religious broadcasters, the issue arises, more generally, of religious disinformation as un-science. This is a difficult concept to tackle since religion in general enjoys some level of societal protection and even official recognition by states and nations. There are however, several cases where (religious persuasion notwithstanding) one can clearly demonstrate that religious broadcasters have used the technologies of the Information Age for un-scientific pursuits. Hughey (1990, p. 36), for example, noted that "televangelists now offer all sorts of religious paraphernalia for their viewers to purchase, including bibles, lapel pins, bookmarks, books, records, audio and video tapes, bumper stickers, pictures, crosses, etc." and that "Oral Roberts once offered viewers the imprint of his healing hand on a piece of cloth." While this may just be innocent marketing, and while these items may offer some psychological comfort to the faithful, there is an aspect of such marketing that is reminiscent of the dodgy cures that have kept

organizations like the ADA and the FTC busy. Consider, for example, the offer of a prayer handkerchief from evangelist Don Stewart via his website (Don Stewart Association, 2010) that reads:

> The Green Prosperity Prayer Handkerchief is a cloth that Don Stewart has personally prayed over, blessed, and anointed. Don believes the prayer cloth is a Touch Point of Hope to help people release their faith because, "all things are possible to him that believeth." (Mark 9:23) Thousands of people around the world who have used the Green Prosperity Prayer Handkerchief have given inspiring testimonies of the miracles of healing, prosperity, and spiritual salvation.

The specific claim of healing is one that bears some examination. Interestingly enough, the testimonies on the site do not specifically refer to medical healing experiences, but they come close, one of them suggesting that the handkerchief was responsible for the writer obtaining a job:

> Your prosperity handkerchief came, and then I was blessed with a job! It was a FINANCIAL MIRACLE!!! The anointing was so strong that God's blessings just began to flow as soon as you mailed it to me.

It is doubtful whether the FTC is likely to clamp down on the televangelists who peddle these physical objects such as blessing oil and prayer handkerchiefs or the perhaps more dangerous products such as healing prayer prophecy and intercession (none of which have been approved for the treatment of any disease by the FDA) yet their promotion represents a clear example of un-science in the Information Age.

In *The Age of American Unreason*, Susan Jacoby (2008, pp. 17-18) was somewhat less charitable concerning the relationship between religious expression and mass media in the Information Age, writing:

> Modern media, with their overt and covert appeal to emotion rather than reason, are ideally suited to assist in the propagation of a form of faith that stands opposed to most of the great rationalist insights that have transformed Western civilization since the beginning of the Enlightenment...

She added that religious fundamentalists "with their black-and-white view of every issue, have made effective use of each new medium of mass communication" and contends:

> From the rantings of Pat Robertson on the 700 Club to Mel Gibson's movie *The Passion of the Christ*, religion comes across most powerfully on video when it is unmodified by secular thought and learning... Gibson's *Passion*, for instance, is rooted in a Roman Catholic brand of fundamentalism, long rejected by the Vatican itself, that takes the Gospel of Matthew literally and blames Jews for the crucifixion of Jesus.

The continuing insistence on privileging unscientific thought in the guise of religion has implications that run deeper than offences to faith and the promotion of social divisions. Ehrlich and Ehrlich (1996, p. 26) argued that such currents of religious thought have militated against public understanding of numerous important biological and health issues, writing:

> The widespread lack of familiarity with evolutionary processes has helped set the stage for a potentially catastrophic public health crisis from a surge of antibiotic-resistant diseases (such as tuberculosis, now becoming a serious problem in much of the world) and emergent viruses (such as AIDS and Ebola)...

THE PERSONALIZATION PARADOX

Information personalization becomes an increasingly attractive prospect with the ever-increasing flood of news and other information becoming available. Information providers from search engines to online newspapers have begun to offer information customization to users. The forms of personalization vary tremendously. In some cases, such as with certain major newspapers, the delivery of customized news is offered as an optional service in which users receive the news that is most likely to interest them based on their prior choices. In other cases, such as with the Netflix movie service, personalization may come in the form of recommendations and ratings based on previous choices and stated preferences from the user. Pariser (2011), however, has argued that more insidious forms of personalization such as web filtering by search engines can actually create a kind of bubble for the user in which they are unwittingly surrounded by more and more of the same kinds of information based on their prior choices. What is worse, suggested Pariser (2011) is that many of the particular filtering choices are based on financial considerations rather than the goal of providing the broadest information to the user.

As Granovetter's (1973) work has suggested, repeated exposure to only familiar ideas and concepts presents fewer learning opportunities for the individual. Information personalization, then, particularly as an involuntary phenomenon, may present the user with information that is consonant with only their set of views or concerns, promoting ignorance by exclusion of other ideas. Though there may be some value in deliberate choices of information discrimination (e.g., the automatic filtering of junk mail, spam and phishing schemes), the deliberate or inadvertent filtering of information in scope and variety suggests an imposed limitation on the universe of both facts and opinions that are available in the Information Age.

5

Media and Ignorance

The very concept of an Information Age has become fashionable among academics, policy makers, business leaders and others. Yet, within this Information Age persist several deeply rooted traditions of ignorance, perpetuating legacies of prejudice, discrimination, suspicion and superstition. In spite of the prevailing assumption that information equals enlightenment, some of the darkest aspects of past ignorance are sustained and even promoted by the media of the Information Age. These media include traditional mass media such as newspapers, radio and television as well as so-called new media including Internet-based communication via the World Wide Web, e-mail and social media. In the Information Age, both the traditional and new media forms make their contribution to misinformation, disinformation and the persistence of ignorance.

CBN, SATELLITES AND IGNORANCE

On the small Caribbean island of Grenada in the early 1990s, before the spread of cable television, the only alternative to government-owned media was an out-of-the-way facility that broadcast religious programming. The program content did not feature any local religious figures. Instead, the broadcasts from that facility comprised live or replayed terrestrial broadcasts derived from satellite feeds of U.S. based international television evangelists. These broadcasts were delivered free of charge to anyone within signal range and were relatively typical of media systems that are still in use to provide religious television programming to viewers around the world today. The Trinity Broadcasting Network (TBN), for example, boasts of its international reach on its website where it claims to be Touching Billions Now (tbn.org).

In many urban cities and small rural outposts, Pat Robinson's Christian Broadcasting Network (CBN) is another major player in this type of religious broadcasting that has exploited the technologies of the Information Age to spread a digital evangelism that reaches literally many millions of people worldwide. This would be meaningful enough if Robertson only used these

technologies to preach Christian religious ideals. However, the content of programming such as CBNs flagship *The 700 Club* presents a much broader focus in which Robertson and his co-hosts opine on matters ranging from religion to geopolitics. Several content analyses of the show (e.g., Abelman & Neuendorf, 1985; Abelman & Pettey, 1988) have demonstrated that less than half of its content can be considered religious, with a majority of material falling into the categories of social and political themes, with a later study (Abelman, 1990) indicating that some 45 percent of the show's content was in fact political rather than religious. The political biases of religious thought are not new. Much of the recent history of humankind reflects the intertwined influences of political power and religion leading to religious wars and conquest in the name of God. In the Information Age combinations of religious and political influences represent a powerful force capable of imparting not just religious guidance, but also powerful disinformation and ignorance to huge audiences.

When a major earthquake hit Haiti on January 12, 2010, Robertson attributed the event not just to divine will, but also to satanic influences, saying on *The 700 Club* (ABC News, 2010) that: "Something happened a long time ago in Haiti. They got together and swore a pact to the devil. They said we will serve you if you'll get us free from the French. True story." He even quoted the devil as saying "Okay, it's a deal" (Parker, 2010, p. A23) and suggested that "ever since, they [Haitians] have been cursed by one thing after the other." A charitable view of such statements may suggest simple ignorance of the sort that does not know about or understand geological phenomena as natural occurrences. Parker (2010, p. A23), however, noted the incongruence between an Information Age existence and the espousal of views like Robertson's in the following terms: "Earthquakes answer to no demon, and the shifting of tectonic plates should be no mystery to 21^{st}-century man."

Should one still choose to excuse Robertson's statements as simple or humble ignorance of geology, there would arise a need to also excuse *The 700 Club*'s host's ignorance of meteorology when he drew connections between abortion and hurricane Katrina in 2005 or his ignorance of geopolitics when he "totally" concurred with the Rev. Jerry Falwell who blamed the terrorist attacks of September 11, 2001, on the American Civil Liberties Union, as well as pagans, "the abortionists, feminists, gays and lesbians, the liberal organization People for the American Way, the entire federal court system and anybody else who has tried to secularize America" (People for the American Way, 2001).

Other evidence, however, suggests something less indicative of humble ignorance and more akin to Smithson's (1989) category of "taboo knowledge"

and "willful suppression of unpleasant knowledge" as well as Tuana's (2006, pp. 3-13) "not knowing because privileged others do not want us to know" and "willful ignorance." Gonzalez (2005) has noted that during the Rwandan Genocide, Robertson appealed to the U.S. public for donations to fly humanitarian supplies into Zaire, ostensibly to save refugees. However, there was more to this operation than Robertson would disclose to his almost 1 million (per day) faithful viewers. According to Gonzalez (2005, p. 22),

> the planes purchased by Operation Blessing did a lot more than ferry relief supplies... An investigation conducted by the Virginia attorney general's office concluded in 1999 that the planes were mostly used to transport mining equipment for a diamond operation run by a for-profit company called African Development Corp... And who do you think was the principal executive and sole shareholder of the mining company? You guessed it, Pat Robertson himself... Investigators concluded that Operation Blessing "willfully induced contributions from the public through the use of misleading statements..."

Robertson, through the magic of Information Age satellite technologies, manipulates his audiences not just through religious fervor but also through discourses that, rather than representing humble ignorance, may reflect the vast potential for misinformation and disinformation in the Information Age.

OTHER VOICES FROM THE HEAVENS

The spread of religious messages via the technologies of the Information Age is no longer the exclusive domain of U.S. or Christian broadcasters. The proliferation of Arab satellite channels since the 1990s has seen the emergence of a wide variety of programming types that have become available to Arab audiences. Among them are various entertainment channels including music-request and game-show programming, news, and religious broadcasts. Either on specialized, dedicated religious channels (numbering around 80 in 2009) or as part of the programming of other channels, satellite television spawned a cadre of religious broadcasters whom some authors have characterized as Arab or Muslim televangelists (Echchaibi, 2008; Hardaker, 2006; Moll, 2010). Some of these broadcasters such as Egypt's Amr Khaled have become quite influential with what some writers have described as innovative approaches to reconciling the demands of modern society and traditional beliefs. Hardaker (2006) described Amr Khaled as "Islam's Billy Graham" and noted:

> Unlike other Middle Eastern preachers, Khaled has had a taste of life on the other side of the religious and cultural divide. Three years ago he was banned from speaking in Egypt because of his popularity. In self-imposed exile, he set up shop in London, where he says he lived "a wonderful life, in freedom."

Other such Arab televangelists, however, present a philosophy that is neither modern nor moderate. Some of the religious broadcasts from Saudi Arabia, for example, feature extreme Wahabi philosophies typical of fundamentalists in Saudi Arabia with followers in other Arab countries. Some of these programs are even broadcast in English to conceivably attract non-Arabs in their broadcast footprint or with the anticipation of being relayed on other systems worldwide. These broadcasts, which some journalists in the region have characterized as "dial-a-fatwas" are old enough to have attracted some attention but serious scholarly measures of their content have yet to be conducted. Broadcasters and authorities in that region have appeared more concerned about the lack of coordination of views on these many different programs and channels (Radsch, 2009) than the proliferation of extremism via this medium. One English language broadcast from a Saudi Arabian channel, for example, responded to a viewer's e-mail about the necessity of the veil by suggesting that not only should women be completely covered when venturing out in public but that they should only venture out when it was absolutely necessary and in those cases always accompanied by a male chaperone. It is difficult to escape the irony of such ignorance (falling under several of the same unsavory categories as Pat Robertson's statements) and disinformation being promoted via the modern information infrastructure of our Information Age.

BREASTFEEDING FATWA

The Information Age is characterized by the availability of a wealth of information as well as diverse methods of information management. This information is not limited to science and technology as even religious scriptures and texts have been digitized and made searchable. Campbell (2010, p. 5) addressed the assumption that religious communities would tend to shy away from new media technologies such as the Internet, writing:

> There is significant evidence, and examples, of the fact that most religious communities do not simply reject new forms of communication technology. Indeed there are countless examples throughout history of the religious appropriation of the latest technology for spreading their faiths, from the printing press spreading the Bible, the language of the people, to the use of the mediums of radio and TV for televangelism and even the rise of evangelism and cybertemples and churches via the Internet.

Yet, such motivations, plus easy access to data and the ability to publish opinions both instantly and widely have not guaranteed sensible, valuable, or even rational discourse from religious circles. In 2007, for example, BBC news

reported on a ruling by an Egyptian religious scholar from Al-Azhar University which addressed a particular problem in modern Muslim societies.

With an increasing number of women in the workplace, these societies now have to contend with the implications of traditional religious/cultural restrictions on gender mixing. Among the issues is that of the traditional rules of *hijab*. This set of rules defines male-female interactions in general but is most commonly manifested in the practice of female veiling. While the more extreme form of veiling includes full body and face covering (*abayya* and *niqab*), in many Islamic societies—particularly those in which women may be found in the workplace—it takes the forms of wearing a head covering (usually simply called a *hijab*) along with some other normatively defined rules of dress. Traditional rules of *hijab* also dictate segregation between unrelated adult men and women which poses difficulties in the mixed workplace.

In response to this concern, Dr. Izzat Atiya of Egypt's Al-Azhar University made the following recommendation:

> He said that if a woman fed a male colleague "directly from her breast" at least five times they would establish a family bond and thus be allowed to be alone together at work.

> "Breast feeding an adult puts an end to the problem of the private meeting, and does not ban marriage," he ruled.

> "A woman at work can take off the veil or reveal her hair in front of someone whom she breastfed." (BBC News, 2007).

Beyond the simply ludicrous, there are more virulent forms of ignorance and Islamic religious disinformation spread via other technologies of the Information Age such as the Internet and the World Wide Web. Lewis (2005, p. 112) called the Internet a "crucial tool for global terrorism" adding:

> The Internet enables global terrorism in several ways. It is an organizational tool and provides a basis for planning, command, control, and communication among diffuse groups with little hierarchy or infrastructure. It is a tool for intelligence gathering, providing access to a broad range of material on potential targets, from simple maps to aerial photographs. One of its most valuable uses is for propaganda, to relay the messages, images, and ideas that motivate the terrorist groups. Terrorist groups can use websites, e-mail, and chatrooms for fundraising by soliciting donations from supporters and by engaging in cybercrime (chiefly fraud or the theft of financial data, such as credit card numbers).

Additionally, several high profile cases of radicalized U.S.-based Muslims have involved the influence (via the Internet) of radical Islamists and their supporters.

FICTIONAL OSMOSIS AND THE ACCELERATION OF DISINFORMATION

Elsewhere (Mohammed, 2011), I have outlined the concept of fictional osmosis which refers to the process by which fictions become integrated into discourse, tradition and culture. Fictional osmosis can be found in the ensconcement of historically accepted falsehoods as well as the propensity of modern fictions to be accepted as fact. It is a process that increases exponentially with new media and greater information volumes in our Information Age. Where information flows more readily, the processes of mythmaking increase in intensity and the creation of believed fictions is more deeply entrenched.

The notion of myth in scholarly discourse is somewhat more complicated than the popular denotations of simple falsehood or traditional legend. Scholars have interpreted myth as a larger concept involving several interrelationships among socially constructed and shared stories including explanations of natural phenomena, morality tales, historical and religious accounts and other narratives that evolve over time. Scholars have emphasized multiple roles and functions of myths in such domains as making sense of socially determined meanings (Barthes, 1957) and the reconciliation of social contradictions (Levi-Strauss, 1963). Noting that "the world is shaped by myths," Radford (2003, p. 11) is among those who have made the explicit connection between modern media and mythmaking, writing:

> Our understanding of ourselves and our culture is based largely upon what we are told by the media. Yet much of the media's content includes unexamined assumptions and myths... Frequently these myths are also myths in the sense that they are fictions...

This is not to suggest that the process of myth is unique to the most modern iteration of the Information Age. Lefebvre (2008) argued, for example, that while the Internet has facilitated disinformation mythmaking and the spread of false information in recent years, the processes of mythmaking have been well known throughout history and have been driven by factors including support from powerful forces, ethnic conflicts and the creation of scapegoats, media use, and the roles of powerful personalities.

DaVinci and Disinformation

One of the most powerful examples of the disinforming power of modern media and its acceleration of fictional osmosis may be found in Dan Brown's (2003) The *DaVinci Code* and the popular responses to the book (and then the film). Brown's novel was both entertaining and disinforming to vast audiences, as it cleverly mixed fact, fiction and speculation to weave its narrative. In the context of widespread societal ignorance of history and religious thought, this mixture proved quite effective in selling novels and in dispersing both confusion and disinformation to audiences.

Brown presented several archaeological debates over the historical figure of Jesus Christ alongside fictional or fictionalized accounts of conspiracies and secret societies. Neatly intertwined, the novel (and later the film) spawned several other books that sought to separate the fact from the fiction. Several of these books were in fact Christian perspectives that sought simply to re state church doctrine on some issues that offended the established sensibilities, such as the insistence that Christ did not or could not have had a sexual relationship or children. Church doctrine, however, had the advantage of both, a well-established history and a well-established information system of its own. On a much larger scale, other ideas from Brown's work moved into societal belief as fact rather than speculation or fiction. Fabrications of secret societies involving the Knights Templar and Leonardo DaVinci, for example became widely accepted as information rather than entertaining fiction, alongside speculation about the notion of the Holy Grail being the Holy Bloodline and facts about both religious relics and world history. Wodak (2006, pp. 1–2) recounted media descriptions of the phenomenon in 2005:

> Even more visitors are lined up in front of the Mona Lisa in the Louvre, Paris, debating the possible traces and clues signaling hidden meanings described in "The Da Vinci Code": Has Leonardo painted a man or a woman?... The same is true for the second famous picture which plays a central role in this book, The Last Supper. Are there only men depicted or is a woman sitting next to Jesus Christ? Might it then be true, as claimed by Dan Brown, that Jesus had been married and that his wife, Maria Magdalena, is sitting next to him?

This process might seem innocent enough and it might not matter that vast audiences believe in a secret society known as the Priory of Sion or that Leonardo Da Vinci was encoding secret messages in his paintings at their behest. However, closer examination of some other traditional beliefs reveals something of the extent to which fictions are merged into popular discourse and then into cultural canon. Often, this happens because fictional stories become popular and so work their way not just into storytelling but also into

the matrix of texts and cultural expressions. Once integrated, it is difficult to extricate fictions (including various forms of ignorance or disinformation) from truth, and they meld into cultural expression.

Historians have made numerous attempts to demonstrate that many of the ideas about Columbus found in popular thought (and even some textbooks) are not true. Columbus did not set out to prove that the earth is round nor did he set sail with a crew of criminals. These are not matters of historical debate either, because these and other erroneous ideas quite clearly arise from a largely fictional work—*The Life and Voyages of Christopher Columbus* by Washington Irving (1828) of which Hedges (1956, p. 128) wrote, "There is not enough factual weight to it to hold it down. Even as 'sufficiently literary' history it is not informative. Students of Irving look upon it as simply romantic like romance or like fiction." Russell (1991), for example, identified Irving's romanticized and fictional accounts of Columbus arguing with clerics of his time about the world being round as one of the key factors establishing that particular item of ignorance in the larger popular consciousness. This particular nugget has been echoed in countless textbooks (worldwide) despite the fact that the Ancient Greeks had conducted several experiments to demonstrate the earth's spherical shape and documented their understanding of this idea.

If such an idea could become so clearly diffused into the popular consciousness in 1828 and take hold so firmly without the benefit of the multiple channels of communication of today's Information Age, then what are the implications of fictional osmosis today and in the future?

INTERNET RUMORS AND URBAN LEGENDS

In the Information Age, fictions make their way into public consciousness everyday with tremendous speed and efficiency. In an age of information plenty, we are apt to make the assumption that vast amounts of information are a safeguard to the dangers of disinformation and myth. Instead, myths persist and even thrive in several forms including the urban legend and Internet rumors (spread via specious websites and e-mails).

These dis-informative practices contain something of the practical joke, inflicted harmlessly on large numbers of people by creative pranksters. Dismissed as such, their significance is easy to miss. Reconsidered, however for their dis-informative potential, and taken in the context of an informal social movement that both exploits and subverts the technologies and practices of the Information Age, they become much more substantial as social symbols of contestation and resistance. Urban legends and Internet rumors taken together as particular artifacts of modern information society are both influential and distinctive, drawing on traditional modes of social intercourse as well

as modern forms of transmission. Shibutani (1966) called rumors a collaborative process and characterized them as informal, collective behaviors that serve in part not just to report or interpret stories, but also to construct meanings. Donovan (2007, p. 61) described some specific characteristics of rumors and legends, going on to classify urban legends as a specific subset of rumors and writing:

> Rumors act like news, but are distinguished by being primarily disseminated outside the auspices of formal media or formal organizational authority. Thus, there is nothing in the definition of rumor that absolutely requires the content to be false.

The question of the truth or accuracy of content of urban legends or rumors has not been a primary concern for most researchers into the phenomenon, who have generally concluded that, like with traditional folktales, the message is often a cautionary one, advocating for a particular set of social norms and demonstrating the danger (however exaggerated or contrived) of deviations within the context of the social ritual of discourse (Llewellyn, 1996-97; Wyckoff, 1993). Fernback (2003, p. 32) noted:

> Often, these legends have a moralistic component and are symbolic of our almost morbid cultural fascination with the ugliness that lies just beneath the surface of the normalcy and peacefulness of everyday existence. They reinforce social norms by emphasizing traditional morality in the face of these underlying social pathologies.

Donavan (2002, p. 190) argued that modern urban legends are somewhat distinct in their form and function:

> Because they are largely "false" in an empirical sense—lacking documentation, evidence and direct testimony—they resemble myth or folklore. Yet because they make informal claims to be news, are contemporary, and generally do not involve supernatural themes or heroic historical figures, they operate somewhat distinctively.

Urban legends pre date the age of the public Internet. Fine (1985, p. 64) wrote of one particular subset of pre-Internet urban legends, namely the "mercantile legends" surrounding powerful corporations and suggested that they "typically posit a connection between a corporation and some harmful situation or event." Fine's examples of these legends from the pre-Internet era include legends of the Kentucky fried rat, worms in McDonald's hamburgers (encountered by the author in Canada where it was told as the story of a friend whose uncle had a contract to farm worms for the MacDonald's corporation) and Jockey shorts that cause sterility.

Often told as a personal communication (my friend says his uncle told him), these legends targeted not only the corporations but also the personali-

ties associated with them. Fine (1985) noted that a former president of McDonald's was tagged in such legends as a member of the Church of Satan. As we will explore in later sections with reference to modern forms, earlier urban legends also had both geopolitical and religious tones such as the notion that Uncle Ben's (rice) gives money to the Palestine Liberation Organization or that Procter & Gamble is owned by a satanic cult. Fine concluded (p. 79) that these mercantile legends reflected perceptions of the economic order— warning of the "danger from corporations and danger in mass-produced and mass distributed products" and noting that "the stories revolve around the enormous size, power, control, and wealth of the corporation."

These mercantile legends were not the only ones in circulation prior to the widespread diffusion of Internet technologies. Brunvand (1981) surveyed a wide range of legends which he described as being part of American folklore. With the caveat that the same is probably true in other cultures, the list of legends included the killer in the backseat, the baby in the oven and the razor blade in the apple. Noting both the cautionary nature of these tales as well as their morphology, Brunvand (1981, p. xii) called these "living folklore." In the Information Age such rumors take on a new virulence and real social meaning. The popular "kidney in ice" urban legend, for example, prompted the New Orleans Police Department (New Orleans Police Department, 1997) to issue the following bulletin in 1997:

> Over the past six months the New Orleans Police Department has received numerous inquiries from corporations and organizations around the United States warning travelers about a well organized crime ring operating in New Orleans. This information alleges that this ring steals kidneys from travelers, after they have been provided alcohol to the point of unconsciousness.
>
> After an investigation into these allegations, the New Orleans Police Department has found them to be COMPLETELY WITHOUT MERIT AND WITHOUT FOUNDATION. The warnings that are being disseminated through the Internet are FICTITIOUS and may in violation of criminal statutes concerning the issuance of erroneous and misleading information.

This particular rumor falls into a larger body of rumor that suggests a global conspiracy and a far-flung black-market trade in crudely harvested organs. Donovan reported a variation of this legend that circulated via e-mail and on newsgroups in the 1990s sometimes titled as "Reason to not party anymore" in which the cautionary tale is told of a person (usually male) who meets a woman at a party. After a night of drinking and/or drugs, the male subject awakens naked in a bathtub full of ice:

He looked down at his chest, which read 'CALL 911 OR YOU WILL DIE' written on it in lipstick. He saw a phone was on a stand next to the tub, so he picked it up and dialed. He explained to the EMS operator what the situation was... She advised him to get out of the tub. He did, and she asked him to look himself over in the mirror. He did, and appeared normal, so she told him to check his back. He did, only to find two 9 inch slits on his lower back... His kidneys were stolen. They are worth 10,000 dollars each on the black market.

The myth statement is accompanied by appeals to fact and authority as well as the specific cautionary appeal:

Regardless, he is currently in the hospital on life support, awaiting a spare kidney. The University of Texas in conjunction with Baylor University Medical Center is conducting tissue research to match the sophomore student with a donor. [. . . .] This is not a scam or out of a science fiction novel, it is real. It is documented and conformable [sic]. If you travel or someone close to you travels, please be careful . . .

This was only one manifestation of the rumor, which, aided by years of spreading and the use of information technologies, painted a picture of a rampant informal and illegal trade in human organs worldwide. This is, of course, neither completely true nor completely false, but rather greatly exaggerated from uncertain reports that spread via a combination of mass media and interpersonal communications across the globe. Myths making such extreme claims may also trigger skepticism in the reader, which may be detrimental to their popularity. Other myths that make much more subtle health claims have been quite popular, particularly where they have targeted seemingly powerful industries.

One such case was the "dioxin" myth that continues to circulate and enjoy some popularity. The premise was that the ubiquitous plastic water bottle contained a carcinogenic chemical known as dioxin which would leach out of the plastic into the water if the bottle were frozen or left in direct sunlight. An interesting component of this myth was the dynamics of the very specific authority claim that was made to support it at one point in its evolution. The specific reference was to a statement in a newsletter from the Centers for Disease Control and Prevention (CDC) that purported to announce this danger. In response to the popularity of the myth, the CDC released a statement indicating that it had never made any such announcement in any of its publication. In 2008 the CDC's Public Health News Center (Johns Hopkins Bloomberg School of Public Health, 2008) issued a statement entitled "Email Hoax Regarding Freezing Water Bottles and Microwave Cooking" which read in part:

> The Internet is flooded with messages warning against freezing water in plastic bottles or cooking with plastics in the microwave oven. These messages, frequently titled "Johns Hopkins Cancer News" or "Johns Hopkins Cancer Update," are falsely attributed to Johns Hopkins and we do not endorse their content... Freezing water does not cause the release of chemicals from plastic bottles.

However, the prevailing popularity of the myth meant that searches for the CDC newsletter about dioxin inevitably returned hits of sites reporting the myth rather than the CDC's denunciation of it.

The most popular Internet urban legends and rumors are compiled by several Internet sites including Snopes.com. They vary widely in terms of content and focus—from relatively innocuous advice on how to use gas pumps to maximize the gas received for your money and harmless speculation on the size of untapped petroleum resources in parts of the United States to potentially dangerous medical and nutritional advice (such as using asparagus to cure cancer) to political rhetoric that targets the president of the United States and religious speech denigrating particular faiths. The rumors also include several bits of dangerous advice on topics such as emergency phone calls and false missing children reports (that diverted resources from real searches for missing children).

Probably Not Dangerous

Among the relatively innocuous rumors and legends encountered in the Snopes.com listing of the top 25 urban legends and rumors was one that warned the reader to use the "clear" button on the gas pump to avoid being charged for the gas pumped by the previous customer. The cautionary tale is told as having happened to either the writer or to someone close who found duplicate charges on their card after failing to use the "clear" button. Another rumor circulated as gas pumping tips which purported to maximize one's yield from the pump—such as pumping when the temperature is colder to maximize volume, etc. While Snopes experts questioned the efficacy of these suggestions, the motivation for the spread of such a message might be seen in the context of current gas prices. Similarly related to ongoing concerns about petroleum prices is the message that claims that the U.S. is sitting on either 41 years (or 2041 years—depending on the version of the message) of untapped petroleum in something called the Bakken Formation.

The Politics of Fear

The listings of rumors and legends have also included several messages that sought to denigrate President Barack Obama, in several cases, by linking

him to Islam. One rumor (Mikkelson & Mikkelson, 2010b) claimed that the president not only cancelled the national day of prayer but also allowed Muslims to hold a day of prayer on the capitol grounds:

> President Obama has decided that there will no longer be a "National Day of Prayer" held in May. He doesn't want to offend anyone. Where was his concern about offending Christians last January when he allowed the Muslims to hold a day of prayer on the capitol grounds. As an American Christian "I am offended." If you agree, copy and paste no matter what religion you are. This country was built on freedom!!

Snopes.com explained the kernel of factual material that was twisted into this particular rumor as follows:

> Although it is true that President Obama has so far chosen not to host an ecumenical service in the East Room of the White House in observance of the National Day of Prayer as his predecessor, President George W. Bush, did each year throughout his tenure in office, that service was a personal preference of President Bush; it was neither an official ceremony prescribed by the bill that established the National Day of Prayer nor a long-standing presidential tradition. In fact, George W. Bush is the only president who has regularly organized White House events in observance that day.

Additionally, categorized within the same post is a photograph of President Obama removing his shoes with the caption "Obama Prays to Allah..." and a message that reads:

> This is OUR President at an "Islamic Prayer Day" session LAST WEEK AT THE WHITE HOU.S.E Oh, yes, Obama prays all right: WITH THE MU.S.LIMS!! This is OUR President at a MOSQUE prayer session LAST WEEK AT THE WHITE HOUSE, on the site where the INAUGURATION is held every 4 years! He canceled OUR CHRISTIAN "NATIONAL DAY OF PRAYER"...Now... THIS. For Obama to continue as our president is an INSULT TO OUR FOUNDING FATHERS!

Snopes.com explained that the photograph (others from the set are shown) actually shows the president entering Istanbul's Blue Mosque, where, as the website explained, "protocol dictates that visitors remove their shoes before entering."

Other myths also sought to associate President Obama with Islamic sentiments, such as one that associated the president with the issuance of U.S. postage stamps commemorating Islamic observances even though those stamps existed since 2001, long before Obama's presidency, and a myth called "Dhimmitude" (a specialist term for the treatment of subjugated populations under Muslim rule) that claimed that Obama's health care reform allowed preferential treatment to Muslims.

Another myth that combined both the political and the religious was a rumor that a redesigned Pepsi can featured the pledge of allegiance but omitted the words "under God." Based loosely on the fact that a post 9/11 Dr. Pepper can featured the words" One nation...indivisible" the myth claimed to show a decreasing respect for the founding principles of the United States.

Outside of the overtly political, however, the religious xenophobia was also evident in reports, for example, that a Tyson processing plant had replaced Labor Day with Muslim holy days. The xenophobia and politics of fear were also evident in a rumor that called for protests against a film purportedly in production that depicts Jesus as being homosexual (not true) and in an online petition to overturn a nonexistent law that provides social security benefits for illegal aliens

Health and Safety

Several of the most popular Internet rumors have dealt with health and safety issues including a warning about the dangers of bacterial formation on cut onions. At their most innocuous these were poor health and medical recommendations, probably not based in any real research of fact, but not directly harmful. No one is probably harmed by increased consumption of asparagus as recommended by one rumor that claims the vegetable can cure cancer, although the false hope that it might bring an actual cancer patient is another matter. A rumor that advises people in danger to dial #77 or 112 when faced with danger (as it is a direct line to the police), however, is considerably more dangerous. Indirectly hazardous is the "Ashley Flores" missing child hoax which has tied up police phone lines and diverted valuable attention and resources from real searches. Similarly the frequent issuance of false virus warnings cloud the landscape so effectively that real warnings (of which some are among the most popular distributed messages) are rendered useless.

Somewhat more typical of the traditional cautionary tale is the rumor of "Burundanga soaked business cards" which suggests that someone handing you a business card (inexplicably—usually at a gas station) may have soaked the card in a substance known as Burundanga. The purported intent is to disable the victim and then rob or otherwise take advantage of them. Snope.com explains that while Burundanga is a real substance with real effects, it would probably have no effect if simply presented as residue on a business card.

CONSPIRACY THEORIES AND INFORMATION

With multiple sources of information come multiple sources of disinformation. Among these, related to urban legends and myths, is the special case of the conspiracy theory. Widely dispersed tales of "actual" explanations of

major or mysterious events today spread virulently across the Internet and social media, supported in part by television and magazines. Once only part of fringe discourse, increasing spread and decreasing gatekeeping have promoted these ideas into the realm of popular thought and even into politics. While broad understanding exists of what might constitute a conspiracy theory, precise definitions are somewhat less common, since there has been relatively little scholarship dedicated to understanding the mechanisms and motivations of these stories. Nevertheless, Keeley (1999, p. 116) has suggested that the notion of a conspiracy theory can be defined as

> a proposed explanation of some historical event (or events) in terms of the significant causal agency of a relatively small group of persons, the conspirators, acting in secret.

According to Douglas and Sutton (2008, p. 211) scholars use a similar approach in defining and analyzing such theories; they wrote:

> Scholars characterize conspiracy theories as attempts to explain the ultimate cause of an event (usually one that is political or social) as a secret plot by a covert alliance of powerful individuals or organizations, rather than as an overt activity or natural occurrence...

Yet in both the academic literature and popular discourse we may observe a duality surrounding conspiracy theories. Most sensible people and reasonable scholars ostensibly tend to denigrate such ideas, attributing them to the uninformed or otherwise unintelligent. Parsons, Simmons, Shinhoster, & Kilburn (1999) even suggested that there is a relationship between the perceived political power of the individual and their propensity to believe conspiracy theories; that is to say, persons who feel powerless are more likely to believe such theories. Yet, as Sunstein and Vermeule (2009, p. 202) have noted, many conspiracy theories enjoy broad popularity and appeal:

> In August 2004, a poll by Zogby International showed that 49 percent of New York City residents, with a margin of error of 3.5 percent, believed that officials of the U.S. government "knew in advance that attacks were planned on or around September 11, 2001, and that they consciously failed to act." In a Scripps–Howard Poll in 2006, some 36 percent of respondents assented to the claim that "federal officials either participated in the attacks on the World Trade Center or took no action to stop them."

The bulk of conspiracy theorizing tends to focus on largely inconsequential debates over the causes and circumstances surrounding either major events or simply well-publicized ones (such as the death of Princess Diana). Often, they also concern mere curiosities such as the existence of the Loch Ness

Monster or UFOs. Among the most popular and influential conspiracy theories, Sunstein and Vermeule (2009, p. 205) have included the following:

> the view that the Central Intelligence Agency was responsible for the assassination of President John F. Kennedy; that doctors deliberately manufactured the AIDS virus; that the 1996 crash of TWA flight 800 was caused by a U.S. military missile; that the theory of global warming is a deliberate fraud... that Martin Luther King, Jr. was killed by federal agents... that the moon landing was staged and never actually occurred...

Yet, Sharp (2008, p. 1371) has reminded us that conspiracy theories can also circulate serious biological and medical misinformation, noting that:

> Conspiracy theories about HIV/AIDS and the encouragement of condom use being a plot against certain ethnic groups crop up from time to time. Nonsense these ideas may be, but they are not irrelevant, because they may need to be taken into account in planning public health's response to the AIDS epidemic.

Keeley (1999) noted several properties of the conspiracy theory, including its explanatory ability and its suggestion that the conspirators are not all-powerful but rather simply poised to play pivotal roles. He also suggested that the group of conspirators is generally seen as small though the actual size is often vague, and is thought to be acting in secret since public action would invite resistance.

Conspiracy theories have existed in the modern past, surrounding such events as presidential assassinations (McCauley & Jacques, 1979) for example. However, the idea of the conspiracy, intertwined with public speculation about major events is a much more ancient phenomenon. Clarke (2002, p. 132) has noted, for example, that

> conspiracies have consistently taken place throughout history. Elvis Presley may or may not have faked his own death, but Richard Nixon really did conspire to cover up his involvement in the Watergate burglary, and Cecil Rhodes really did conspire to provoke conflict between the British Empire and the Boer Republics.

Today, the multiple, globally accessible and gatekeeper-free technologies associated with the Information Age have made conspiracy theories more popular and often given them equal status with actual news.

Inherent in the spread of conspiracy theories is the agency of unscientific or pseudo-scientific inquirers, many who eschew notions of empiricism or proof. As Keeley (1999, p. 120) has put it:

> Conspiracy theories are the only theories for which evidence against them is actually construed as evidence in favor of them. The more evidence piled up by the authorities

in favor of a given theory, the more the conspiracy theorist points to how badly "They" must want us to believe the official story.

Sunstein and Vermeule (2009, p. 210) similarly noted:

On our account, a central feature of conspiracy theories is that they are extremely resistant to correction, certainly through direct denials or counterspeech by government officials; apparently contrary evidence can usually be shown to be a product of the conspiracy itself.

Adding to this resistance is the peculiarly modern digital phenomenon of information malleability. To a much greater extent than in previous times and even prior phases of the current Information Age, data are now subject to manipulation. Though text could be altered early in the history or written communication and photographs have always been vulnerable to darkroom tricks, the modern digital modes of information representation have made complex alterations to messages not just easier, but much more accessible. The evidentiary potential of images, for example, is all but completely eroded when images are both ubiquitous and replicable, subject at each replication to deliberate tampering, including a tremendous array of creative techniques that may change both content and meaning. This ability and the widespread means of both alteration and distribution now undermine the credibility of much of the information around us and often serve to bolster the charges of conspiracy theorists since no visual evidence is now without suspicion.

Such a proposition relates to the official provision of information such as photos from the moon landings. Conspiracy theories hold that any such images would be doctored and these charges further fuel the notion of conspiracy. Outside the realm of officialdom, however, the occasional information vacuum drives the creation of fake information, which, circulated out of context, further fuels conspiracy ideas. These perceived information vacuums are rare nowadays but do sometimes occur. When hurricane Katrina struck New Orleans, for example, a lack of images of the storm itself prompted the circulation of pictures purporting to be "Katrina pictures," some showing tornadoes, others obviously doctored to create what someone imagined a hurricane might look like. In this case, ignorance of meteorological phenomena and the scale of the particular storm allowed such images to pass into the public imagination. More relevant to the development and persistence of conspiracies, however, was the gory variety of faked images purporting to be those of Osama Bin Laden after he was shot by U.S. Navy Seals in May of 2011. Heslam (2011) writing in the Boston Herald, noted that even some lawmakers were taken in by the fakes:

The head of the Bay State's Democratic party is demanding U.S. Sen. Scott Brown reveal who showed him the fake photograph of Osama bin Laden's corpse after the Wrentham Republican went on television bragging that he'd seen the image—and later confessed he'd been duped.

Xenophobia and the Global Scope

Despite the global scope of the Information Age technologies, there is no inevitable removal of boundaries or dispelling of old prejudices. The technologies often simply reproduce the worst of the old suspicions and fears, often through deliberate misinformation which masks the availability of real information about the other. Thus, one may receive an e-mail message with attached pictures or video purporting to show a young boy being punished for stealing bread at a market. The message claims that the pictures or video are taken in Iran, or Pakistan, or some other Islamic-sounding country and show a young boy having his arm run over by a car wheel. This vicarious experience of the horrible event becomes real to the e-mail recipient due to the immediacy of the visual portrayal. A little investigation reveals that the images actually demonstrate little more than a street performer's antics in a third world market and that the last parts of the sequence showing the boy emerging unscathed from the event is usually omitted (Mikkelson & Mikkelson, 2006).

More specific xenophobia is evident in the previously mentioned legends and rumors that have gained currency with the ascension of Barack Obama to the U.S. presidency. The xenophobia and ignorance evident in messages seeking to depict the president as a Muslim are notable as they appeal to pre-existing prejudices and phobias but also because they exploit ignorance. To suggest, for example that a picture of the president quite clearly shown removing his shoes equates somehow to an act of worship begs the question of what kinds of predispositions are necessary in the recipient for this rumor to be believed.

Explaining Myths

Donovan (2002, p. 192) noted that myths of various kinds serve to simplify the world in particular ways, suggesting that this partially explains the persistence of myths when large volumes and varied types of information are available:

One of the persistent qualities that researchers of rumor have found is its role in the reduction of anxiety through the reshaping of information into acceptable forms... This quality in part explains why word-of-mouth and informally circulated genres persist as sources of meaning in a world which not only has high levels of cognitive information inputs but also high diversity in the character of those inputs.

This reduction of complexity is an important element of the myths examined above. The myths reflect, for example, conflations of the complexities of the president's diverse background with gross oversimplifications of Islamic religion and culture along with greatly exaggerated accounts of the influence of perceived foreign elements such as illegal immigrants. The question that remains is whether the myriad networks of new technologies improve or worsen social and cultural ignorance.

Viruses, Subversion and Debunking Behavior

It might be attractive to suggest that the mentality behind promulgating Internet myths and rumors is something like that of the virus maker who exults in the spread of his or her handiwork—destructive though it might be. A limitation of this analogy is that the virus maker is a subversive voice, whereas so many of the Internet rumor makers echo well-established prejudices and popular ignorance in addition to subverting traditional information hierarchies. Similar to the virus, the Internet-fueled legend or rumor behooves the recipient to take either pre-emptive action or corrective action. Through Internet rumoring, the creators of these myths may aim to discredit widespread social understanding for personal, political or religious reasons, while purveyors of hate or xenophobia may express speech that would be widely condemned for its inaccuracy and bigotry if spoken publicly or on traditional media. Naïve transmitters may accept these myths at face value and transmit them for their titillating value. Skeptical recipients may debunk some (though perhaps not all) of these myths. With Internet rumor or legend come what we might call the debunking load, which is manifest in the time and effort to check and extricate truth from fiction. Some resources such as snopes.com serve to make this task easier but it is often still time consuming. This concept of debunking load adds yet another component to the overall information load on modern information users.

Folklore

While the folklore perspective of Brunvand (1981) and others is a valid mode of analysis of urban myths, two important factors draw us toward the need for alternative explanatory frameworks. The folklore analysis depended on word of mouth transmission among culturally similar individuals with common understandings of myths and values. The post-Internet legend is spread to masses which may comprise diverse actors. Thus if a folklore perspective is to be perpetuated, it also requires a redefinition of folklore into a broader and more inclusive paradigm and expansion of culture as a more dynamic concept.

Whereas urban legends and Internet rumors may be somewhat informal in their form and function, there are other more deliberate applications of such disinformative processes. The idea that falsehoods may become entrenched through random processes of diffusion begs consideration of the implications of deliberate use of this tendency for fictions to spread and take hold—such as in the service of marketing or other forms of propaganda.

6

Disinformation, Propaganda and Video Games

The study of modern communication is often traced to Harold Lasswell's scholarly interest in the role of propaganda during World War I. Lasswell (1927b, p. 627) defined propaganda quite broadly as "the management of collective attitudes by the manipulation of significant symbols" and argued, even at that time, for a technological basis, writing (p. 630) that "the ever-present function of propaganda in modern life is in large measure attributable to the social disorganization which has been precipitated by the rapid advent of technological changes."

To provide some chronological context, World War I was a time when radio was still in its experimental stages and wartime propaganda was already a major issue—suggesting that the phenomenon pre dates our Information Age. Further support for this notion can be found in such excursions as Wilkerson's (1967) study of war propaganda in the Spanish-American War of 1898 (in which privately-owned newspapers were heavily involved in beating the war drums). Lasswell's (1927a) seminal work *Propaganda Technique in the World War* reached even further back in time to recount tales of horror used to sway public opinion against the enemy during the Crusades.

Taken at its simplest, wartime propaganda has historically served important roles both on the frontlines and on the home front. Lasswell (1927b) suggested that war propaganda involved placing the blame for war on the enemy, claiming victory (and associating that claim with divine influence), making the case for war by citing such benefits as security, peace and a better world and discrediting the enemy and as well as demonizing them. Lasswell (1927b, p. 630) argued:

> War propaganda involves the enemy, the ally, and the neutral. It involves leaders on both sides and the support of certain policies and institutions. It implies the control of attitudes toward various forms of participation-enlistment, bond buying, and strenuous exertion.

He also argued that war propaganda is used to convince the homeland of their role in the war effort as well as to convince other countries of the need for the war and win their support.

The assumptions of the Information Age suggest that the availability of multiple information sources would negate the power of war propaganda. Entire societies cannot be swayed, convinced or hoodwinked into believing things that are not true when information is readily available from multiple sources—or so the reasoning goes. How then, did a campaign of misinformation convince a majority of Americans of ideas like the existence of weapons of mass destruction in Iraq, a sinister alliance between Saddam Hussein and Al-Qaeda and that (stemming from these) the appropriate response to the terrorist attacks of September 11, 2001, included an invasion of Iraq?

According to Kamalipour and Snow (2004, p. 8), the fundamentals of war propaganda have changed with the coming of the Information Age in the following manner:

> Traditional conceptions of propaganda involve crafting the message and distributing it via government media or independent news media. Current conceptions of information war go much further and incorporate the gathering, processing, and deployment of information by way of computers, intelligence, and military information systems.

The availability of new information technologies, therefore, does not negate the possibility or power of war propaganda, but rather, has changed the approaches necessary for its success. Purveyors of such propaganda adopt tried and tested techniques from corporate advertising and public relations to suit the needs of the war machine. In September 2002, for example, *The Times* of London reported:

> The Bush Administration is to launch a multimillion dollar PR blitz against Saddam Hussein, using advertising techniques to persuade crucial target groups that the Iraqi President must be ousted. The campaign will consist of dossiers of evidence detailing Saddam's breaches of United Nations resolutions and is due to be launched this week at American and foreign audiences, particularly in Arab nations skeptical of American policy in the region. The White House is aware that it lacks substantial new intelligence on Iraq's nuclear program or evidence directly linking Baghdad to the September 11 attacks. But it will build on the contents of President Bush's speech made to the United Nations General Assembly last week, in which he listed Saddam's violations of UN resolutions. (Reid, 2002)

Altheide and Grimes (2005, p. 617) bluntly asserted that "the invasion of Iraq was justified to the American people by a sophisticated propaganda campaign that reflected a think tank's vision for a new foreign policy." The

particular organization identified in their research, and identified by several news outlets was the Project for a New American Century, a conservative and extremely hawkish elite group of policy makers who expressed the need to capitalize on catastrophic events to rebuild U.S. power in particular geopolitical contexts. There remains a level of debate as to whether the PNAC was the driving force behind the Iraq invasion. There is also debate over whether the media were co-opted into parroting the government's policy positions through strategies such as embedding (in which journalists were given privileged access to frontline activities). Regardless of where these debates lead, the outcomes of the war propaganda campaign are somewhat clearer; not only did large numbers of Americans come to believe that Iraq possessed weapons of mass destruction, they also believed that Saddam Hussein was in cahoots with al-Qaeda and was involved in the attacks of September 11, 2001. This was despite the fact that any member of the public could easily have read online that Saddam Hussein, although clearly a brutal dictator, did not run a religious regime and that his country was ravaged by many years of international sanctions.

The notion of war coverage still also evokes the specter of disinformation as a deliberate strategy unhindered and even aided by the presence of new and traditional communication technologies. Beelman (2001, p. 16) pointed out with regard to the U.S. military campaign in Afghanistan:

> For reporters covering this war, the challenge is not just in getting unfettered and uncensored access to U.S. troops and the battlefield—a long and mostly losing struggle in the past—but in discerning between information and disinformation. That is made all the more difficult by a 24-hour news cycle, advanced technology, and the military's growing fondness for a discipline it calls "Information Operations."

The modern approach to disinformation for ignorance in the form of war propaganda has proven to be remarkably sophisticated, including the widespread manipulation of the presumed diverse and free forms of modern media through both the provision of misinformation and the suppression of facts. Hafez (2008, p. 43) associated this kind of control in both the 1991 Gulf War and the 2003 (and continuing) Iraqi operations to a continuing supremacy of politics over media, writing:

> In the Gulf War in 1991, the U.S.A managed to prevent images of probably more than 100,000 Iraqi victims from being shown on Western TV screens. They were able to control the media by creating information hubs, exerting censorship and public relations initiatives that were often outright propagandist and false—quite like in the 2003 war.

Writing in the UK's *Guardian* newspaper, Kampfner (2003, p. 2) called the story of the rescue of Private Jessica Lynch "one of the most stunning pieces of news management yet conceived" and argued that the story provided "remarkable insight into the real influence of Hollywood producers on the Pentagon's media managers, and has produced a template from which America hopes to present its future wars." Such grand deceptions may seem unlikely in the presence of multiple competing sources of information and the ease of access that so many around the world enjoy. How, then, do falsified stories like the Jessica Lynch episode or the Iraq WMD PR efforts manage to take hold and sway public opinion? In addition to the direct techniques of battlefield information operations, at least two additional strategies have emerged in the public sphere to bolster the power of modern war propaganda and cope with the public's ability to find and share information. The first of these strategies is the claim of privileged information.

PRIVILEGED INFORMATION

Whereas modern audiences are capable of finding and evaluating information through many different channels, this ability proves useless if the information is somehow privileged or restricted. Stowell (2007, p. 414) has noted:

> Access to information might be considered to be an important human right but it is also increasingly seen as capital, essential to the wealth of the nation state and as such information and knowledge treated as a capital becomes something that must be guarded and controlled.

Sunstein (1986), focusing on the legal aspects of governmental information manipulation, has argued that the notion of government being able to selectively withhold information is neither new (the framers of the U.S. constitution kept their deliberations secret) nor in contravention of the first amendment, arguing (1986, p. 894) that: "Even if it is agreed that citizens should generally be able to deliberate about government action, the need for secrecy sometimes justifies government control of information." Among the types of information that governments may seek to control, Sunstein (1986, p. 894) included military or diplomatic secrets, technical data or scientific information with military applications as well as deliberations among public officials.

Yet, even if such approaches are indeed traditional, legal, and even common, does this necessarily mean that they are always conducive to truth, democracy and justice? Miller (2004, p. 7) took the idea of information privilege in the context of military intelligence to suggest that major players in

the international propaganda arena aim to achieve what he has termed "information dominance" which he explained in the following terms:

> The concept of information dominance is the key to understanding the United States' and the United Kingdom's respective propaganda strategies, and it is a central component of the United States aim of "total spectrum dominance." Information dominance redefines our notions of spin and propaganda and of the role of the media in capitalist society. To say that it is about total propaganda control is to force the English language into contortions that the term propaganda simply cannot handle.

Integrating inter-operable systems of what has been termed "weaponized information" has become the hallmark of modern information-based military operations. Military operations, however, are not fought only on the battlefield. These uses of information, particularly under the control of governments and their militaries reflect a class of privileged and protected activities that may be touted as being in the interest of the population but may not always reflect democratic ideals. The implications of class, economics and power stemming from this perspective are reflected in Stowell's partially Marxist but overtly Foucaultian analysis in which he has argued (2007, p. 416):

> If information is power then it brings with it the realization that those who control it have power over those who do not. So there is little to be gained by those who exercise control in providing an equality of experience... We can accept Foucault's argument that knowledge and power are inextricably linked and that those who are denied or cannot gain access to information have little power. Conversely those that do have access to information have power.

With continuing reference to the role of information privilege in fostering ignorance, support for the U.S. military actions in Iraq and Afghanistan was partly enforced with claims of privilege. Intelligence reports, accessible to only a select few, were cited as evidence and harnessed along with powerful social pressures (to, for example, support the troops) to craft support for these excursions. Pillar (2006) has argued that intelligence information was sometimes ignored by policy makers and at other times "misused publicly to justify decision already made." In the context of an increasingly open information market privileged information has become an important tool for social manipulation and disinformation.

The public cannot access privileged information; even to attempt such access may constitute a criminal act. Whether officially classified as state secrets or simply alluded to as some shady category of "intelligence reports," privileged information can be a powerful propaganda tool both in what is and what is not released. The claims made in such information may be strategically released for optimum effect—such as those of secret meetings between Iraqi

officials and terrorist operatives or of aluminum tubes or yellow cake uranium purchases in Africa. They are not subject to verification by ordinary citizens or even by journalists and only dissent from within the ranks of the information privileged may provide some context on the creative and titillating uses of half-truths and carefully excised facts.

These privileged claims acquire credibility and enter the public consciousness—sometimes presented on grand stages such as the United Nations Security Council as was the case with Secretary of State Colin Powell's presentation before that body on February 5th 2003. The mythic status of "intelligence"—bolstered by images of secret agents and national security suggests an authority and importance that transcends ordinary information. Despite being privileged, however, these claims are sometimes simply untrue. According to CNN (2005), Col. Lawrence Wilkerson an aide to Colin Powell, described the speech as the lowest point in his life, partly because of the revelation that some of the "intelligence sources" were known to be untruthful. In particular, one source, known as "Curveball" turned out to be an Iraqi defector in Germany whom the CIA had never actually interviewed and whom German intelligence officials characterized as crazy and out of control (Pleitgen, 2008).

If the Powell example can be excused as an inadvertent falsehood (multiple aides indicated that the secretary was not aware of this weakness of the information) privileged information has also been known to be deliberately fabricated in the pursuit of public support of military objectives. Perhaps the best example of this can be found in the fall of 1990 after Saddam Hussein had laid claim to Kuwait and its oil, backing up his threats with invasion and occupation in August.

Winter (1992, p. 25) recounted a well-televised hearing before the U.S. Congressional Human Rights Caucus held in the run-up to U.S. involvement in the conflict:

> a young Kuwaiti woman identified only as "Nayirah, age 15, Kuwaiti escapee" testified. The only eyewitness to the alleged incubator murders, Nayirah sobbingly told the hearing and TV cameras that as a volunteer in a Kuwaiti hospital, she saw the Iraqis as they "took the incubators and left the children to die on the cold floor." Hundreds supposedly died and eventually the figure 312 was arrived at. Television footage showed what were alleged to be mass graves.

Winter and others (including Stauber & Rampton, 2002) have noted that U.S. President George H. W. Bush repeated the story of the incubator deaths several times in championing U.S. and international involvement in the conflict and that decisions to commit troops and other resources followed

closely on this pivotal presentation. Thus, with the help of international public relations consultants and deliberate creative misinformation the Kuwaiti royal family successfully swayed public opinion towards U.S. and international involvement in their territorial battle with the Iraqi dictator (Stauber & Rampton, 2002). This created information was privileged not by intelligence or officialdom but simply by the claim of a firsthand account that the average viewer was not in a position to verify. Yet even this minor privilege was enough, timed as it was and only subject to contradiction after some time and investigation by journalists who were eventually able to falsify the story.

Although the modern spread of information has facilitated the eventual falsification of many of these stories, they continue to be successful as forms of disinformation and those that wield them have continually avoided repercussions. Hafez (2008, p. 43) noted that the political ramifications of such disinformation do not generally materialize as might be expected in part because "journalism is in most cases unable to check and dismantle disinformation as fast as would be necessary." This time factor is inevitably related to information volumes and the speed of the 24-hour news cycle. Such information realities provide the perpetrators of disinformation with enough cover to disseminate falsehoods and enable those falsehoods to spread (with the aid of both formal and informal media channels) and to take effect before they are disproven. By the time the truth behind the Jessica Lynch exaggerations, the Kuwait incubator lies or the WMD scares are eventually revealed (having been persistently supported, repeated and normalized throughout their useful life), the political needs of such stories are long past being fulfilled and post-hoc justifications created and dispersed. Thus challenges to the many bits of disinformation involved in justifying and precipitating military actions in Iraq, for example, are met with the (altogether reasonable) claim that the world is a better place without Saddam Hussein—which argument rhetorically deflects attention away from the perpetration of disinformation leading to thousands of human deaths on both sides.

Normalization

The second strategy of modern war propaganda in the public sphere as alluded to above is one of normalization. After a long period of social repetition on the vast variety of communication channels, the basic premises of the war effort are normalized in the public imagination. Yet, the process of normalization now requires some level of participation by audiences. The use of war-based video games as war propaganda has served to fill that need. New media technologies have increased not only the volume of information and ideas but also the variety of ways in which information is spread. Video games

enjoy immense popularity, having outstripped home movies in terms of revenues. This particular media form has also raised several concerns about the effects of this participatory and experiential pseudo-activity. The main tropes of the video game debate have included familiar concerns about violence in young people, but only more recently has this violence been placed in a greater social context. Roger Stahl (2006), for example, noted the connections among video games, violence and war:

> Wartime news looks like a video game; video games restage the news. Official military training simulators cross over into the commercial entertainment markets; commercial video games are made useful for military training exercise. Advertisements sell video games with patriotic rhetorics; video games are mobilized to advertise patriotism. The business of play works closely with the military to replicate the tools of state violence; the business of state violence in turn capitalizes on playtime for institutional ends (p. 125).

For scholars like Stahl these interconnected systems of war promotion engender and maintain the cultivation and support of institutionalized violence. Players identify with the mission and purposes of the in-game characters who engage in violence against "others" who are often portrayed as inherently evil. Sisler (2008, p. 208) noted that "the Middle East is a favorite virtual battleground" for modern videogames and that several popular titles "take place in the Middle East or in ostensibly anonymous yet overtly Middle-Eastern settings" where the enemy other is objectified, stereotyped and destroyed in the following terms:

> Generally speaking, the player controls American or coalition forces...the enemy is depicted by a set of schematized attributes which often refer to Arabs or Muslims' headcover, loose clothes, dark skin color. In many cases, the in-game narrative links these signifiers to international terrorism and/or Islamist extremism.

The promotion of "othering" is in itself a form of ignorance, but the glorification of vicarious violence also provides a misrepresentation of the realities of armed conflict that constitutes its own category of ignorance. The hegemonic power of these representations may be underestimated.

While privilege and normalization aid in the success of war propaganda and disinformation, they are but coping mechanisms for the new decentralized forms of media. As with all media developments, however, the ability to both use and abuse new media evolves with time and need. The persistence of war propaganda gives reason enough to question the errant assumption that new and decentralized media necessarily serve as protection against information manipulation. The absence of gatekeeping, fact checking, critical inquiry, and

simple skepticism of new media may in fact aid the spread of disinformation and ignorance.

NEW MEDIA, OLD IGNORANCE

The Information Age has seen the development of distinctions between different knowledge systems. More recently, some academics and policy makers have, for example, focused on the question of what they have termed "traditional knowledge." With an almost exclusive focus on the knowledge base of certain indigenous or otherwise "traditional" groups, such studies also feature an emphasis on the stock of biological data possessed by these people. In some ways, concerns about this data are prompted by the information industries and their attempts (real or perceived) to monopolize biological and pharmaceutical information. Inherent in this focus is an automatic and presumed distinction between modern (Western) science and exotic traditions.

This bias is indicative of more than colonial/historical notions that privilege Western science over other knowledge traditions, however. It also demonstrates the implicit tendency of the modern Information Age—centered in the modern dominant Western economies and their models of production, reproduction, and thought—to underestimate the persistent role of its own traditional knowledge systems.

The Information Age also facilitates ignorance through its enabling of the persistence of some of humankind's oldest suspicions, divisions and prejudices. In an age of multiple and diverse sources of information, framing of traditional divisions can be remarkably uniform, consistent and true to ancient tensions. These divisions and the ability of Information Age media to stoke their fires are evident in the tensions between large groups of humanity variously identified as East and West or Islamic and Christian. Brown (2001) has argued that the terrorist attacks of September 11, 2001, in New York City have served to amplify the difficulties of the relationship between Islamic and Western societies. However, he noted that the divisions run deep into history and the perception of threats from Islamic empire building originating in Arabia and then championed by the Turks. In this context, the largely Christian states of Europe perceived Islamic expansion as the deadliest of threats to their existence, while Muslim societies viewed events such as the Crusades as evidence of open Christian aggression. Prados (2001, p. 2) characterized the historical relationship as one based in legacies of conflict, noting:

> Although the various Islamic empires that existed during that lengthy period were sometimes allied with one or more European states, Islamic-western relations tended to be a story of conflict: the early Arab conquests after the emergence of the Islamic religion; the European-led crusades from the 11^{th} to 13^{th} centuries; the expansion of

the Ottoman Turkish empire into southeastern Europe in the 15th and 16th; and the establishment of colonial or quasi-colonial regimes over much of the Arab world by France, Britain, and to a lesser extent Italy in the 19th and early 20th. As Arab states acquired full independence following World War II, their citizens continued to harbor strong sensitivities over anything that suggested "western imperialism."

According to Rami G. Khouri, (2004, p. 1), executive editor of Beirut's *Daily Star* newspaper,

> Arab memories even of the Crusades, more than eight centuries earlier, remain real and politically relevant. In the past two centuries since Napoleon's armies invaded Egypt and launched the modern European colonial era in the Middle East, local public opinion remains deeply resentful of Western political and military intervention. This has been manifested again in widespread Middle Eastern opposition to the American-led war to change the Iraqi regime and redraw the political map of the region.

While the murderous actions of Islamic extremists in September 2001 served as the primary point of reference towards Islam and Muslims for a generation of Americans (and perhaps will continue to do so for generations to come), this was not the first or only source of suspicion and fear. In the early history of the United States, despite strong sentiments of support for religious freedom and even specific mentions of the rights of "Mahamadans" or "Mahometans" in the debate over disestablishment from figures such as Thomas Jefferson, even older suspicions and stereotypes of Muslims and Islam could yet be found. According to Hutson (2002), despite several instances in which the Founding Fathers argued in favor of tolerance for all religions, some elements in society harbored long-standing stereotypes of the Muslim "other":

> An evangelical Baptist spokesman denounced "Mahomet" as a "hateful" figure who, unlike the meek and gentle Jesus, spread his religion at the point of a sword. A Presbyterian preacher in rural South Carolina dusted off Grotius' 17th century reproach that the "religion of Mahomet originated in arms, breathes nothing but arms, is propagated by arms."

This mixture of entrenched resentments with modern media coverage remains a primary element in the messages and debates on both sides. Brown (2001) characterized the modern role of media as reinforcing mutual misperceptions of the past, writing:

> From about 1970 onwards western media began to report more extensively on Arab and Islamic matters. Much of this reporting, however, focused on those aspects of Islamic life least likely to be attractive to western readers: the status of women in some highly traditional Muslim states like Saudi Arabia, the use of mutilation as a punish-

ment for theft, public executions by decapitation and of course the fatwa against Rushdie. This pattern of reporting was, to be sure, based not so much on prejudice as on the well-known appetite of the western media (and its consumers) for "bad news" or stories that offend popular sensibilities. Nevertheless, it reinforced negative western perceptions already in place as a result of longer-term historical issues...

The persistent mutual ignorance on both sides came into sharp focus when the Danish newspaper *Jyllands-Posten* published cartoons depicting Islam's prophet Muhammad in 2005. International media covered the widespread demonstrations stemming from furor in many Muslim communities over what adherents perceived to be derogatory representations. Beyond the notion that the images were derogatory, the opposition to them was also based on the fact that many Muslim communities hold to a widely perceived prohibition on visual portrayals of Muhammad. Many news stories covered the story in terms of religious sentiments on the part of the Islamic world versus the recognition of the importance of free speech in the industrialized West.

The fallacy of neat divisions into "East and West" or "the West" and "the Islamic World" were clearly and sadly demonstrated in events such as the violence that broke out in places such as Nigeria over this very issue. According to Polgreen (2006, p. 8) three days of rioting over the Danish caricatures in the Onitsha area of Nigeria during 2006 "reignited" old ethnic and political tensions pitting Muslims against Christians and leaving more than one hundred dead:

> Dozens of charred, smoldering bodies littered the streets... after three days of rioting in which Christian mobs wielding machetes, clubs and knives set upon their Muslim neighbors... Rioters have killed scores of people here, mostly Muslims, after burning their homes, businesses and mosques in the worst violence yet linked to the caricatures of the Prophet Muhammad first published in a Danish newspaper. The violence in Nigeria began with attacks on Christians in the northern part of the country last week by Muslims infuriated over the cartoons...

Hussain (2007, pp. 114-115) has suggested that, in the controversy over and coverage of the Danish Muhammad cartoon issue, modern media presentations were responsible for questionable debates, flawed at various levels but consistent with centuries-old mistrust, arguing:

> It is clear that the basic principle of free speech was not at issue. Similarly, the notion of religious sensitivity, framed by the media as the opposite pole in the dichotomy of this debate, also had little or nothing to do with the misconceptions that were the root of the problem...

In choices such as the wording of headlines, Christiansen (2006, pp. 65–66) pointed to the persistent and traditional biases inherent in Western media coverage:

> It is illuminating to note how a headline can seem absurd when applied to a Western nation, yet the same headline is deemed acceptable (to editors, at least) when applied to a country such as Turkey. The *Guardian's* "Turkey's Islamic leader moves to reassure West" is my particular favorite, because it manages to be terrible on so many different levels... (the headline referred to the then Turkish Prime Minister-elect, Recep Tayyip Erdogan, and not an actual imam or other religious leader). Can we imagine, with any degree of seriousness, Angela Merkel, the leader of the *Christian Democrats* in Germany, being described as "Germany's Christian leader"...? (italics in original)

Hussain suggested, further, (p. 115) that the framing and treatment of the story by international media were replete with wording that supported preconceived and flawed notions about the perceived "other," including such phrases as "depictions of Muhammad or Allah are banned in Islam." He argued that even such a seemingly simple statement misrepresented a monolithic Islam (which does not exist) and made the case (p. 116) that such statements perpetuate misconceptions among Western readers

> as most uninformed members of largely Christian societies tend to believe, wrongly, that Muslims view Muhammad just as Christians view Jesus: as divinity incarnate. This was evidenced clearly in *France Soir's* headline after its editors decided to republish the Danish cartoons, "Oui, on a le droit de caricaturer Dieu" ("Yes, one has the right to caricature God). The now outdated terms Mohammedanism for Islam and Mohammedan for Muslim are products of this fallacy and all its implications. Though the terms are now obsolete, the false perceptions of Muhammad and Islam on which they were based persist in Western societies and their media to this day.

The widespread ignorance among Western journalists and their audiences was not the only dimension of ignorance involved in this issue. Muslim ignorance and unquestioning acceptance of debatable ideas within their own set of religious and traditional edicts are also to blame. The prohibitions on the creation and use of images of the prophet Muhammad stem from a larger assumption that all images are prohibited under Islamic jurisprudence. Upon closer examination, however, this notion, held precious by so much of the Muslim world, may simply be a result of the persistent and prevalent overemphasis of particular ancient ideas. Whereas Western journalists may be excused for adopting this generalization, Mirza (2005, p. 413) explained that the presumed prohibition may not be as clear cut as even followers of the religion assume, writing:

Many have considered Islam to have prohibited icons throughout its history, thus explaining why Islamic art developed in unique ways that stressed geometric designs and calligraphy and steered away from the making of inanimate representations of animate beings. But recent findings have pointed to the fact that certain "icons" were created, some even depicting Muhammad in the effort to explain his miraculous life. Art historians have thus debated why some Muslims throughout history have refrained from making images while others have not.

Part of the reason for this observed discrepancy involves the varying interpretations of religious edicts by different communities over the centuries, which led to the creation of various visual works including several portraits of the Prophet Muhammad. Schwartz (2006, p. 29), however, attributed the (active or passive) ignorance of this history to the influence of radicals such as the Saudi-based Wahabbis, who promote extreme views including blanket prohibitions of images, writing:

> Reporters and commentators have established the claim that Islam strictly forbids artistic depiction of Muhammad, other prophets, and living beings in general, and that in publishing cartoons of the prophet the Danish newspaper *Jyllands-Posten* deeply offended all Muslims. Journalists have foisted this nonsense on the Western public by recycling the apologetics for radical Islam offered by Western academics... In reality, portrayal of Muhammad is not universally banned in Islam.

Noting that early Islam focused heavily on the banning of idol worship, Schwartz is among those who have argued that the Qur'an itself is silent on the question of images *per se* (as opposed to idols) and that the sayings of the Prophet regarding images were often reported well after his death and have been subject to various interpretations over the years. The truth of these assertions is simply established by the existence of images of animated living creatures in the form of paintings, pottery and other artifacts from various Muslim societies throughout history as well as paintings of the prophet Muhammad. According to Schwartz (2006, pp. 29-30),

> The Smithsonian Institution in Washington contains a picture of the prophet seated with his companions. The work appears in Bal'ami's Persian Version of Taban's Universal History, from the 14th century... The prophet is shown on the magical steed Buraq, flying over Mecca, in a 15th century manuscript, now in the British Museum...

The cartoon debacle, while an instructive case, is only a small part of the ongoing dynamics of representation and misrepresentation widely enabled by both traditional and new media which results in perceptions of the other that are still remarkably similar to those of pre-Information Age ideas. The persistence of passive and active ignorance of "the other" in the face of

multiple channels and vast volumes of information represents a broad failure of will to challenge preexisting prejudices on both sides of the divide. Numerous studies have examined negative portrayals of Arabs and Muslims (and even the seemingly logical juxtaposition of these two is problematic) by Western media. Relatively few, however, have done similar work to describe the prejudices, stereotypes and suspicions that appear in Arab communication media with regard to portrayals of the West and groups and ideas associated with it.

MacFarquhar (2001, p. B3), for example, described the contents of Saudi school textbooks in required religious knowledge classes that tell students that "It is compulsory for the Muslims to be loyal to each other and to consider the infidels their enemy." He noted (2001, p. B3) that such ideas, stemming from the extremist Wahabi philosophy (endorsed and spread with the help of the Saudi government) makes its way into other information media as well, writing:

> That extremist, anti-Western world view has gradually pervaded the Saudi education system with its heavy doses of mandatory religious instruction, according to Saudi officials and intellectuals. It has seeped outside the classroom through mosque sermons, television shows and the Internet, coming to dominate the public discussions on religion.

Toosi (2005, p. 1) has described Egyptian views of the United States, noting that among young Egyptians popular discussions were "the notion that the U.S. invasion of Iraq was a plot to help the Israelis control the Middle East" and "the idea that the U.S. government is controlled by an elite group of Jews." Toosi's (2005, p. 1) evaluation of the communication about and with the West concluded that:

> To say there is a communication gap between the Arab world and the West is an understatement. There's lots of talking at each other, but the listening that goes on is either non-existent or highly selective. Information is a malleable commodity; even the most basic facts are up for debate... The media here feed the idea—accepted even among well-educated Egyptians—that Arabs and Muslims are under attack by the United States. Words and pictures relentlessly convey the suffering of millions of Arabs and Muslims at the hands of the United States and U.S.-backed Israel.

Outside of the apprehension and suspicion evident in Arab media coverage, the Congressional Research Service (Prados, 2001, p. 1) observed that perceptions in the Middle East of the United States can also include ambivalent reactions:

The image of the United States as a "land of milk and honey" as well as a land of freedom and opportunity co-exists with another image of moral decadence and hostility to Islamic society in the minds of many residents of the Middle East. These conflicting images can lead to wide swings in popular attitudes toward the United States. The friendliness that many Americans encounter in casual contacts with ordinary citizens of Middle East countries can turn quickly to hostility and, on occasion, to violence when the United States adopts a policy seen by locals as inimical to Arab or Muslim interests.

While Arab media representations sometimes equate the United States and the broader West, they may also reflect specific objections to U.S. policy and actions. The duality of friendliness and hostility that Prados (2001) reported to Congress is also related to distinctions sometimes made between positive Arab receptions of individual Americans that exists alongside distaste for U.S. foreign policy. As Toosi (2005, p. 1) noted, Middle East attitudes to the United States, while tinged with suspicion can indeed be multifaceted:

It would be easy to say Egyptians are anti-American, but the term is too simplistic, especially when most Egyptians insist they have good feelings toward the American public. America is many things to Egyptians. It is democracy, it is human beings, it is military might, it is freedom; at the same time, it is the child who grew into an arrogant tyrant instead of a benevolent champion.

Beyond this social ambivalence, Arab media's representations and reporting of modern geopolitical issues, including conflicts in the region, tend to conflate several bodies of thought and imagery including historical animosities. Sachs (2003, p. B1) described the combination of images from the Palestinian territories and the American military operations in Iraq during 2003 on the website of an Arab newspaper, suggesting, more generally:

The media in the region have increasingly fused images and enemies from this and other conflicts into a single bloodstained tableau. The Israeli flag is superimposed on the American flag. The Crusades and the 13th-century Mongol sack of Baghdad, recalled as barbarian attacks on Arab civilization, are used as synonyms for the American-led invasion of Iraq. Horrific vignettes of the helpless—armless children, crushed babies, stunned mothers—cascade into Arab living rooms from the front pages of newspapers and television screens.

Despite a still-emerging emerging culture of non-governmental media and journalism, most mass media in the Middle East continue to be government-owned, government run, or controlled by elements that are pro-government. The prevailing assumptions of both traditional and new media coverage in the Arab region tend to privilege the idea of the West in general and the United States in particular as persisting in the onslaughts of the

crusades, contributing further to the mutual mistrust and ignorance on both sides of the cultural divide. In describing European and Middle-East relations in the media age, Hafez (2008, p. 36) concluded that "Arab media sometimes show the same tendencies as Western media to subscribe to hegemonic nationalism" adding that among the prevailing ideas is the notion that, "Arab media have to be one sided... to balance out the Western dominance of international news flows and get heard in 'world opinion.'" Within that one-sidedness, however, resides a tendency towards indulging in vitriolic expressions against the perceived enemy, which is often embodied in the state of Israel. As Pattir (2006, p. 20) has put it:

> The phenomenon of demonizing Israel and the Jews through cartoons in the Arab press is neither new nor recent. It has been part and parcel of its mode of editorial conduct since the establishment of the Jewish state more than 57 years ago... Daily, weekly and monthly papers, periodicals and magazines are loaded with cartoons containing the worst kind of anti-Semitic content... through denial of the Holocaust; the Jew as a repulsive stereotype; Israel as a Nazi-like entity; and the Jews as a whole as the greatest existing threat to humankind.

While the emergence of decentralized mass and interpersonal media may change the dynamic of government control all too often associated with such expressions, Hafez (2008, pp. 38–39) considered the emergence of new and globalized media to be a necessary but not sufficient condition for global dialogue, noting that the creation of separate information ghettoes is a more likely outcome of the technologies:

> Even where technical access is granted via satellite dishes, Western consumers hardly ever tune into the TV programs of other countries... Such access is limited to migrating minorities and very tiny information elites. We subscribe to a myth of globalization if we assume that the world is construed like a giant web of communication that connects us all and comprises a "global civil society." On the contrary: Satellite technology and the digital age have enabled the deepening and extension of geo-linguistic regional media spaces and intra-cultural media spheres—in Europe as much as in the Arab world.

HATE.NET

By 1995, the Internet had already begun to feature significant hate sites (Levin, 2003). According to the *New York Times* editorial page (The New York Times, 1999):

> Anyone who has sampled the hate sites on the Web cannot help but notice a striking thing. The more extreme the doctrine, the firmer its reliance on what passes for logic and historical evidence... In their literature, false notions of evolution coexist with

false ideas of revelation. Invented histories support insupportable conceptions of culture. But for too many people, now as always, and especially for the young, plausibility is often more compelling than fact, the explanatory power of a sinister theory more satisfying than the circumstances of living in a complex, rapidly shifting world.

While this particular passage refers specifically to the case of racial supremacists, the same argument could be made of religious supremacists including Islamic terrorists who have utilized the Internet for recruitment and organization (Cortese, 2006; Warren, 2007). Terrorism is a manifestation of hate and a consequence of ignorance (in its active sense) at several levels. In the case of Islamic terrorism (and here I dispense with the political correctness of the dubious term "Islamist"), adherents to such philosophies display willful ignorance in their blind acceptance of a particular set of ideas to the exclusion of numerous other peaceful and productive philosophies. The arguments of illiteracy and passive ignorance sometimes used to explain terrorism hold little water in a world of widespread availability of competing ideas. Thus, terrorism and other forms of hate are the results of extreme and active denial of competing ideas—suppressing knowledge that would deny the supremacy of one particular ideology or race over another. Where communities might have one time been relatively isolated and demonization of outsiders a common phenomenon stemming from simple passive ignorance, there is no such justification available today. Acts of hate and violence in the Information Age are more likely the result of selective disinformation cultivated into ideologies of exclusion and strategies of destruction.

Hate groups and terrorist movements alike use the technologies of the Information Age ranging from satellite television to the Internet to promote their philosophies of prejudice and ignorance. By such philosophies, all members of various groups including variously—ethnic minorities, immigrants, homosexuals and even Westerners can be lumped into targets of harassment, denigration or even violence. Information Age technologies are involved in promotion of hateful ideology, recruitment of members and, by some accounts, coordination of violent attacks.

With the global reach of information-age technologies and access to vast information resources, proponents of hate are able to effectively conflate several sets of ideas. In the case of racial supremacists in the United States several investigations have demonstrated the use of Victorian-age racial myths and stereotypes conflated with perversions of Biblical ideas. In the case of Islamic terrorists, political conflicts such as the Israel-Palestine territorial disputes are often conflated with dubious stories from the annals of Islamic history and particularistic interpretations of Qur'anic injunctions. In these ways, extremists, hate-mongers and other similar groups employ the contents

and technologies of the Information Age to create, promote and instill disinformation in their recruits and members while choosing to ignore competing scientific, religious, social and other negations that are equally accessible.

Race in the Information Age

The very concept of race has come into question in the modern times. While it might be tempting to associate such perspectives with the assumed enlightenment of the Information Age, we might well be reminded of statements such as those of Dr. Jacques Loeb, an early 1900s head of the Department of Experimental Biology at the Rockefeller Institute for Medical Research. Writing in the magazine entitled The Crisis in 1914, who asserted that the assumption of race supremacy rests on no scientific ground, writing (1914, p. 92),

> We have heard a good deal about inferior races, the white races being superior, the Negro being inferior, and similar things. Biology has not in a single case been consulted, and if it had been consulted there are no data today to confirm any such sweeping statement. Each character is inherited individually. The pigment of the skin and the shape of the eyes or nose have absolutely nothing to do with the intellectual power.

Important to the present analysis is the fact that the relationships among concepts of race, racism and ignorance are, for some, at the heart of modern analyses of the uses and misuses of information and what has been called the epistemology of ignorance (Mills, 1997). The centrality of race to modern notions of ignorance emerges partly from the work of Charles Mills (1997) in his work entitled The Racial Contract. In first popularizing the term "epistemology of ignorance," Mills (1997) described the so-called racial contract as more than an implicit set of understandings about race in society, suggesting that it is, instead, an invitation to misinterpret and an excuse to agree on not-knowing—ignorance in its active and destructive sense. According to McCann-Mortimer, Augoustinos and Lecouteur (2004, p. 410):

> Like the concept of gender, "race" is entrenched in both popular usage and scientific discourse as a taken-for-granted, essentialist category... European imperialist expansion and colonial rule over indigenous peoples during this period created ideal conditions for the proliferation of essentialist beliefs... Social Darwinism generated a fertile ground for the emergence of scientific racism and, in particular, the empirical investigation of biological and psychological "racial" differences. This research program was vigorously pursued in the U.S. between 1910 and 1940, particularly as "race psychology" came to dominate the concerns of U.S. psychologists. After the 1940s, however,

influential scholarly critiques of scientific racism led to the eventual demise of this research focus.

Notions of the indefensibility of scientific racism evolved over the decades and survived World War II with its emphasis on ideas about racial superiority and the consequent genocide of Jewish populations at the hands of the Nazi regime. In 1950 *Time* magazine quoted a UNESCO report (Time Magazine, 1950) addressing ideas about race and racial superiority:

> The idea of "race" and "racial superiority" has caused a lot of trouble in the world. Last week an international group of distinguished scientists working for UNESCO issued a report on what science knows about this emotional subject... "To most people," said the report, "a race is any group of people whom they choose to describe as a race. Thus many national, religious, geographic, linguistic or cultural groups have, in such loose usage, been called 'race.'" Such groups "do not necessarily coincide with racial groups, and the cultural traits of such groups have no demonstrated genetic connection with racial traits."

By the 1990s Charles Murray and Richard Herrnstein had re-ignited debates on race and racial superiority with the publication of their best-selling title *The Bell Curve* (1994) which suggested an association between race and IQ scores. Subramanian (1995) noted that the publication of the landmark title *The History and Geography of Human Genes* (Cavalli-Sforza, Menozzi, & Piazza, 1994) held the potential to eradicate Murray and Herrnstein's ideas:

> The book's firm conclusion: once the genes for surface traits such as coloration and stature are discounted, the human "races" are remarkably alike under the skin. The variation among individuals is much greater than the differences among groups. In fact, the diversity among individuals is so enormous that the whole concept of race becomes meaningless at the genetic level. The authors say there is "no scientific basis" for theories touting the genetic superiority of any one population over another.

Craig Venter was the chief private scientist involved with the Human Genome Project. McCann-Mortimer, Augoustinos and Lecouteur (2004, p. 411) noted that after the completion of the draft of the human genome Venter claimed the project's work "had demonstrated that 'race' was not a scientifically valid construct." However, they argued that, despite Venter's claims, the idea of race would continue to plague modern society:

> Given the entrenched use of "race" as a commonsense, "natural" category to classify people in both everyday and scientific discourse, it is perhaps not surprising that Venter's statement regarding the scientific illegitimacy of the concept was met with skepticism and incredulity by scientists and members of the public alike. All indications

suggest that the controversy over the scientific legitimacy of "race" will continue well
into the 21st century.

The presence of hate and racial supremacist content on the Internet might
appear to be a relatively ghettoized phenomenon, restricted to particular areas
and found only through deliberate searching for such material. However,
according to Daniels (2009, p. 660), in the aftermath of Hurricane Katrina in
2005, web users could easily (and unknowingly) have navigated their way to
such sites:

> A wide constellation of websites with domain names such as Katrina Families
> (www.katrinafamilies. com) and Parish Donations (www.parishdonations.com) ap-
> peared, featuring digital photos of distressed people in the flooded Gulf Coast region.
> Beyond the digital photographs featuring only white people, the sites contained no
> overtly white supremacist or racist rhetoric and appeared to be legitimate appeals to
> help people in the devastated coastal area. Web traffic to those sites was redirected to
> Internet Donations.org (www.Internetdonations.org), which also appeared to be a
> rather generic site, except for that the fact that the domain name was registered to
> Frank Weltner, a St Louis, MO-based white supremacist.

SEX AND DISINFORMATION

The persistent biases, prejudices, fears and ignorance that are common in
Information Age discourse also apply to major components of the Information
Age itself such as the Internet. Not that fears about new media are a new
phenomenon. In 1909, early in the life of movies, but well after they had
become a popular form of mass entertainment, Jane Addams (1909) blamed
them for various social ills. In particular Addams identified a plot by some
boys who had seen a movie showing a stagecoach ambush who then plotted
and perpetrated such an attack on their local milkman complete with gun and
lasso. Many more years of debate on the perceived deleterious effects of movies
would follow—tinged as they were with elitist class sentiments since this new
form was often popular among largely poor and predominantly immigrant
populations. In 1928 the Payne Fund, a foundation for research on children,
formed the Committee on Educational Research to study the effects of movies
on children. Such fears, complete with their associations of moral corruption
and the need to protect children, returned in the early age of the public
Internet.

On July 3, 1995, the cover of Time magazine featured a graphic of a
child's face staring in horror, behind a computer keyboard with the headline
"CYBERPORN: EXCLUSIVE: A new study shows how pervasive and wild it
really is. Can we protect our kids—and free speech?" In that issue Elmer-
DeWitt, Bloch, Cole and Epperson (1995, p. 38) cited a study entitled

"Marketing Pornography on the Information Superhighway" which they said was authored by a team at Carnegie-Mellon University and was soon to be published in the *Georgetown Law Journal*. That study, according to the *Time* article, found that some 83.5% of images on the then popular Usenet news-groups were pornographic. Stressing the deviance of the images available online and the possibility of access by minors, this article stoked the mounting fears of a population that was both excited and threatened by the relatively new (but already popular) media forms.

A few weeks later Elmer-Dewitt and Dowell (1995, p. 57) reported on the serious concerns that had arisen from the article—not over Cyberporn, but rather questions "regarding the study's methodology, the ethics by which its data were gathered and even its true authorship." They cited independent experts Donna Hoffman and Thomas Novak, Vanderbilt University professors who said that the author, Marty Rimm (who wrote the article while he was an undergraduate student),

> grossly exaggerated the extent of pornography on the Internet by conflating findings from private adult-bulletin-board systems that require credit cards for payments (and are off limits to minors) with those from the public networks (which are not).

According to Elmer-Dewitt and Dowell (1995, p. 57), Hoffman and Novak argued that the figures used in Rimm's study were "either misleading or meaningless":

> for example, the study's now frequently cited claim that 83.5% of the images stored on the Usenet newsgroups are pornographic. Hoffman and Novak maintain that a more telling statistic is that pornographic files represent less than one-half of 1% of all messages posted on the Internet.

The doubts over the study and its author's motivations, while substantial, did not quell the already inflamed fears over the sexualization of the Internet and the dangers to children, which led to several attempts to legislate Internet speech, including the Communications Decency Act and the Child Online Protection Act. McMurdo (1997, p. 81) described the reaction, including the legislative efforts, as being part of what Stanley Cohen (1972) characterized as a "moral panic," writing that,

> The Internet, and in particular its connection in the public mind with pornography, has become the object of just such a moral panic. Typical broadcast reporting often fails to even differentiate whether cases of "pornography on the Internet" are either, on the one hand, instances of publicly accessible material, which young children could happen to view by chance, or on the other hand, instances of individuals using

the Internet to communicate encrypted material privately among themselves, which nobody could happen to view by chance.

Such panic was evident in the U.S. legislature in the months leading up to the passage of the Communications Decency Act. According to Featherly (2003, pp. 76-77), when Vermont Senator Patrick Leahy suggested that the U.S. Department of Justice be given 150 days in which to make a proper study of obscenity on the Internet,

> Exxon responded by arguing that the United States did not have 150 days to wait for a government study while America's children became further defiled by online pornography, nearly half of which, Exxon claimed, depicted the sexual torture of women.

Despite the moral panic and the best efforts of elected officials to curb freedom of expression on the Internet in the name of protecting children, the U.S. Supreme Court upheld the protection of the first amendment instead, with Justice John Paul Stevens noting that "the level of discourse reaching a mailbox simply cannot be limited to that which would be suitable for a sandbox" (Featherly, 2003, p. 77). Later efforts at blanket censorship of the Internet met similar fates.

7

Ignorance Is Good Business

Both knowledge and ignorance figure in the question of social power in the Information Age. Graham (2006, p. 4) argued that the knowledge economy, dependent as it is on the creation and negotiation of meanings, demonstrates the importance of the politics of information, writing:

> The knowledge economy is an economy of meaning. Political economy is the study of how values are produced, exchanged, distributed, and consumed (the economic), and how power is distributed, maintained, and exercised (the political) within particular social and historical contexts. The emergence of a "knowledge economy" in policy is nothing more than a political acknowledgement that certain classes of meaning are privileged; that there are more and less valuable meanings; that access to these meanings is restricted; and that meanings can in fact be owned and exchanged, if not entirely consumed.

Roberts and Armitage (2008, pp. 345–346) took this concept further, suggesting that "the knowledge economy is precisely rooted in the production, distribution, and consumption of ignorance and lack of information" and that both knowledge and ignorance play important roles in the formation of what they called "advanced global capitalism." They argued (p. 345) that "the knowledge economy is at the same time an ignorance economy" and despite improvements in science and production "many such production methods and services are predicated on ignorance-intensive activities, on activities that contribute to a decelerated pace of technoscientific development." They argued (2008, p. 347) that even in the Information Age, specialization leads to the degeneration of knowledge and the promotion of ignorance and that the information and communication technologies, hallmarks of our age, promote ignorance in the following manner:

> Increasing amounts of knowledge are being codified and embedded in information management systems, databases, websites and so on. While this makes the information easily retrievable for those with access to the technologies (and we must remember that many even in the advanced nations have limited or no access), it also leads to the discarding of important tacit elements of knowledge that are not amenable to

codification... the codification of knowledge necessitates choices about which knowledge should be codified. Hence, there is a danger that the knowledge base becomes skewed towards that knowledge valued by those elements of society that have the resources to codify knowledge.

The (dis)Information Age has been characterized by increasingly complex relationships among knowledge, information and commerce. Not only has information increasingly become the focus of the modern economy, it has, at the same time, been increasingly commoditized. Simple examples of paid subscription television, Internet access and database fees could draw our attention to the increasing importance of information as commodity. Despite massive growth in this area, modern industry has faced some challenges with regard to the information-as-commodity question.

INFORMATION AS COMMODITY

For several decades, the modern music industry sold physical copies of music to customers in the form of vinyl discs. Copying technology in the form of audio tape posed some problems to the industry as consumers gained the ability to make tape-recorded copies of vinyl albums and singles. While open-reel tape had provided this ability for some years, its price, size factor and costs limited the spread of its use. However, much cheaper, smaller and easier-to-use audio cassettes soon provided duplication capability to a much broader swath of users. The issue of consumer copying developed into a widespread concern for the music industry and persisted for several years, pitting the industry against its own customers in emerging issues of intellectual property, which Roberts and Armitage (2008) described as one the defining dimensions of ignorance in the knowledge economy. However, the question of content ownership and control was an issue that exploded much more dramatically with the television and movie industries who launched legal challenges to the SONY VCR.

The home video cassette (or video tape) recorder (VCR or VTR) machine was launched in the 1970s. While it was initially slow to diffuse to the broader public, the advantages of being able to temporarily (or permanently) store visual material including television shows and televised movies soon began to catch on. By the early 1980s such uses of the technology so concerned the information industries of television and film that the VCR became the subject of legal action between the manufacturer (SONY) and major film and television studios (SONY *Corporation of America et al. v. Universal City Studios, Inc., et al.*, 1984). The so-called "time-shifting" function (Lin, 2001) not only allowed the information consumer to replicate and essentially control a copy of television material, but, more importantly, challenged the power over content

and time traditionally held by powerful producers, media managers and advertisers (Levy, 1987; Rubin & Bantz, 1987). The powerful media companies, instead of embracing the new technology, tried to destroy it and continue to limit consumer freedoms. Eventually, led in part by the adult sexual content industry (Brummett, 1988; Levy M. R., 1989; Litman & Komiya, 1990), the television and movie studios adopted VCR and later DVD technology for movie and program distribution, eventually making home video their biggest source of revenue. Information as commodity (television shows as advertising income) was therefore not to be trusted to the consumer unless corporate information producers had control over that information and its commoditization—an argument echoed in more recent debates about digital video recorders and their ability to not just time shift, but also to zoom past commercials.

Meanwhile, the music industry had responded to cassette tape technology in the late 1970s and 1980s by providing prerecorded albums on tape, banking on the desirability of high-quality recordings and attractive album art. However, a much more important development would emerge to challenge as symptom and symbol of the Information Age—the digital music file.

The MP3

During the evolution of the personal computer, sound was one of the concerns in the development of what was termed multimedia computing. Several iterations of sound capabilities emerged, with generations of computers in the early 1990s being able to reproduce digital samples. The size of the files required for these early sounds at high quality were prohibitive, particularly given the limited storage space of computers at the time. Sounds were limited to short clips and full songs were impractical in terms of disk space as well as for transmission over relatively slow dial-up modems. The answer would emerge with a new form of compression that would enable entire songs to be stored in much smaller files with little loss of quality. The MP3 audio compression method provided the answer digital audiophiles were searching for. Developed initially at the German Fraunhofer Institute, the standard emerged out of the work of the Motion Picture Experts Group (MPEG) and found popularity as the Internet began to diffuse. Its true impact on the modern Information Age would come some years later in 1999 with the launch of the file-sharing system known as Napster.

The MP3 provided a completely new set of challenges to the music industry. Whereas earlier music copying was largely characterized by low-quality reproductions of music shared among small circles of friends, Napster allowed near-perfect digital copies to be shared among widely flung masses of users

with no revenue to the record companies who owned the rights. Information in the form of music was already a commodity. The challenge of Napster was in the fact that it allowed users to bypass the commodification of this information and share it for free. The music industry responded much like the media companies of the VCR age—by attempting to quash the challenging technology through legal action. Their actions, as in the SONY vs Universal Studios case, demonstrated two types of ignorance. On the one hand, the industry's strategy sought to deny access to information on legal grounds, arguing for a hitherto untested concept of ownership of information. On the other, the industry either failed to recognize the economic potential of engaging the new technologies or deliberately refused to explore its possibilities.

INFORMATION COMMODITIZATION

Central to the cases above, but also central to the development of an Information Age (and its knowledge economy) has been the transformation of information into a commodity. Burke (2000, p. 1) argued that while the particular manifestations of modern information commoditization may be significant, this is not a new idea, but rather one that is "as old as capitalism" itself. He argued that trends towards treating information as a commodity were evident in the early trading and commercial behaviors of China and Europe. Graham (2006, p. 339) noted, however, that there are differences between knowledge and other commodities, writing:

> The idea of the knowledge economy is a challenge to the basic economic principle of scarcity, for once knowledge is consumed, unlike many other commodities, it does not disappear; rather its consumption may result in the development of further knowledge. Additionally, the consumption or use of knowledge is non-rivalrous and may be non-excludable. Furthermore, knowledge is not subject to diminishing returns. Such characteristics present challenges to our ability to measure and assess the value of knowledge, to the establishment of ownership rights over knowledge, and consequently, to its market exchange.

Despite these issues, the Information Age and its knowledge economy have evolved steadily over the years. In the late 1980s and early 1990s early adopters subscribed to so-called information services including America Online and Compuserve—dial-up systems that literally provided information for a price. By that time information was already being bought and sold in many different forms—as it had been for centuries. However, the focus on information as a primary product in and of itself and the focus of the economy were somewhat newer. Graham (2006) argued that in the new knowledge

economy, the main commodity is not so much information but rather meaning. He argued (2006, p. 5) that

> the knowledge economy is about the production, distribution, ownership, and exchange (the commodification) of meanings. To understand the implications of our knowledge economies we need to understand the processes by which meanings are produced, exchanged, and evaluated, and how such processes shape the political character of any given social system... Because a knowledge economy is concerned with the production, distribution, and exchange of knowledge commodities, there emerges an imperative to produce new—or at least seemingly new—knowledge that can be turned into money values.

Beyond what Graham would characterize as "knowledge commodities" newer media forms themselves become commoditized as commerce-enabling devices and platforms. Within the first few years of publicly available Internet connections, advertisers were already experimenting with methods and models for using the Internet for advertising. Net purists resisted the commercialization of the Internet and the Web that advertising would entail—insisting early on that the open and nonproprietary ethos of the ARPANet should be maintained for further development of Internet and Web-based technologies. Yet despite these objections, advertising still made its way to the Net, and with it, increasing commercialization. Foster and McChesney (2011, p. 3) pointed to what they called "the paradox of the Internet as it has developed in a capitalist society":

> The Internet has been subjected, to a significant extent, to the capital accumulation process, which has a clear logic of its own, inimical to much of the democratic potential of digital communication, and that will be ever more so, going forward. What seemed to be an increasingly open public sphere, removed from the world of commodity exchange, seems to be morphing into a private sphere of increasingly closed, proprietary, even monopolistic markets.

In 1995 the *Wall Street Journal* reported (Rigdon, 1995) that even though it might be years before the World Wide Web took off as a "massive shopping mall" advertising revenues were already rolling in, noting at that time that more than 270 companies were spending in excess of 12 million dollars on Web advertising but that its potential was yet to be realized. Despite fears and fluctuations, by 2010 estimates of Internet advertising revenues were in the region of 26 billion dollars. In addition to the volume and value of online advertising that grew during the early years of the 21st century, new dimensions of commercial activity were also constantly evolving.

The advent and popularization of social media presented new opportunities for advertising and marketing online. In 2007 the *Financial Times* (Allison & Van Duyn, 2007, p. 15) reported that

> Mark Zuckerberg, Faceboo"'s 23-year-old founder and chief executive, told hundreds of advertisers and media executives in New York that the social networking site's new technology represented a new era for advertisers, where commercials would be replaced by messages planted in online conversations between friends... Users will be able to become "fans" of a company's page, 10,000 of which were launched last night... Anything they do on the page, such as reviewing a product, would then be communicated to that user's friends and accompanied by a logo, creating "social ads."

At the same time, Zuckerberg also announced plans for technologies that would track users' purchases on other websites, and then report those to their friends on Facebook. Despite the ominous connotations of both messages planted in online conversations and the reporting of data on external web activities and purchases, social media indicators have still caught on as supplemental forms of information commodification/commoditization. Facebook "likes" and other social media indicators such as followers on Twitter are increasingly being used as measures of commercial success which, while not necessarily directly monetized, present evidence for advertiser spending and reach.

INFORMATION, CULTURAL DNA AND RECYCLING

To build on Graham's afterthought of the "seemingly new" dimension of information mentioned above, we may examine the notions of cultural DNA and recycling. With some guarded reference to the larger body of what is sometimes called "evolutionary culture theory," (Durham, 1990) information products may be conceived as recombinant cultural DNA, being constantly recycled into modified forms. These evolutions of form are frequently represented to consuming audiences either as retro-fashion or simply as new items even though they may be remakes or direct replications of earlier information commodities. The massive flow of information can mask information and awareness of older forms, working to enable remakes and recastings of old information as new.

The notion of the remake or adaptation is certainly not a new phenomenon. Chopoidalo (2009, p. 1) has noted, for example, that

> the processes of adaptation, whether in creating a play from a narrative source text, preparing a play text for performance, translating a text from one language to another, altering a text from one culture to fit better with another culture's literary conventions, or creating a new text as a reply to an earlier one, permeate virtually every aspect

of the study of Shakespeare's plays and their reception by audiences and readers from the time of their first performances to the present day.

Whether one considers the numerous adaptations of Shakespeare or the notion that Shakespeare himself was responsible for adapting the work of earlier writers such as Thomas Kyd, the concept of cultural adaptation and re-making has been with us for centuries. Whereas previous generations may have seen remakes and adaptations being associated with cultural reproductions, the modern Information Age is also concerned with capital reproduction. Some elements of past cultural forms enjoy explicit re-making (i.e., adaptations that give due credit to their original inspirations). Lanier (2010) placed several film adaptations of Shakespeare films in this category of recognized adaptations, noting the importance of the high-culture associations of Shakespeare. Similarly, Buhler (2002, p. 243) noted:

> Romeo and Juliet are ubiquitous figures in popular and mass-market culture and have been for well over a century, perhaps for as long as marketing strategies have appropriated from works increasingly set as "high culture".

However, the modern context of the remake or adaptation may often involve little or no recognition of the original form in an attempt to present the remake as wholly original. Thus the wholesale reproduction of old information as new enables information producers to capitalize on commodities that would otherwise have expended their capacity to create value. As Leitch (2002, p. 40) has noted:

> A remake's very status as a remake presupposes audiences who come to it with broadly incompatible backgrounds which encourage different wishes and expectations. The remake aims to please each of these audiences: the audience that has never heard of the original film it is based on, the audience that has heard of the film but not seen it, the audience that has seen it but does not remember it, the audience that has seen it but liked it little enough to hope for an improvement, and the audience that has seen it and enjoyed it.

With the evolution of the Information Age has come an accumulation of content so great that more and more audience members may now fall into Leitch's first category of those who have never heard of the original. The sheer volumes of information and media productions being produced also reduce the life cycles and the reproductive cycles of media content. This means that remakes of songs and movies can be produced more quickly after their originals since the market is quickly flooded by many other products in the time in-between the two versions.

An added dimension of this recycling is the use of digital-era enhancements such as special effects. The producers of remade films may create a product that is very different from the original, but which relies less on narrative creativity (for example, simply reproduces the original narrative) and more on visual stimulus for effect. Remakes are rarely exactly the same as originals. A few shot-for-shot remakes have attempted to reconstruct faithful renditions, but most involve evolutionary developments of form or function which are then commoditized, usually implicitly, as new. Leitch (2002, p. 40) has argued that in the great majority of remakes: "the revisionary impulse is subordinated to the goal of increasing the audience by marginalizing the old film, reducing it to the status of the unseen classic."

Subtle approaches to this recommoditization include retitling of re-makes to break the connection with previous iterations—such as in the case of the 2007 movie *I Am Legend* (Lawrence, 2007). This particular 2007 film was an adaptation of a novel called *The Omega Man* (Matheson, 1954). However, several intermediate adaptations and remakes filled the years between the original novel and the most recent film. Matheson's novel was adapted as *The Last Man on Earth* (Ragona & Salkow, 1964) and further adapted and remade as *The Omega Man* (Sagal, 1971) before again being remade as the 2007 *I Am Legend* (which was accompanied by a copycat direct-to-video release called *I Am Omega* [Furst, 2007]). Thus the connection to the original source material is revealed only after several intermediate generations and retellings have had their chance to earn income—by which time the connection seems less important than the success of the new form.

Within this scope of analysis we may also consider multiple commoditization as a form of extension of information value. Whereas recommoditization utilizes different evolutions of cultural expressions over time, multiple commoditization utilizes diverse manifestations of the same commodities (e.g., graphic novels or comic books made into films) and thematic variations of major expressions and symbols (such as may be found in accompanying websites or merchandising). This extension of an intellectual property such as a film into physical properties, complete with systems of licensing to ensure control of revenues has become a hallmark of the information economics of the Information Age. What is perhaps somewhat more disconcerting in this mix of intellectual and physical property production is the involvement of national and international government resources to enforce producer rights—usually being the rights of the largest and most powerful media corporations in the world. In that process, major information producers increasingly wield greater and greater power over content and the users' ability to use such content. In the context of "prosumption" or the simultaneous production and

consumption of content by users (who often borrow elements from the major producers of media materials) Collins (2010, p. 45) was among those reminding us of the need to balance copyright protections with user rights, noting:

> Copyright law in the U.S.A draws its authority from the constitutional mandate to "promote the progress." In contemporary times, this is usually taken to mean that the grant of a limited monopoly—a securing of rights to exploit a work—is awarded to generate an incentive to create, the rationale being that creators would be less likely to produce works if no means existed to prevent piracy and free-riding. Rewarding the author, however, is only a secondary consideration; the incentive to create is a means to an end. The primary objective of copyright is to furnish society with creative works

Commoditization is aided by strategic uses of disinformation and ignorance. In some senses all of advertising may be considered fundamentally disinforming—creating not only biased impressions of particular products and services but also conditioning strategic ignorance of competing products and ideas. Advertising has, over many decades and with the support of large capital investments, created the social acceptability of falsehoods and fantasies in promoting the sale and consumption of both information and traditional products. Strategic ignorance can also be found in the selective presentation and withholding of information in advertising—information is presented that is beneficial to sales. Some information is withheld passively (such as the failings of the product—or the existence of several previous versions) except where mandated by law (as in drug advertising in the United States). Other information is creatively disguised or withheld such as with the use of fine print—or referrals to detailed statements increasingly stowed away on a website that viewers are directed to consult.

CONSUMER INFORMATION AS COMMODITY

Beyond the trade in various aspects of information as content, the Information Age has also seen the development of another information product—consumer data sets—largely based on technology-based surveillance methods. Clarke (1988, p. 500) used the term "dataveillance" to describe such "systematic monitoring of people's actions or communications through the application of information technology" (also cited in Fuchs, 2011). Michel Foucault (1977, p. 200) described surveillance as an objectification of the person under scrutiny: "He is seen, but he does not see; he is the object of information, never a subject in communication." Palmås (2011, p. 347) took a Foucaultian perspective on corporations in the Information Age, arguing that major corporate players exercise power on the one hand through their ability to "control and police the spread of competitive knowledge" and on the other, to

exploit economies of scale based on what he termed the "panspectric concate-nation of digitalization of behaviors and data mining." This latter phenome-non involves both the collection of increasingly diverse data sets through the surveillance of purchasing decisions and other behaviors and even the genera-tion of predictions based on such data. Manzerolle and Smeltzer (2011) argued that the customer surveillance associated with the generation of these data-bases undermines customer sovereignty (an essential component of free markets) and introduces inequities of information power into the market, writing (p. 324):

> The explosion of consumer data has created a market value—indeed, an entire indus-try—for any type of personal information that might be useful for trying to anticipate, steer, or exploit consumer behavior. In so doing, this intensifying feedback loop of consumer information circumvents the supposed neutrality of market exchanges by creating and exacerbating informational asymmetries between sellers and buyers... As a result, consumer databases not only serve to create a proxy or model for consumer behavior of market exchanges, they also provide the basis for the commodification and sale of consumer identity as a "body" of information.

Thus while this form of information commoditization is increasingly wide-spread and even seen as necessary, it both dehumanizes and disadvantages the consumer while working counter to the ideals of the free market. Classical economic theory posits a theoretical situation called perfect competition in which (among other conditions) consumers enjoy complete information about the market. In the context of varied sources of information on prices and availability of commodities, one may be tempted to imagine consumers with perfect information who could navigate the market with perfect efficiency. Yet, consumers are ultimately not empowered by their ease of market information since data sets derived from surveillance work to erode any advantages and return them to relative ignorance even as to what aspects of their behaviors corporate marketers may be in a position to manipulate and exploit.

COMMODITY INFORMATIZATION

Information commoditization in its various forms has been accompanied by the less obvious notion of what we may call "commodity informatization." Commodity informatization may be described as the introduction of informa-tion dimensions as enhancements to previously existing (primarily non-information) commodities. Not only do modern automobiles feature ostensi-ble information systems and services such as satellite-linked navigation or concierge systems, they also feature a wide range of less obvious information capabilities. With fairly standard on-board diagnostics and engine control

computers, the modern automobile is increasingly informationized with communications capabilities such as telephone and video systems. Telephones, initially person-to-person communication devices, now provide a wide range of information services and are marketed on the basis of these abilities. Televisions are now Internet connected, washing machines are Internet connected, and with a mobile app, one can even automate a home or unlock a car remotely.

THE U.S. RADIO BUSINESS AND IGNORANCE

Among the businesses that have benefitted most from (and traded most in) ignorance in our Information Age is the set of media outlets collectively known as "talk radio" in the United States. An amalgam of local and syndicated broadcasts, this phenomenon emerged over a period of years but has its roots in the very early uses of radio for both public discussions and political debate. Among the precipitating conditions leading to the success of U.S. talk radio were the migration of stations to FM for its improved music quality during the 1970s and 1980s (which left AM stations to focus on news and talk programming), consolidation of radio station ownership in the 1990s and the phenomenal success of particular shows such as the Rush Limbaugh radio program over recent decades. Steuter and Wills (2009, p. 133) described the rise of talk radio in the following terms:

> Talk radio's audience increased dramatically over the last two decades of the twentieth century. Between 1980 and 1998, the number of programs increased from 75 to 1,350... A shift in population demographics also played a role, since as people age, studies show, they begin to prefer talk to music programming. Technological advances also contributed; inexpensive 800 numbers, cell phones, and satellite communications made the call-in format more accessible, while nationwide syndication provided stations with relatively low cost programming.

Hofstetter et al. (1999, pp. 355–356), examining what they called "Information, Misinformation, and Political Talk Radio" noted that "despite enhancing the level of political information among audiences, political talk radio may also increase political misinformation among the same groups," explaining:

> Frequency of exposure to conservative talk radio displays a significant negative correlation with political information, indicating that although conservative talk radio listeners are more interested in politics, read the newspaper more often, and are more likely to vote, they are less likely to hold accurate beliefs even regarding non-ideological facts (such as which branch of government determines the constitutionality of a law).

Beyond simple political misinformation, however, Steuter and Wills (2009, p. 131) are among those who have identified talk radio and its rhetoric with the promulgation and institutionalization of hate speech in several forms which reaches millions of listeners every day, noting that "popular right-wing talk show hosts broadcast inflammatory rhetoric daily, abusing and demonizing minorities, environmentalists, liberal politicians and government social programs." They argued (2009, p. 132) that while radio remains the primary vehicle, these programs have spread their particular brands of rhetoric to other media as well:

> Violent inflammatory speech has become a staple of several talk radio shows that have risen to prominence over the last decade. The hosts of these programs are profoundly influential in shaping opinion among the documented 100 million Americans who listen regularly. Their messages are widely broadcast on more than 1200 radio stations and are available on the Internet, satellite radio, and television. Some, like Bill O'Reilly, have programs on both television and radio stations. Commentaries by big-name hosts draw big ratings and, for the station's corporate owners, translate to big money from advertisers and profits for shareholders.

The most successful of the figures in this industry has been political commentator Rush Limbaugh, whose loyal followers have established and maintained his number one position for several decades despite the fact that as Nicola (2010, p. 281) noted, he is a college dropout and a failed disc jockey. So popular is Limbaugh in conservative circles that not only is he a frequent fixture at major political events but his name is regularly called with reference to conservative leadership contention. His program has been widely studied and is considered one of the major influences in modern U.S. politics. At the most basic level of analysis, Limbaugh's discourse would invite the label of ignorance if only for its tendency to provide what Lee and Capella (2001, p. 386) characterized as "one-sided information" thereby deliberately concealing alternative views. However, the ignorance promoted by Limbaugh's program also includes a number of more active and virulent dimensions of disinformation and misinformation couched as views on issues such as race and gender.

As political commentary goes, Limbaugh's daily program features all of the expected criticisms of liberal politicians along with the character attacks and policy jabs that characterize modern political speech that Nicola (2010) characterized as being primarily political theater. Misinformation and disinformation might be considered par for the course in such political commentary, and audiences tune in for exaggerated representations of the politics of the opposing side, glowing reviews of favored policies and even critiques of conservatives for not being sufficiently faithful to Limbaugh's particular vision of conservatism. Yet at the microphone and off-air, Limbaugh has been known

to push the envelope of free speech in other ways, using the airwaves, for example, to denigrate Michael J. Fox and to cast doubt on the effects of the actor's Parkinson's disease. Among the many instances of ignorance in the form of racist speech on Limbaugh's program, the *Journal of Blacks in Higher Education* (Anonymous, 2009, p. 15) has listed the following:

> In the 1970s Limbaugh told a black caller to his radio show, "Take that bone out of your nose and call me back."... Limbaugh said that the NAACP "should get a liquor store and practice robberies."... Limbaugh told his listeners, "Let's face it, we didn't have slavery in this country for over 100 years because it was a bad thing. Quite the opposite; slavery built the South. It had its merits. For one thing, the streets were safer after dark." ... Limbaugh said..."You know who deserves a posthumous Medal of Honor? James Earl Ray. We miss you, James. Godspeed."

Despite these and many more instances of racially charged discourse on his program including thinly veiled disparaging of presidential candidate and President Barack Obama, Limbaugh seems to be able to escape serious social, economic or political consequence in the conservative talk-radio universe. Nicola (2010, p. 295) has explained this phenomenon thusly:

> Attacks on Limbaugh's merrily blatant racist discourse reinforce the message: liberals are humorless; liberals are language police; worse—liberals are thought police; liberals are hypocrites who can indulge their own racism at length but who won't permit even the most innocuous mention of race to cross conservative lips unchallenged... Limbaugh emerges from these skirmishes over explicit racial appeals not only unscathed, but stronger...

Limbaugh, who regularly refers to the National Organization for Women and feminists in general as fascists and "feminazis" (Elgin, 1995) is far from being the only one making such statements and is not even the most intensely ignorance-promoting character on talk radio. Steuter and Wills (2009, p. 140) are among a wide range of analysts who have suggested that the broader talk radio industry is replete with programming that prominently features ignorance in the form of biased denigration of "the other," writing that "millions of Americans and, thanks to streaming audio, people around the world, tune in for a daily diet of right-wing talk radio that is overwhelmingly racist, homophobic, and anti immigrant." Giroux (2006, p. 173) similarly wrote of

> the rampant sexism, the homophobia, and a resurgent racism taking place in the United States coupled with the language of hate and scapegoating that spews forth daily on talk radio and from infamous conservative talking heads such as Ann Coulter, Rush Limbaugh, and Michael Savage, all of whom reflect a disdain for human rights...

Michael Savage, by some accounts rating as the third or fourth most popular personality on U.S. talk radio has referred to Iraqi civilians as vermin and scum (Media Matters for America, 2006) among his many other statements of ignorance couched as denigration of various non-dominant social groups. Fost (2003, p. E1) listed several of Savage's notable excursions into promoting intolerance including the following:

–On U.S. propaganda in World War II, including cartoons mocking Germans and Japanese, and how a similar effort is needed today: "We need racist stereotypes right now of our enemy in order to encourage our warriors to kill the enemy..."

–On welfare mothers: "Welfare mothers should be put on Norplant until they can support themselves. Otherwise they have no right to have a baby... Where is it written that welfare mothers have the right to knock babies out like puppies?"

Perhaps the most notable of Michael Savage's (born Michael Weiner) statements emanated from his very short stint on television before MSNBC fired him over his treatment of a caller. Johnson (2003, p. D5) recounted the incident in the following terms:

"Oh, you're one of the sodomites," Savage said. "You should only get AIDS and die, you pig. How's that? Why don't you see if you can sue me, you pig. You got nothing better than to put me down, you piece of garbage. You have got nothing to do today, go eat a sausage and choke on it."

In 2008, a release from ADA Watch and the National Coalition for Disability Rights (PR Newswire, 2008) called for Savage's firing over his attacks on persons with disabilities which had included calling children with autism "frauds" and "brats" as well as a litany of other examples including his statements to the effect that

high levels of asthma impacting minority children were because "the children got extra welfare if they were disabled"... The "handicapped" workers at the Phoenix Cafe would "drool" and put dung in diners' food... Members of the disability rights community are the "Wheelchair Mafia"... The Americans with Disabilities Act (ADA)... should be called the "Lawyers' Improvement Act"... When he was younger, he "touched the hand of a midget [Dwarf]," it really "freaked him out" and, since that episode, he doesn't like public places.

Steuter and Wills (2009, p. 141) have argued that the content of talk radio involves what they characterized as the "transference of hatred from ideas to people" which "can be linked to real action" noting an example from Kalispell in Montana:

A local talk show host on KGEZ began a tirade against environmentalists and conservationists, blaming them for the loss of forestry and aluminum industry jobs in the community. Verbally linking them to al-Qaeda, he read out their names and addresses on air... [they] found their cars vandalized and received harassing phone calls. When some concerned residents spoke out against the attack by the radio host they, too, were named on-air and became in turn targets of abuse. Law enforcement officials were contacted and urged to look at the harassment... a direct link was found between the harassment and the broadcasts.

AUTOINTOXICATION, SCIENCE AND IGNORANCE

In numerous fashion and lifestyle magazines, television infomercials and supermarket aisle posters, in the United States and elsewhere, consumers are encouraged to "detoxify" their stomachs, or bodies, or "systems." Many substances that are toxic to the human body may actually be found in the human body. These substances, such as carbon dioxide, are routinely and usually quite easily expelled by the body in normal metabolic and excretory processes. While serious medical conditions can be precipitated by the pathological accumulation of toxic substances, the notion that the body routinely accumulates harmful toxins and that overall health can be improved by somehow enhancing the excretion of toxins (known in medical literature as "autointoxication") has become big business.

The venerable *Redbook* publication (Redbook, 2009) points to Oprah Winfrey as a driving force behind the popularity of so-called detoxification:

No one knows how to start a fad quite like Oprah. Ever since she did her 21-day cleanse last year, women have been signing up for detox diets that claim not only to rid the body of toxins but also to help you lose weight in the process... Oprah's diet, which cut out caffeine, sugar, alcohol, gluten, and animal products, isn't as extreme as programs like the Master Cleanse, which replaces food with a lemonade-like concoction for up to 10 days.

While noting that dieticians do not generally approve of detox or cleansing diets, the magazine excuses Oprah's cleanse or detox approach because it recommends fruit, vegetables and whole grains. There is more at play in the larger scope of the detoxification business, however, and much of it demonstrates clearly how ignorance is good for business. The history of this particular manifestation of ignorance in the Information Age predates Oprah's endorsements.

Ernst (1997) noted that the idea of autointoxication is an ancient one found in several cultures and echoed as a dominant idea in European medicine of the 19th century. Following in the tradition was a propensity to blame any number of conditions such as fatigue, depression, headache and epilepsy

on the presence of toxins in the body and a proclivity to treat this perceived imbalance or toxicity with any number of treatments including pills and evacuative enemas as well as "retentive enemas" (in which fluids such as honey, wine and tobacco were introduced into the body). Ernst also noted the rise in colonic therapies in the 1990s including, notably, coffee enemas following in the autointoxication tradition. Despite official condemnation of the concept of autointoxication and its related treatments by the American Medical Association at the turn of the twentieth century, Ernst (1997, p. 198) argued in 1997 that "false claims, a lack of evidence, big money, aggressive advertising, disregard of risk" characterized the continuing promotion of treatments for autointoxication which he called a "triumph of ignorance."

Despite the availability of sound information to indicate that the ancient ideas of autointoxication and the related "cure" of detoxification diets or procedures are either simply unsound or potentially dangerous, the notion of detoxification and the sales of detoxification diets and procedures have skyrocketed. The trade is not limited to pills either, as much of the business in the detoxification industry derives from information in forms such as magazine articles and website content. In the book *Detox Diets for Dummies*, for example, Wootan and Phillips (2010) argue that removing toxins from your body (presumably through the dieting that they recommend) can lead to increasing energy, boosting immune function (under which heading they make an oblique reference to improving the body's ability to kill cancer cells), managing stress and decreasing fat.

So pervasive are the detoxification myths that the UK-based public interest group called Sense About Science undertook a study of a cross-section of the products and procedures in 2008. Based on that study, BBC News reported (2009):

> There is no evidence that products widely promoted to help the body "detox" work, scientists warn... The charitable trust Sense About Science reviewed 15 products, from bottled water to face scrub, and found many detox claims were meaningless."

UK authorities were also reported to be concerned about the claims being made by advertisers of detoxification products.

In the United States many of these detoxification products and procedures are shielded from official censure by the use of the "dietary supplement" label. This label, plus very creative product labeling which avoids specific health claims have been used to circumvent lawsuits and official action. Yet, not all detox products have been able to exercise this impunity. In January, 2009 the Federal Trade Commission in the United States announced that it had charged the marketers of a product known as the Kinoki Foot Pads with

deceptive advertising. These pads and several variants of them surfaced on the U.S. market some months before along with television advertising that claimed that attached overnight to the soles of the feet, the pads would draw toxins out of the body. The proof offered in the television advertising was that the pads went on clean and white but changed to a soiled greenish brown hue by morning—the claim (or at least the implication) being that the soiled area was sullied by the presumed toxins that had been drawn through the skin out of the body of the user. In the specific case of the Kinoki pads, the advertising also claimed to treat several medical conditions such as high blood pressure, depression and to help users lose weight. According to the FTC press release (Federal Trade Commission, 2009):

> In its complaint, the FTC charges that all the advertising claims either are false or did not have evidence to support them when they were made. The FTC seeks to bar the defendants permanently from deceptively marketing the foot pads. The FTC also asks the court to order the defendants to provide monetary redress to consumers or otherwise give up their ill-gotten gains... The Commission filed the complaint against the company marketing the footpads and two of its principals. According to the complaint, the defendants marketed Kinoki Foot Pads with deceptive advertisements on television and the Internet... In advertisements, the defendants claimed that if consumers applied the Kinoki Foot Pads to the soles of their feet at night, they could remove heavy metals, metabolic wastes, toxins, parasites, chemicals, and cellulite from their bodies. In addition, the advertisements claimed that use of the foot pads could treat depression, fatigue, diabetes, arthritis, high blood pressure, and a weakened immune system. The complaint also states that the defendants falsely claimed to have scientific proof that the foot pads removed toxic materials from the body.

Ionized Water and Other Cures

Not all such claims end up under FTC or other official scrutiny. Several companies also market various varieties of "ionized" or "alkaline" water that claim to have detoxification and curative properties. Using the technologies of the Information Age, these bottles of water and the devices used to generate them are marketed on the Internet with consumers often being recruited as resellers of the water or preparation devices. Some websites claim that this water flushes toxins out of the body, reverses the effects of aging and produces several other health benefits because of such purported properties as hexagonal-structure and micro-clustering. Testimonials on some sites from customers include one from a "chronic fatique" (sic) patient (presumably someone who suffers from Chronic Fatigue Syndrome) describing her as "not tired anymore" after drinking the water for ten days. Websites touting these products and devices include not only online video testimonials but also live

chat interfaces through which one can discuss the benefits of the water with an online "expert" and links to social media connections.

Based quite loosely on some scientific investigations into the properties of what is sometimes called electrolyzed water or electrolyzed alkaline water (EAW), the health claims made by the marketers of alkaline or ionized water extrapolate health benefits that are generally neither proven nor even scientifically investigated. The customers who invest in such devices claim that the water reduces the pH of their bodies (an interesting claim in itself) and some swear that they have been cured of serious diseases by this therapy.

This sort of quackery could be, and indeed was, spread in ages prior to ours. Despite the fact our Information Age provides the means to debunk such myths and therefore should result in more informed (and even skeptical) consumers, the confluence of business and disinformation thrives on the Internet and on traditional media—arguably with more power for their increased speed and connectivity.

TELEVISION, LEARNING AND QUACKERY

As the lessons of the use of radio have indicated, the so-called "new media" hold no monopoly on disinformation and ignorance. Though primarily characterized by the newest media forms, the present Information Age continues to build on the power of more traditional mass media in the forms of print, radio and television. Consequently, the business of quackery, predicated on ignorance and falsehoods has not depended solely on the newest of media for its success in the Information Age. The famous broadcaster Edward R. Murrow noted television's power to teach, but within recent times, even the television, has acted as a vehicle for the promotion of ignorance.

According to King (2000, p. 228): "The educational possibilities offered by television were recognized almost from the beginning. Research into the most effective uses of television in the classroom began in earnest in the early 1950s." By the 1960's Kime and Gillespie (1967) had evaluated the use of television in the educational context with some insights into the challenges faced by educators and suggest what they called oblique methods of television-based instruction, though they still perceived classroom television as a separate domain from ordinary television that would be experienced in the home. Outside of the classroom situation, mainstream television has served as a tool of education for the general public both in terms of news and current affairs as well as more general education through the presentation of vicarious experiences.

Bridging the gap between classroom and mainstream television started with such notable examples as *Sesame Street* and *The Electric Company* in the late 1960s. Though television in the United States is primarily driven by private commercial interests, it has not been completely devoid of legislative attempts to influence content. Kunkel (1998) has traced the legislative agenda to the work of a small group of activists called Action for Children's Television. This group, formed (by some accounts) either in 1968 or 1969, was outraged by the perceived use of television as a vehicle for marketing toys and other products to children, who were ill-equipped to comprehend the manipulative techniques being employed on children's programming and advertising. In addition to their advocacy activities, Action for Children's Television sponsored empirical research including several studies by a researcher named F. Earle Barcus, who found in 1972 that the amount of non-program content in children's television was about a third more than the non-program content in prime time programming (Berne, Condry, & Scheibe, 1988).

Kunkel (1998) noted that after the Action for Children's Television group demanded one hour of educational children's programming be included in each programming day for television stations in the U.S., the FCC embraced the idea in the early '70s but held off from making any actual rules to encourage or require steps toward this goal—opting instead for industry self-regulation to achieve this end—with poor results. As Kunkel (1998, pp. 40–41) wrote: "Several years later, it was apparent that the industry had failed to respond to the FCC's call for improvements" and "congress reacted to the situation by passing legislation known as the Children's Television Act (CTA), first in 1988 approving a version that was ultimately vetoed and then two years later enacting the Children's Television Act of 1990, which became law."

More recently Discovery Networks demonstrated that educational content aimed at adults via commercial television could also be successful, although even in this case, ignorance has threatened to overrun information. Writing in the Washington Post on Discovery's acquisition of the Learning Channel in 1991, Day (1991, p. F3) described the Discovery Channel as "the Bethesda-based cable network that's turned educational programming into an entertainment gold mine." Since that time, what is now known as Discovery Networks has expanded into a global force in factual programming, facing the challenges of a global market as well as evolving technologies. The influence of Information Age technologies on the framing and discussion of science has itself been problematic for channels such as those owned and operated by Discovery Networks and the National Geographic television outlets. Metz (2008, p. 334) analyzed what she termed "subjunctive" documentary production in which the new media form known as "computer-generated imagery" or

CGI is used to supplement production visuals in productions such as Discovery's "Walking with Dinosaurs." Metz (2008, p. 334) asserted that with the use of these technologies "the television documentary has strayed into a highly fictive, and problematic, territory" holding negative implications for the representation of science, since

> the need for drama in science documentary, coupled with the advent of computer-generated imaging (CGI) technology, has led to the development of almost completely fiction-driven science documentary... These subjunctive documentaries are profoundly aggressive in their insistence that the fictions they are "documenting" not only could be real but truly are real, because CGI has made them so. In a matter of years, the form has matured quickly, from using CGI as an illustrative tool to creating images so compelling that the need to attend to the factual basis underlying the image has become secondary.

Beyond the use of illustrative CGI technologies, another instructive example of television's role in the degeneration of science, information and education in favor of ignorance and disinformation may be found in the evolution of what was once known as The Learning Channel but is now known simply as TLC. Edgecliffe–Johnson and Fenton (2010, p. 17) described TLC as "the female-focused television channel best known in the U.S. for Jon & Kate Plus 8, a controversial reality show about a couple with eight children" and noted that "once called The Learning Channel, TLC has been repositioned in the past two years... to reverse a steep drop in ratings." Despite promising revenues and some success in the 1980s, this and other learning-based networks have been forced into low-budget reality programming to sustain viewership.

Outside of the (former) educational channels, television also serves as the main conduit for promotion of ignorance in the form of infomercials—for individual products as well as serving to promote sales of books and other media. One of the most famous instances of this is the case of Kevin Trudeau, who, after being prevented from selling various medically oriented items and supplements by court order, proceeded to sell books claiming to contain natural miracle cures that some unspecified "they" were apparently suppressing.

Writing in the *Mississippi Law Journal*, Bryant Bell (2010, p. 1044) described Trudeau's multi–faceted commercial ignorance promoting activities in the following manner:

> This convicted felon has been remarkably successful doing infomercials for everything from how to achieve a photographic memory to how to cure your addictions to how to beat cancer by ingesting a particular type of calcium that, as fate would have it, he

also happened to sell. In fact, he is so slick that he could sell you the shirt off of your own back, and you would walk away beaming over the great deal you just got. Trudeau's fortune, of which the exact amount is unknown, has been made by selling modern snake oil that has been swallowed by millions.

Following a 37-million-dollar judgment against him in 2004, Trudeau settled actions brought against him by the Federal Trade Commission. The terms of the settlement, as explained in an FTC press release dated September 7, 2004 (Federal Trade Commission, 2007a), demonstrated something of the scope of the information richness of Trudeau's disinformation empire:

> A Federal Trade Commission settlement with Kevin Trudeau—a prolific marketer who has either appeared in or produced hundreds of infomercials—broadly bans him from appearing in, producing, or disseminating future infomercials that advertise any type of product, service, or program to the public, except for truthful infomercials for informational publications. In addition, Trudeau cannot make disease or health benefits claims for any type of product, service, or program in any advertising, including print, radio, Internet, television, and direct mail solicitations, regardless of the format and duration.

Lydia Parnes, the Acting Director of the FTC's Bureau of Consumer Protection referred to Trudeau's enterprise in 2004 as "an infomercial empire that has misled American consumers for years" (Federal Trade Commission, 2007a, para. 3).

One might imagine that with such a comprehensive ban and other substantial fines included in the settlement Trudeau might have disappeared from television, the Internet and book production altogether. However, Trudeau surfaced again in several other guises and proceeded to write and promote a weight-loss book in 2007. In September of that year, the Federal Trade Commission charged Kevin Trudeau with violating the previous agreement by misrepresenting the contents of his book, *The Weight Loss Cure "They" Don't Want You to Know About*, alleging (Federal Trade Commission, 2007b, para. 1) that

> Trudeau claims that the weight loss plan outlined in the book is easy to do, can be done at home, and ultimately allows readers to eat whatever they want. However, when consumers purchase the book, they find it describes a complex, grueling plan that requires severe dieting, daily injections of a prescription drug that consumers cannot easily get, and lifelong dietary restrictions.

Trudeau's record of spreading disinformation and the response of the FTC might well make the case for the severity of the problem of disinformation and the spread of ignorance in the Information Age. However, in today's

globalized Information Age, the freedom to spread misinformation and ignorance often spreads beyond traditional national borders. This international scope becomes evident from the FTC's 2007 press release:

> In court documents, the FTC pointed out that one required phase of the protocol requires that consumers get daily injections of a prescription drug that is not approved by the United States Food and Drug Administration for weight loss. To obtain the drug, *a consumer would need to either go overseas*, or find a doctor in the U.S. who will prescribe the drug for off-label use (emphasis added). (Federal Trade Commission, 2007b, para. 4)

The particular substance referred to somewhat obliquely in the complaint is a hormone known as Human Chorionic Gonadotropin (hCG), a chemical that most people encounter when discussing pregnancy tests, as it is found in the urine of pregnant women. The hCG weight-loss approach had been discredited in the medical community several decades before being promoted in Trudeau's book of 2007. For example, Greenway and Bray (1977, p. 461) concluded from a double-blind randomized trial of injections of either hCG or a placebo that

> weight loss was identical between the two groups, and there was no evidence for differential effects on hunger, mood or localized body measurements. Placebo injections, therefore, appear to be as effective as hCG in the treatment of obesity.

This was among 14 studies with the same finding according to Time magazine (Szalavitz, 2011) that noted the rise in hCG diet and injection activity in the United States in 2011, suggesting that

> some doctors will actually give injections of hCG, but many people take hCG pills, which are sold online—illegally, according to the FDA—for use in this diet. There's even less evidence for the effectiveness of pills than the injections, however, and it's impossible to know whether the pills actually even contain hCG.

The Federal Trade Commission (FTC) and the Food and Drug Administration (FDA) are U.S. agencies with little influence outside of the United States, and Trudeau's resurrection of the idea of hCG for weight loss created international concerns. While the FTC complaint hinted at the problem of Americans traveling abroad to obtain the injections, it did not address another issue—the spread of this approach in foreign countries. Despite the dangers of this approach and broad medical and official condemnation, anecdotal evidence suggests that hCG weight loss treatments are becoming increasingly popular in several countries. A UK-based physician, for example, wrote to a newspaper in the small Caribbean island-nation of Trinidad and Tobago to

address reports of illegal use of the treatment (Guardian Media Limited, 2011), writing:

> I would like to inform the public that there is no sure way to weight loss except by commitment, diet and exercise. There is an illegal trade in T&T whereby some of my older medical colleagues have informed me that patients are receiving a female pregnancy hormone injection called human chorionic gonadotropin (hCG) as a sure way to lose weight... This is in breach of several laws and standards including the FDA (U.S.A.), the local drug authority, and the Advertising Standards Authority.

In 2009, when economic conditions in the United States were particularly bad and many Americans faced debt challenges, Trudeau could be found promoting his new book *Free Money "They" Don't Want You to Know About* on television infomercial slots. Citing the various legal rulings and government actions against him as ammunition, Trudeau has played the victim and repeatedly asserted his First Amendment rights while using television and the Internet to promote his books and simultaneously raise the specter of government persecution. According to Bryant Bell (2010, p. 1067),

> The FTC has attempted holding Trudeau in contempt for violating past settlements or court orders, has issued more injunctions against him, and fined him for millions of dollars. But nothing is stopping Trudeau from misleading the nation through his infomercials and books.

The Trudeau empire bears strong testimony to the spread and persistence of ignorance in the Information Age. Combined with the apparent impotence of the authorities to effectively thwart such disinformation, this and the other examples above do indeed suggest that ignorance is good for business.

SHADY BUSINESS

The Disinformation Age has also been a boon for scammers of various types and nationalities. As Brenner (2010, p. 83) noted, "fraud has exploded in cyberspace." Cohen (2003, p. 19) noted that "criminals have adopted the Internet because of its increased efficiency in facilitating the business processes of the criminal enterprise" and pointed out that "their gains in productivity are among the great success stories of the Internet, and many in corporations only wish they could achieve the same level of efficiency."

Shady business on the Internet is driven by several factors, among them:

1. The anonymity afforded by Internet technologies
2. The vast size, scope and increasing reach of the network

3. Relatively low cost of each additional (i.e., marginal) e-mail, web or social media message

Anonymity

Whereas the average user values privacy and the ability to protect his or her identity online, these same properties of the network provide the spammer and the scammer with the cover needed to ply their trades. With the knowledge that their messages would probably be blocked by several different methods, the sender of fraudulent messages employs several methods to either remain anonymous or to pretend to be someone else. Messages are bounced around to appear to come from trusted sources; domain names sounding similar to trusted companies are employed; or, in more recent efforts, known addresses such as those in one's contact list are listed as the sender.

Size, Scope and Reach

The size of the Internet user base has increased continuously since the Internet went public in the early 1990s. Internetworldstats (Internet World Stats, 2011) placed the total worldwide user base at approximately two billion or about 28.7 percent of the world's population during 2011 with a more than 400 percent increase over 2000 statistics. This potential market may then be multiplied by the number of different platforms or activities that a user may engage on the Internet—from the World Wide Web to Facebook and e-mail— each use of the Internet technologies provides an additional marketing or spamming opportunity.

Cost of Spam

Spam is an Internet Age phenomenon. The history of its name is hotly debated, though some association with the repetitive singing of the word spam from a Monty Python sketch may be involved. We do know that several instances of early unsolicited advertising campaigns on the servers that would become the Internet all led to angry uproars from users and that Dvorak, Pirillo and Taylor (2003, p. 245) have likened spam to a cancer. Mass mailing fraud schemes were known before the Internet, but as small as they were, the costs would quickly add up—to the extent that many of the schemes were aimed specifically at wealthy persons or even companies. Cranor and La Macchia (1998, pp. 75–76) pointed to the economics of e-mail distribution as a factor in the proliferation and success of bulk e-mail and the scams that accompany them, writing:

Some bulk email services will send 100,000 email messages for under $200, and do-it-yourselfers can buy a million email addresses for under $100... Serious bulk mailers invest a few hundred dollars in specialized software capable of sending 250,000 messages with forged headers per hour and harvesting email addresses from Usenet, the Web, and online services... A bulk mailer can send out hundreds of thousands of messages a day with minimal work and monthly service fees. With such low expenses, bulk mailers can recoup their costs even if only a tiny fraction of the messages they send out result in sales.

They noted, however, that though the price of sending the marginal e-mail message may be small, the costs of dealing with unwanted messages are extremely high, including time and technical resources for screening. One might add that the risks of screening out needed messages also tend to reduce efficiency in personal and business affairs.

Resulting in part from these factors (and from plain old-fashioned criminal ingenuity) new media forms have spawned a wide range of fraudulent and illegal activities designed to pilfer both information resources (including financial information and entire identities) as well as money from unsuspecting users. The Nigerian (419) or "Advanced Fee Fraud" scheme is among the best-known manifestations of online fraud. This particular scheme frequently involves a message sent to a user asking for assistance in transferring a large sum of money out of Nigeria (or some other country with which the user is unlikely to be familiar or have real contacts). The writer may purport to be a Nigerian government or banking official, a clergy member, industrialist, political dissident or other similar figure who has either inherited or discovered a large sum of money and who needs assistance in transferring the fortune out of his or her country. The 419 designation stems from the fact that the Nigerian Criminal Code section that pertains to fraud is section 419. The notion of advanced fees is also central to the scheme. Brenner (2010, p. 64) described the progression of this scheme in the following manner:

> If the recipient of the e-mail agrees to assist and sends money to the author, that will begin a process in which "difficulties" continually arise in retrieving the money, difficulties that require the victim to continue to contribute funds to the retrieval effort. As with many scams, the process will continue until the victim is out of funds or realizes he has been had.

While it may have flourished with the help of the Internet, this particular scam at first utilized traditional mail and an early approach to mining data in the form of addresses from stolen mailing lists. In 1994, the *Wall Street Journal* (McMorris & Geyelin, 1994, p. B6) reported on a case from California dating to events as early as 1991 in which a Mr. Alex Holland and a co-conspirator named as Prince Churchill Ovu were found guilty of defrauding a New York

businessman named Mr. Mersentes of $800,000 through a money transfer scheme from Nigeria. At that time, the paper also noted that authorities in the U.S. and other countries had already "investigated several similar schemes involving letters and documents from supposed Nigerian officials" (McMorris & Geyelin, 1994, p. B6). Snopes.com (Mikkelson & Mikkelson, 2010a) linked this scam to an earlier phenomenon known as the Spanish Prisoner Scheme—popular via mail in the 1920s, while Brenner (2010) connected the scam to an even older variation of the Spanish Prisoner scheme dating to the sixteenth century.

8

Information Age Journalism and Ignorance

One of the last professions one would usually associate with ignorance (particularly in an age of information plenty) is journalism. In the popular imagination, the valiant men and women of the press were traditionally associated with uncovering facts, exposing corruption and generally keeping the public well informed with credible and useful material. Feldstein (2004) even cast journalists as being similar to oral historians who aim to educate the citizenry and protect historical knowledge for the future.

If these are rather romanticized views, they may be tempered by the understanding that the history and practice of news is somewhat more politically involved and economically driven. O'Boyle (1968, p. 300) noted the "intimate association between journalism and politics" that could be found, for example in the French newspaper business of the early 1800s where "writing for the newspapers was regarded as a normal step in a man's political career and an accepted means of gaining political office" and that in England, Germany and France "the occupation combined belles lettres, reporting, and political agitation" in varying measures (p. 290). Today's increasingly corporate-minded, and corporate-owned journalism is further influenced by the whims of powerful corporate owners who indirectly or directly determine editorial leanings and story coverage. According to Dugger (2000, p. 49),

> The owner of the corporation appoints the CEO who appoints the managers who appoint the editors. Those editors dependent, through the intermediate executives, on the pleasure of the owner and the CEO, hire and fire the reporters and decide what stories the reporters are assigned to write, what stories they are not assigned to write, what the stories that are published say and how they say it, and what stories get killed.

THE FARCICALIZATION OF JOURNALISM

Lacey and Longman (1997) recounted that early writers of a journalistic nature were called "intelligencers," suggesting something of the informed nature of both the reader and the writer. The flourishing of news and infor-

mation would, at first, appear to necessarily engender a wave of "intelligenc-
ers" in the Information Age. Yet several forces have conspired to prevent such
an ideal situation and, indeed, have resulted in quite the opposite in many
ways. In our Information Age, we are faced with media both new and tradi-
tional that act as "ignorancers" instead, involved in what Radford (2003, p.
188) characterized as the "sexing up and dumbing down" of the news with its
shift from being a public service into being a commercial vehicle. A former
employee of Fox News made a similar connection between that media organi-
zation and the spread of ignorance when quoted as saying:

> There is a general trend, a downward trend in journalism that Fox has taken a hand
> in... It has created an atmosphere in newsrooms around the country that makes news
> a commodity, that cheapens our trade and [is] creating a less informed, more vapid
> public (quoted in Kitty & Greenwald, 2005, p. 17).

Much has been said to cast Fox News as a 24-hour campaign machine for
both the Republican Party and the broader conservative political movement in
the United States. For example, Kitty and Greenwald (2005, p. 38) called it
and "elite playground for the Republican in-crowd" and Broderick and Miller
(2007, p. 137) noted that "Rupert Murdoch launched the Fox News Channel
in an attempt to counter a news media he viewed as dominated by liberal
interests." While deliberate manipulation of information to benefit a particu-
lar party or group fits with Proctor's (2008) definition of ignorance, we may
leave that aside for a moment to note that less direct attention has been paid
to the station's penchant for broadcasting dis-informing material that is
exaggerated, incorrect or otherwise capable of contributing to the persistence
of ignorance.

A complicating factor in the case of Fox News is the effect of perceived
bias on interpretation of content. In an experimental study Turner (2007)
exposed subjects to the text of news stories and measured their perceptions of
bias based on whether they were told the stories originated from Fox News or
CNN. He found that the participants were more likely to perceive the stories
as having a conservative bias if attributed to Fox and more likely to be per-
ceived as liberally biased if attributed to CNN. This and other studies holding
out for the perception that actual bias is minimal or nonexistent generally fail
to recognize both the historical reality of biased news (whether politically-
based, class-based or otherwise) and the emerging opportunities for unchecked
bias inherent in media without gatekeepers—or worse, driven by ideologues of
whatever flavor. Turner (2007, p. 443) argued:

> A substantial portion of the American public still perceives CNN and FNC as being
> ideologically biased. Hence, we are left with an intriguing discrepancy. Systematic

academic research struggles to find more than a hint of ideological bias in the news, yet the perception that such bias exists is widespread among the mass public.

This works to support Turner's contention that the bias is all in the viewers' minds. The discrepancy, however, is a little easier to understand when the systematic academic research being cited stretches back to the 1980s and even as far back as 1972. Further, the conclusion ignores the work of others such as Groeling (2008, p. 631) who finds "substantial evidence for bias" in the news of not only Fox News but also other major news outlets.

In considering the persistence of ignorance in the Information Age, the analysis here is less concerned with which political party a news outlet aligns with than with their propensity to promote misinformation and ignorance to audiences on a broad scale. In July of 2010 Fox News carried fanciful stories about terrorist organizations training "attack monkeys" to carry out attacks on civilian targets. The reports, complete with Photoshopped images of monkeys holding handguns were carried in all seriousness and accompanied by real journalistic outrage expressed by Fox's news staffers. Not too long after that Fox also featured guests who insisted that a vast conspiracy of terrorist "anchor babies" was being instituted by al-Qaeda.

Beyond such blatant (and perhaps comical) misinformation, some of the most important contributions of Fox News to the U.S. and international audience has been its promotion of particular figurehead pundits who opine on the politics and social issues of the day. Whereas this could be said about most news organizations and questions can also often be raised about the credentials of their presenters and guests, Fox News provides some intensely strong examples of ignorance from its cast of characters.

The tradition in news has been to feature persons in authority or with expertise on particular topics to comment on issues, provide information, or explain complex situations to audiences. This concept of the "authorized knower" has received some criticism because these "authorized knowers" can often have their own biases or represent the powerful status quo. While the "authorized knowers" on Fox News are predictably from certain U.S. conservative religious and political organizations, it is their propulsion of certain personalities into the national and international spotlights that may be their most poignant contribution to ignorance.

Glenn Lee Beck, born in 1964 in Washington State, a confessed former drug addict and alcoholic, has risen to the top of U.S. commentators in recent years with no small contribution from his presence on Fox News, which ended in 2011. It would be an act of academic snobbery to suggest that formal education is a prerequisite for someone to comment on news and society in the manner that Beck's program and several best-selling books attempt to do.

Yet, the fact that Beck dropped out of the one college course he ever at-
tempted should raise some questions, as does the claim that he then educated
himself by reading the work of six famous people including Hitler, Nietzsche
and Carl Sagan.

We might, at the very least, suggest that Beck would be at somewhat of a
disadvantage against others who have spent their lives becoming educated in
particular fields or who have had privileged positions of power or policy. His
ignorance may be of the simplest kind and may well be excused. However, not
only did Fox News present Beck as an expert on almost everything from
economic policy to politics, Beck then proceeded to characterize his opponents
as not just ignorant—but also stupid. One of his several bestsellers is titled
"Arguing with Idiots: How to Stop Small Minds and Big Government" (Beck,
2009).

The suppression or avoidance of particular kinds of ideas (particularly so-
cially beneficial ones) is an insidious form of ignorance. Beck and others who
shape public discourse are guilty of this kind of ignorance and guilty of
promoting it to their audiences. In his pursuit of a particular set of ideals
(defined variously in terms of conservatism, traditional values and free market
capitalist ideals) Mr. Beck's campaign against all that he considers "progres-
sive" has not spared even the church. Syndicated *Washington Post* columnist
Dana Millbank (2010, pp. 114–115), for example, recounted Beck's denuncia-
tion of churches that dared to preach social and economic justice and his
appeal to his followers to leave such congregations:

> Beck told his followers that they should quit their churches if there was any mention
> of "social injustice" or "economic justice" in those houses of worship... Social justice
> and economic justice, they're code words," Beck advised. "Am I asking people to leave
> their church? Yes... If you have a priest that is pushing social justice, go find another
> parish." In the usual style, Beck embroidered the case against "social justice" and
> "economic justice" churches with the accusations of "socialism, Marxism, [and] com-
> munism."

This is the same Glenn Beck who poked fun at the 11-year-old daughter of
the president on May 28th, 2010, during his (Beck's) talk show, making
negative comments about her level of education. Reynolds (2010, p. B4),
calling Beck "Fox News' most notorious hatemonger," recounted the incident
thusly:

> The latest brouhaha erupted over the BP oil spill when the President made a casual
> remark in a news conference that his daughter Malia had asked him "Did you plug
> the hole yet, Daddy?"... Never missing an opportunity to dish up dirt against the Pres-
> ident and his family, Beck, mimicked Malia on his radio show with his radio pal play-

ing the part of Obama. He attacked Malia's intellect for asking the question and also put words in her mouth to suggest her father was a mere puppet and a man who didn't like Blacks.

Reynolds' later comments draw attention to the pervasive nature of this kind of ignorance, described by Proctor (2008) as active, strategic, cultivated and manipulated (for profit or other advancement of particular groups) in the Information Age. The association spreads to a broader context, however, as Reynolds noted some common threads with global reach:

> These attacks from high-powered conservatives on the Obama family are not laughable. Remember the *New York Post* cartoon that showed Obama as a monkey being shot down by police. Is this not dangerous intent? Both Fox News and the *Post* are owned by Rupert Murdoch, a dangerous man.

Kitty and Greenwald (2005, p. 13) noted that the *New York Post* "has a nasty track record of publishing hoaxes and erroneous information." The Information Age is, therefore, one in which the forces of disinformation (the perpetuation of racial and ethnic stereotypes being fundamentally disinforming) are not only potent but also global in their reach. This is so because although the menace of ethnic hatemongering as common to both Fox News and the *New York Post* is threat enough, the fact that both form part of a global empire known as NewsCorp renders the force of such disinformation many times more potent.

NEWS AS A REPEATED SCRIPT

Traditional wisdom holds that news is something that has not been heard before, an event or point of view that is original and worthy of mention for the very reason of being important, timely and out of the ordinary ("Dog Bites Man" is not news; "Man Bites Dog" is news). Yet, in the 24-hour news cycle, and with exponential increases in sources of information, interesting new perspectives on "the news" become possible.

Goffman's (1959) dramaturgical theory has enjoyed some prominence in the field of communication, where scholars have found the notion of performance useful in explaining communicative behavior. This perspective emerged with Goffman's adaptation of ideas from theater into sociology with his 1959 book, *The Presentation of Self in Everyday Life*. The notion of dramaturgical presentation addresses individuals in their social roles and their particular choices of performances based on social factors and circumstances. It has been applied to numerous contexts including Internet communications (Miller H. , 1995) and organizational communication (Pacanowskya & O'Donnell-Trujillo,

1983). However, one aspect of drama has become increasingly relevant to news in recent years—the script.

Literal scripts are a part of most television and radio news, so that is nothing new. The "script" or "text" meant here is the discourse of the news stories themselves—an idea closely related to another popular idea in communications and journalism known as framing theory. Framing theory looks at the manner in which news stories are conveyed to audiences, suggesting that facts are forced into familiar frames of reference. Entman (1993, p. 53) suggested that framing is a process in which the presenter of the information chooses "to select some aspects of reality and make them more salient in communicating texts."

Today, we have stories that are repeated *ad nauseum* using familiar scripts (Britto & Dabney, 2010). This in itself presents something of a paradox since news is, by definition, that which is new. However, in the age of the 24-hour news cycle and global stories spread by traditional mass media, the Internet and social media, news organizations experience a greater need to express stories within prevailing structures and ideas so that they may more readily be consumed. In the same way that Hollywood movies are deliberately formularized to have the greatest market appeal, so too is news formularized to "sell" more to the commercial information market. This occurs both in the choice of stories and in the particular slant taken by journalists and commentators. This idea has been extended in areas such as cultural studies where proponents such as Stuart Hall argue that representation of ideas in media reports are influenced by what is framed in the story and also by what is left out. The repeated tropes are also evident in the repeated faces invited to discuss particular issues. It is common, therefore, for elections to be reported primarily as contests or races instead of in terms of their meanings for voters and impacts on particular issues.

Examples of particular types of framing have been with us for as long as we have had journalism and media coverage. The notion of the "other" as dangerous or threatening has been around for many years. Consider the early framing of immigrants by the venerable *New York Times* in 1892 when fear of contamination was both prominent in public discourse and widely reported in the media:

> With the danger of cholera in question, it is plain to see that the United States would be better off if ignorant Russian Jews and Hungarians were denied refuge here. These people are offensive enough at best; under the present circumstances they are a positive menace to the health of this country. Even should they pass the quarantine officials, their mode of life when they settle down makes them always a source of danger. Cholera, it must be remembered, originates in the homes of human riffraff.

Framing is, therefore, not a new phenomenon. However, it takes on added significance in the modern Information Age when a frightening proportion of the information reaching us is framed in uniform and familiar ways. Steuter and Willis (2009, p. 7), for example, point to "media complicity in reinforcing the broader political framing of a Muslim enemy" in their analysis of Canadian newspaper headlines, suggesting that they "metaphorically position not just enemy soldiers, but increasingly all Arabs or Muslims as animals, insects and diseases" leading to "the language of eradication and annihilation that is the logical corollary to metaphors of the enemy as vermin or virus." (Steuter & Wills, 2009, p. 9).

Not only are the frames repeated, but the script is the same no matter what channel you choose. Britto and Dabney (2010, p. 5) contended that "in a race to secure market share and deal blows to their competitors, cable news networks now mimic one another in terms of content (topic and story selection), format, and programming schedules." What then, of meaning and frames. Ironically, in an age of information diversity, both story choices and story frames remain remarkably consistent across major journalistic outlets, or as Radford (2003, p. 188) argued: "the news is largely homogenized, with reporters from different media telling pretty much the same story—and from the same perspective—with only slight variation in phrasing and images."

THE DEATH OF GATEKEEPING

What does grocery shopping have to do with news? One of the most important elements of news has traditionally been the idea of selectivity. Society has depended on news organizations not just to deliver information but also to prioritize and select the information that qualifies as news. Journalists and their editors have traditionally engaged in a process of identifying, covering and publishing information that is distinguished in terms of several "news values." Among these values are proximity, salience and timeliness. These three traditional news values identified stories as newsworthy based on their proximity or closeness to the audience, salience or importance of the issue covered and the timeliness of the story. Several other criteria have also been used to delineate or identify just what constitutes news. Among these are such ideas as "human interest," the bizarre and the amusing and celebrity issues. If these latter three seem ill-defined, consider as well that even the traditional values of proximity, salience and timeliness are tremendously subjective notions. This was exactly what social scientists in the 1940s began to notice.

This is also where theories of grocery shopping and the news collide.

The notion of "gatekeeping" hails back to the work of Kurt Lewin in 1947. Lewin examined the processes involved in choosing which items from

the grocery store made it to the kitchen table. He conceived of these processes as a system of gates through which an item could either pass or be denied passage depending on the decisions of persons involved whom he styled as "gatekeepers." A colleague of Lewin's named David Manning-White adopted this concept in a study of news publishing. Manning-White examined all of the stories that were available to a particular newspaper and the motivations of the editor in choosing to publish some stories and reject others. He found evidence that the choices of keeping some stories and rejecting others were highly subjective.

While this conclusion may seem somewhat obvious to us today, it was drawn at a time when journalism had some pretensions to being an objective undertaking. Even today the notion of objectivity in journalism and whether this is at all possible is still debated in academic and professional circles. The gatekeeping perspective, in denying objectivity as a valid paradigm for journalism also validated the importance of the judgment, however biased, in determining what was considered news.

Today, the system of gatekeeping that guaranteed both selectivity and prioritization of available information has been seriously undermined. Certainly this process still happens in formal media houses. Every journalist from CNN anchors to your local newspaper reporter is familiar with the process. Story choices are subject to scrutiny, story content is examined carefully, and senior editors make the final decisions on what gets published or printed. The death of gatekeeping, however, emerges not only through its erosion in traditional media, but also because it is circumvented by new media.

Blogs, self-styled news websites run by partisan individuals, social networking sites such as Twitter and Facebook and even the dreaded chain e-mail have become important sources of information that feature little or no gatekeeping even in the elementary form of fact checking. To make matters worse, influential and far-reaching commercial news organizations have, at times, been guilty of citing these informal sources. Hitlin (2003) noted:

> A number of Internet sites, such as Matt Drudge's Drudge Report, are one-person operations that issue reports on gossip and rumor without being constrained by traditional standards of reporting. These sites apply pressure to other news organizations to be the first to report a story or risk being scooped.

Fox News and several conservative talk shows, for example, routinely cite the heavily biased Drudge Report and Newsmax.com as sources of information and even breaking news. Media Matters for America (2004), points out:

> An unsubstantiated rumor about Senator John Kerry's hair, originating with an April 27 Drudge Report Exclusive that cited only anonymous "campaign sources," made its

way onto the April 29 episode of Special Report with Brit Hume on Fox News Channel. In his "Political Grapevine" segment, Hume reported the story without citing any sources.

Drudge suggested in February 2004 that he scooped all the major news organizations with a story about an affair between Sen. John Kerry and an intern, which turned out to be completely untrue (Palser, 2004). Robert Scheer (1999) pointed out that the Drudge Report was the chief proponent of a false story about Bill Clinton having an out-of-wedlock child with a prostitute from Arkansas. Roston (2010) noted that despite the fact that Matthew Drudge is often wrong in his pronouncements, he still gets away with it:

> There's no accountability in there... No higher ups coming down hard and firing him when his big story blows up because it was pieced together without any ethical concern for facts. No advertisers pulling the plug because they fear being associated with a faulty, fact-lacking brand. Treading off of his big get 12 years ago that opened up the Monica Lewinsky scandal, Drudge keeps his audience no matter what he misreports, deliberately or not.

News also spreads without the agency of either news-gathering companies or self-styled news bloggers. That can often mean that the news that spreads is often more what people want to hear than what actually happened. The August 2010 case of a Jetblue flight attendant who cursed at a plane full of passengers and exited the aircraft by deploying an emergency chute demonstrates the discrepancy between the real and imagined news.

Within a day or two of the incident, the flight attendant, Steven Slater, had more than 20,000 supporters on Facebook who were among those calling him a "folk hero" (Siddique, 2010). The mainstream broadcast and print media as well as their online branches ran with the story, based primarily on social media and blog hype. As the days passed, the cavalier folk-hero image quickly began to fade as details of the incident began to be revealed through interviews with passengers and others who actually saw what happened. A very different picture emerged of a volatile individual who may or may not have been inebriated or disturbed. From the beginning the frame was wrong, influenced by social media, journalists themselves covered the story with the "folk-hero" frame, ignoring the more salient issues of passenger safety and legal breaches that may have been raised in the incident. These issues would resurface when Slater was later charged with several violations and faced up to seven years in prison for his actions. The mainstream news media's willingness to readily adopt the folk-hero frame in its initial reporting was both an indication and an indictment of the Information Age. Ignorance of the facts of the case proved no barrier to widespread reporting, and even the true story

would then fail to eclipse the initial hype. In the Information Age, facts can be victims when celebration of fictions is more widespread, meets with consensus and is thus more profitable.

The Information Age has also spawned powerful consensus-forcing currents of coverage that have tended to erode gatekeeping functions and enable journalists and still-powerful mass media to be used as tools of political propaganda. Johansen and Joslyn (2008, p. 591) argued that the mass media failed in their gatekeeping role and were used as propaganda tools during the Iraq war:

> Ideally, news media act as a filter, sifting and sorting information in a manner that ensures a reliable and accurate source from which citizens can base judgments about war. The news media fell far short of this ideal and exacerbated the spread of misinformation about Iraq. Major television news coverage of Iraq was overwhelmingly pro-war. Indeed, leading news organizations emphasized administration information over contrary information to the extent that two prestigious newspapers later apologized to their readers because they "lost focus on other voices." The news media did not do their job protecting the public against political propaganda.

It was not only in the context of battle in Iraq that modern journalism yielded to the influence of government information. Barstow, Stein and Kornblut (2005, p. 1) reported that Under the Bush administration, the federal government and its agencies distributed hundreds of prepackaged television news segments to stations across the country "without any acknowledgement of the government's role in their production":

> "Thank you, Bush. Thank you, U.S.A.," a jubilant Iraqi-American told a camera crew in Kansas City for a segment about reaction to the fall of Baghdad. A second report told of "another success" in the Bush administration's "drive to strengthen aviation security"... A third segment... described the administration's determination to open markets for American farmers... Each report looked like any other 90-second segment on the local news... The report from Kansas City was made by the State Department. The "reporter" covering airport safety was actually a public relations professional working under a false name for the Transportation Security Administration. The farming segment was done by the Agriculture Department's office of communications.

While there is room for debate on whether it is the news media's job to protect the public against propaganda, it is certainly not their job to do propaganda work for either the government or any other powerful social force. When the relaying of such misinformation undertaken as a matter of journalistic practice as in the case of Fox News is added to the international reach of modern mass media, issues of global significance are raised.

INFORMATION AGE TOOLS AND IGNORANCE IN JOURNALISM

Repeated scripts, a lack of gatekeeping, and the rise of informal sources of news all feed into an erosion (or perhaps a redefinition) of journalism. All of these are social factors related to the Information Age and associated changes in economic and social life. Yet, the very technologies of the Information Age, thought to be so fundamental to these transformations are also directly implicated in the decline of journalism and its increasingly tenuous position in the modern world. Some have pointed to the very tools of modern journalism as being partly responsible for the persistence of disinformation and ignorance.

Consider, in this regard, Ehrlich and Ehrlich's (1996, p. 196) contention that reliance on databases like Lexis-Nexis lead to the reproduction of errors in reporting:

> Like any reference material, including the many other databases to which reporters have access, Nexis is only as good as its sources. Any news story written on a given topic, correct or not, enters the Nexis database, where it is often found and copied by other journalists looking for background information on a story... Thus a chain reaction is set off; instead of an error being eliminated from the system, it is amplified as more and more journalists uncritically pick up and use it. In this way Nexis accidentally can serve as a potent positive feedback system for inaccuracy.

The speed and reach of information diffusion in the Information Age aid the systematic (and systemic) spread of error, particularly due to the pressures of time imposed on journalists in a situation where their competitors for news are no longer other journalists subject to fact-checking and gatekeeping, but rather anyone who happens to be on Twitter.

An additional, and increasingly popular, Information Age tool for the journalist is the poll. Rapid and widespread polling have developed into ever-more important tools of modern journalism, with many major news organizations themselves cosponsoring such polls. Robinson (2002) pointed to the surprisingly negative effects of public polling on modern journalism. Among the myriad problems with the use of polls (which may be biased in several ways), Robinson argued that journalistic dependence on polling promotes and amplifies ignorance by depending on prevailing public knowledge (which is often deficient) while failing to provide useful information on issues. Furthermore, this approach to feeding news with scores on public perceptions can be particularly destructive to political reporting and the democratic process by creating what Robinson has termed (2002, p. 89) "horse-race reportage" in which an overwhelming frame of numerical or score-based competition among political candidates precludes serious analysis of important issues.

THE FUTURE OF JOURNALISM IN THE INFORMATION AGE

Predicting the future is a task best left to fortune tellers, market analysts, and weather forecasters, particularly since they all have an implicit license to be wrong at least half of the time. Despite the closure of several newspapers in the United States in recent years, it would still be foolhardy to predict with any air of certainty that journalism is facing its imminent demise, since such predictions have been made (and been proven wrong) many times before. Traditional press journalists were warned of their imminent demise in the 1930s as radio began to present news immediately rather than on the next day and in the 1950s as television began to deliver far more attractive news content than newspapers ever could—though in each case particular types of journalism morphed, adapted and survived (Stam, 2010). In a sense, today's Information Age challenges span a little more ground since they involve all journalists in all media. Yet, it remains possible to view the current challenges in terms of media changes (in this case the changes wrought by social media such as Facebook and Twitter) as well as social changes (such as increasing media choices in both traditional and new media). If history can be an accurate guide, it would suggest that journalism will find ways to adapt to the challenges of the new media forms and practices. Part of the adaptation would involve addressing the several serious issues outlined above that render the field and its practitioners into purveyors of disinformation in the Information Age, thereby contributing to the persistence of ignorance.

9

Social Media, Disinformation and Ignorance

On July 29, 2010, news services reported that personal information including contacts of more than 100 million Facebook users had been collected and made publicly available (msnbc.com, 2010). Users had the ability to either reveal or conceal that information while it was on the Facebook system but the public spread of the information on the open Internet meant that users lost the ability to control those details and they no longer had a choice to protect their privacy. The incident, downplayed by the operators of the Facebook system, revealed something of the increasingly important role of social networks in everyday life and the many possibilities and pitfalls of involvement in these networks.

The various social networking platforms have garnered the expected media buzz and prompted the usual knee jerk moral panic that characterizes each new technology or substantial revision of communications media. Yet, beyond the usual skepticism and xenophobia about "new" communications technologies, neo–Luddites and *technorati* along with the general public are faced with several emerging issues related to social networks and their user communities. From privacy and intellectual property concerns to violence and even deaths associated with online social networks, modern society is faced with an evolving set of technologies that not only redefine virtual relationships but also impact real lives.

Fuelled by the fact that organizers of pro-democracy protests in North Africa and the Middle East used Facebook as one tool (among several others) to mobilize, the hype persists with oft-repeated promises of truly democratic communication where users are in charge and where all voices are heard. The political uprisings in Egypt and Tunisia, followed by several other similar movements in the Middle East and North Africa were widely touted (correctly or not) as Facebook revolutions. Quite apart from this utopian discourse is an emerging reality of ruined reputations, shattered lives, violent threats and physical and emotional harm attributable to online social networking that, despite some sensational media coverage, has received little credible analysis. The predominant discourse is one of exceptional events in an otherwise quite

rosy set of circumstances where not only are lives enriched, but social relationships rekindled. Social networking is seen as the solution to the separateness and isolation blamed on much of media including the Internet. The various platforms are often even described as economic powerhouses—the next big thing, the communications technology that "changes everything." Yet the spread of social media with its lack of gatekeepers and insistence on sharing information may also be conducive to the spread of ignorance and the erosion of privacy.

HOW THE NETWORKS BECAME SOCIAL

The notions of online and virtual communities have received copious attention from scholars from the early days of the diffusion of Internet technologies (Rheingold, 1993; Wellman, 1997). This was so even before the question of how communities would eventually be constituted had clear answers. In more recent evolutions of Internet technologies, electronic spaces have become dedicated to the creation of communities and have specialized in developing options for community creation. "Traditional" newsgroups and discussion fora have given way to MySpace and Facebook, sites or nexuses for content creation that relates to community interests ranging from educator/student spaces to extra-national diasporic spaces.

The social networking site largely replaced the personal website as a means of self-presentation on the World Wide Web. No longer was a personal expression on the Web a major venture involving technical know-how and content generation. The social networking apparatus automatically generated HTML structure and content as well as links to other users and additional content. What is more, the need for developing some kind of specialized content did not really exist. To paraphrase and extend McLuhan, the user was now the message.

Simply by being on the network, one communicates certain information—an identity and willingness to communicate being chief among them. Additionally, the network also ensures that content is generated in several ways—so that visitors to your space contribute to your content by posting or writing on your wall. Updates about the activities of other members of your network also constitute part of your content that is dynamically generated.

There is quite some debate over the actual impact, but little questioning of the idea that Facebook, MySpace, Twitter and several other networked communication technologies are changing the ways in which modern audiences communicate and, at the same time redefining social relationships. These so-called "social networking systems" (SNS) allow users to create and manage virtual social networks that mirror, overlap, and sometimes even

dominate their real social ties. Boyd and Ellison (2007) formally defined social network sites (also sometimes termed social network systems) as:

> web-based services that allow individuals to (1) construct a public or semi-public profile within a bounded system, (2) articulate a list of other users with whom they share a connection and (3) view and traverse their list of connections and those made by others within the system.

Scholars have already documented the use of SNS ranging from educator/student spaces (Green & Bailey, 2010; Selwyn, 2009) to the discussions of cancer and other medical treatments (Gorrindo, Gorrindo, & Groves, 2008; Serin & Marti, 2010) as well as the negotiation of communities and identities (Acquisti & Gross, 2006). Facebook, the most popular of the SNS systems started in 2004 at Harvard, expanded availability to other university students and then to the general public by 2006 (Boyd & Ellison, 2007). The system has become popular among educators (Atay, 2009), companies (Holzner, 2008) and other organizations such as activist groups (Shapiro, 1999). Despite having grown into a major international phenomenon (Kirkpatrick, 2010) it remains primarily a venue for personal contacts and provides opportunities for local networking (Urista, Dong, & Day, 2009).

One of the primary allures of Facebook is its increasing ability to find and foster relationships with past and distant contacts—though it often also serves as an additional means of contact with those who are already in close proximity. The network remains a personal one in the sense that a single user generally can only reach others who allow them access. Facebook "groups" allow a broader level of community engagement. Even though groups can also restrict membership, entry into the group creates automatic access to a wide range of public postings and materials from administrators and other members without additional requests for contact.

Several studies (Pempeka, Yermolayeva, & Calvert, 2009; Ellison, Steinfeld, & Lampe, 2007) have indicated that among particular groups, social networking is often primarily a method of reinforcing existing contacts rather than developing new ones. According to Ellison, Steinfeld and Lampe (2007, p. 1162) participants in their study "overwhelmingly used Facebook to keep in touch with old friends and to maintain or intensify relationships characterized by some form of offline connection…" Here, the work of Mark Granovetter (1973) on the "Strength of Weak Ties" is relevant. Granovetter has suggested that people are more likely to learn from those with whom they are less closely connected than from those with whom they share strong ties and similar experiences. Ellison, Steinfeld and Lampe (2007) emphasized the importance of social networking's maintenance of weak ties, which they characterized as

distant or infrequent contacts (or those distanced by such events as gradua-
tion) to social network users. However, there is considerable room for debate
on the characterization of strong and weak ties since Granovetter's (1973, p.
1361) pre-social networking definition of the strength of ties was quite broad:

> Most intuitive notions of the "strength" of an interpersonal tie should be satisfied by
> the following definition: the strength of a tie is a (probably linear) combination of the
> amount of time, the emotional intensity, the intimacy (mutual confiding), and the
> reciprocal services which characterize the tie... It is sufficient for the present purpose if
> most of us can agree, on a rough intuitive basis, whether a given tie is strong, weak, or
> absent.

One might argue that the network comprising, for example, past class-
mates and present associates may not actually necessarily be the weak ties as
Ellison, Steinfeld and Lampe have designated. Rather, in a social networked
environment that both eliminates geography and suggests new contacts (based
on location, affiliation and other factors) those established connections may,
in fact, be the strong ties. Granovetter (1973, p. 1362) suggested that both
"overlap in... friendship circles" and time were important determinants of the
strength of ties. In the context of modern electronically mediated social
networks, therefore, network ties comprising old classmates might well be
thought of as strong ties compared to those involving new network members
unrelated to one's current stock of acquaintances. It is these novel and
otherwise unconnected network members who characterize weak ties and
constitute the group from which one is more likely to learn from. Then we
may argue that, by emphasizing and supporting strong ties Facebook and other
social media may actually promote ignorance rather than information.

Related to the idea of decreasingly diverse sources of information is the
phenomenon of what has been called prosumption (Toffler, 1980) or the
simultaneous production and consumption of content by users. Though the
term predates the age of the public Internet, today's prosumption involves
participation of the user in content creation. Users, for example, increasingly
not only watch videos on YouTube, but also upload videos and actively
participate in creating comments, ratings and other content. Such a user who
produces and also consumes content is a prosumer, engaged in prosumption.
Fuchs (2011, p. 297) took a dim view of prosumption and its benefits to
corporate media interests, arguing:

> Prosumption is used for outsourcing work to users and consumers, who work without
> payment. Thereby corporations reduce their investment costs and labor costs, jobs are
> destroyed, and consumers who work for free are extremely exploited. They produce

surplus value that is appropriated and turned into profit by corporations without paying wages.

He further argued (2011, p. 298) that prosumption is both an extreme form of exploitation and essential to the survival of particular media forms:

> Production and accumulation will break down if this labor is withdrawn. It is an es-
> sential part of the capitalist production process. That prosumers conduct surplus-
> generating labor can also be seen by imagining what would happen if they would stop
> using platforms like YouTube, MySpace, and Facebook: the number of users would
> drop, advertisers would stop investments because no objects for their advertising mes-
> sages and therefore no potential customers for their products could be found, the
> profits of the new media corporations would drop, and they would go bankrupt.

The production of content by information consumers takes many forms, including uploading videos, posting text and pictures on Facebook pages and creating commentaries on blogs. In addition to actual content development, user input is an increasingly important factor in the popularization of content, manifesting itself in videos or other content "going viral." Among the wide range of viral content that has circulated widely one may find the genre of "ghost riding" featuring Facebook pages and videos of (mostly young) people leaving their moving cars. Writing in the Iowa Law Review James Grimmel-mann (2009, p. 1139) described the phenomenon in the following terms:

> The Facebook page of the "Ghost Riding the Whip Association" links to a video of
> two young men jumping out of a moving car and dancing around on it as it rolls on,
> now driverless. If this sounds horribly dangerous, that's because it is. At least two
> people have been killed ghost riding, and the best-known of the hundreds of ghost-
> riding videos posted online shows a ghost rider being run over by his own car.

Going similarly viral was the practice of "planking" which involves (mostly young) people taking pictures of themselves in horizontal poses. This particu-lar practice was implicated in the death of at least one of its practitioners in Australia in 2011.

Along with the viral spread of content is the inevitable accompaniment of viral marketing that capitalizes through what Burgess (2008, p. 101) described as "the attempt to exploit the network effects of word-of-mouth and Internet communication in order to induce a massive number of users to pass on marketing messages and brand information voluntarily." This presents a further dimension of exploitation beyond that envisaged by Fuchs above and casts the prosumer as even more of a victim of the Information Age than a newly empowered individual player. In the context of user exploitation and the deliberate spread of information, the concept of viral spread through social

media also brings into sharp focus the earlier-mentioned concept of fictional osmosis. The process of fictional osmosis, aided and hastened by the technologies and structures of the Information Age gains exponential momentum from virally spread videos, e-mails, images and text messages. Whether user-determined or corporate-inspired, fictions as urban legend commercial manipulations, propaganda—or other dis-informing materials increasingly find purchase and success through viral media.

Negative associations of Facebook and other social media have been quick to emerge and persist both in the public and private spheres. According to *Strategic Direction* magazine (Strategic Direction, 2008, p. 16), Facebook and other social networking sites quickly devolved into venues for sketchy behavior:

> Initially at least, the fundamental aim of such sites was to encourage individuals to create material for other users to consume. That is fine in principle. However, it has since become the norm for many members to push the boundaries by using the network to flash the flesh and indulge in other mildly risqué behaviors.

Barns (2009, p. 26) noted the association between the use of social networking sites and such ills as "mental illness, suicide, loss of privacy and defamation"; he called the sites "effectively lawless" and questioned their impact by citing research such as Starr and Davilla (2009) associating Facebook and other social networking technologies with anxiety and depression in adolescent girls. On the question of defamation Barns (2009) also noted that social networking sites featured in the case of a British man named Matthew Firsh who won damages against a former friend who defamed him and his company on Facebook. He added (2009, p. 26):

> Social networking is here to stay and in a sense it is like a world or nation. We are not allowed to invade privacy, defame or take actions which cause death or serious harm to people in the real world, and if we do there are sanctions... It could even be argued that given the viral and global nature of social networking that its power to harm people and infringe their human rights is greater than exists in the physical world. This is what makes it such a potent weapon in the wrong hands.

THE DECLINE OF PRIVACY

Stross (2009, p. BU3) wrote in the *New York Times* Business section:

> As the scope of sharing personal information expands from a few friends to many sundry individuals grouped together under the Facebook label of "friends," disclosure becomes the norm and privacy becomes a quaint anachronism.

This notion of privacy as a quaint anachronism reflects the creeping reality of information pools resulting from interconnected technologies and dataveillance. Despite the growth of such information pools, privacy remains an important expectation in the Information Age. That idea that privacy still matters was clear in the concern over a revelation that millions of Facebook users' information had been harvested and posted to a file-sharing website on July 29, 2010. Ron Bowes, who some news outlets called a "security consultant," harvested some 100 million names and associated details from the Facebook system and posted the data through a torrent on a file-sharing website. At a time when news organizations were also covering the leaking of over 90,000 classified documents via the site WikiLeaks, the media was announcing (perhaps predictably) the Death of Privacy. Writing in the UK's *Telegraph* newspaper, Milo Yiannopoulos (2010) placed the blame for the erosion of privacy squarely with the purveyors of Facebook and an ideological disposition towards exposure of private information, writing:

Facebook itself has repeatedly and shamelessly betrayed its users' trust, instituting rollback after rollback of privacy settings, in what its CEO Mark Zuckerberg sees as a quest to encourage people into being more "open" online... Zuckerberg has repeatedly said that he wants Facebook users to learn to embrace openness. "We decided that these would be the social norms now," he once declared, after another wave of privacy rollbacks.

Other publications such as the *Newsletter on Intellectual Freedom* (2010) have also noted Zuckerberg's assertion that privacy is no longer a social norm. Despite several moves by the company to make user preferences for sharing information more easily customizable, the basic premise of the site remains the sharing of information and the issue of the publicizing of private information persists.

THE POLITICAL AND ECONOMIC USES OF UNPRIVACY.

The prevailing discourse of the social networking era is one of assumed connectedness. Even businesses and media outlets encourage you to follow them on Twitter. This assumption of social media connectedness has its dark sides. It assumes, for example, that the use of social media is necessary and beneficial. It also assumes that it is in a person's interest to reveal themselves publicly—all of which, taken together with the attitudes of the social networking service providers, seems to suggest the rise of something that we can call unprivacy. We shall use *unprivacy* here to refer to the idea that strategic and well-managed self-revelation is a desirable method of social interaction. Unprivacy also carries with it a notion that the traditional expectations of

privacy are not just irrelevant, but also quite unproductive since it is by self-promotion that one moves forward in the virtual (presumably also the real) social network. Here it is difficult to avoid notions of Foucault's populations who impose the will of the powerful upon themselves through the successful use of surveillance—only in this case, in a hegemonic twist, the surveillance itself is desired by the population.

The rise of unprivacy and its dark side are evident in the increasingly common practice of employers examining the Facebook pages and other social media activities of potential employees. This increasingly common practice (sometimes combined with demands for access to online accounts) is primarily an extension of the power of corporate forces in society. According to a 2010 survey of recruiters and human resources professionals (Cross-Tab Inc., 2010), 63% of H.R. professionals searched applicants' social networking sites and some 70% of U.S. recruiters rejected applicants on the basis of online information, while only some 15% of consumers believed that their online information was a factor in their job prospects. What is more, recruiters worldwide expected the practice of pre-employment online content screening to increase in the future. The practices of unprivacy and the creeping acceptance of the intrusion of corporate and other interests into private ideas and expressions gradually erodes the line between public and private information. Foucault's notions of information power incorporated self-surveillance as an offshoot of the total information dominance of one group over another. Voluntary self-disclosure of private information extends this concept to implicate the user further in the process of self-surveillance and, by extension, exploitation. Unprivacy itself creates a condition of ignorance in several ways, not the least of which is the availability of private information without context. As Dysart (2010, p. A18) has noted:

> A headhunter, for example, may come across a photo of you at a political rally that's been tagged with your name, and consider that political affiliation as a factor when hiring you—whether or not you happened to be attending that rally as an ardent supporter or interested observer.

While the social networks pose dangers for job-seekers, they are not the only groups with fears about ignorance being so easily transmitted. So dodgy is the social media environment that some advertisers have treated the social networks with trepidation at times. According to *Strategic Direction* magazine (2008, p. 16) social media's spurious and specious associations have had their impact even on major advertisers:

Several big name advertisers including Vodaphone, First Direct and AA have removed campaigns from (Facebook). The reason? Disenchantment at being featured alongside material from an extremist political organization.

More generally speaking, despite increasing advertising levels, negative associations of the social networks have kept the advertisers and marketers on guard:

> To some, of course, the whole concept of social networking is controversial. Any mention of Internet-based liaisons conjures up thoughts of sexual deviants masquerading as genuine users and a fear for the safety of impressionable youngsters. Some companies understandably remain wary of the danger that their brand will become tarnished because of some perceived association with this aspect of the Internet's seedier side. (Strategic Direction, 2008, p. 16)

SOCIAL MEDIA AND REVOLUTION

The widespread and often uncritical acceptance of ideas about the innovative uses and potentials of computer-networked "new" media generally precludes analysis of traditional media as purveyors of social discourse, community formation and even vehicles of motivation. Amidst the hype of Facebook, Twitter and whatever other technology *de jour* emerges, one may be tempted to imagine that social media is a completely new phenomenon. Moreover, the oft-drawn associations between social movements such as those in Iran during 2009 and Tunisia and Egypt in early 2011 create the notion that social media are inherently positive in their mass motivational roles. Both their novelty and benevolence, however, bear serious scrutiny and the hype may constitute a sort of consensual mass ignorance.

Social and other new media (including mobile phone technologies, blogs and several other forms) have long been valued by activists and others with a cause, and Western media coverage has emphasized their centrality to various pro-democracy revolutionary movements, particularly those that the global media covered extensively in Tunisia and Egypt. Global Information Age technologies use selective focus and the spontaneous vicarious presentation of distant realities to frame particular events and issues to the (sometimes) deliberate neglect of others. The flip side of this reality is the promotion of ignorance of both context and competing ideas—even of the simplest notions such as the fact that the nations involved have quite separate governments, histories and politics—or as Lisa Anderson (2011, p. 2) president of the American University in Cairo noted "although they shared a common call for personal dignity and responsive government, the revolutions... reflected divergent economic grievances and social dynamics."

Such a seemingly obvious statement is partly in response to the framing of the Egyptian revolution, foreshadowed as it was by events in Tunisia, and followed by uprisings in Libya, Bahrain, Yemen and Syria, as one of a sudden and spontaneous outpouring of political fervor, precipitated primarily by Egyptians' use of Facebook. Several notable critiques of these notions have been published against the tide of popular euphoria over the democratizing influence of Facebook and Twitter, though Anderson (2011, p. 2) perhaps put it best with the following powerful example of the importance of context:

> In Tunisia, protesters escalated calls for the restoration of the country's suspended constitution. Meanwhile, Egyptians rose in revolt as strikes across the country brought daily life to a halt and toppled the government. In Libya, provincial leaders worked feverishly to strengthen their newly independent republic... It was 1919... That year's events demonstrate that the global diffusion of information and expectations—so vividly on display in Tahrir Square this past winter—is not a result of the Internet and social media. The inspirational rhetoric of U.S. President Woodrow Wilson's Fourteen Points speech, which helped spark the 1919 upheavals, made its way around the world by telegraph...The Egyptian Facebook campaigners are the modern incarnation of Arab nationalist networks whose broadsheets disseminated strategies for civil disobedience throughout the region in the years after World War I.

Evgeny Morozov, author of *The Net Delusion: How Not to Liberate the World* (2011b) has warned that the Internet is also a friend of tyrants and can be a powerful tool of repression. Writing in *New Scientist*, Morozov (2011a) noted that while protestors have used social media to organize, their governments have used the same technologies to suppress dissent:

> Judging by the failed Iranian uprising of 2009, social media in particular provides dictators with all the information they need for an effective crackdown. Monitoring a revolutionary movement has never been easier—the secret police just need to collect enough tweets and pokes... Many authoritarian regimes have already established a very active presence online. They are constantly designing new tools and learning new tactics that range from producing suave online propaganda to cultivating their own easily controllable alternatives to services like Facebook or Twitter.

Additionally, repressive governments make creative use of the flood of information both true and false that faces users everyday and that, even in the limited context of particular events, can be used to foster disinformation and ignorance—sometimes by quite traditional techniques such as discrediting otherwise reliable sources. Mike Giglio (2011) described one such incident in Syria:

> When demonstrations broke out in Daraa recently, phony activists on Twitter blasted out videos of massacres, which were duly picked up by dissidents... The videos turned

out to be fakes, discrediting the type of social-media elite who were crucial news sources in countries like Egypt and Tunisia. State television, meanwhile, has broadcast selective footage of pro=government rallies around the country. "We know how to keep the devil's whispers away from us," one of its reporters recently intoned while on air. As this disinformation campaign has picked up in tandem with the popular protests, it's hard for Syrians to know what to believe.

Triumphal notions of democratization by Facebook or reform by Twitter belie a willful ignorance of historical context, even with regard to the prior fate of social media organization in the Middle East and North Africa. Some three years earlier, for example, Knickmeyer (2008, p. 1) wrote in the *Washington Post* about how an attempted rebellion organized through Facebook was crushed by the Egyptian government, outlining the experience of a 27-year-old activist named Ahmed Maher after

> 74,000 people had registered on a Facebook page created and run by Maher and a few other young Egyptians, most of them newcomers to activism... But the experience of the Facebook activists showed the limits of technology as a means of organizing dissent against a repressive government. Maher would end up among what rights groups said were 500 Egyptians arrested during two months of political activism in Egypt— and find himself stripped and beaten in a Cairo police station...

Even worse, in 2008 Facebook turned on this would-be rebel when his usage patterns offended the system's pre-determined ideas about how it should be used. According to Knickmeyer (2008, p. 1):

> In the pre-dawn hours of Sunday, May 4, the day of a planned strike, the failure of his Facebook movement was only just becoming clear... He saw a message saying his account had been shut down. He had sent so many messages, Facebook suspected him of spamming.

Thus the technologies alone were clearly not the sole determining factor in the eventually successful efforts of 2011. More relevant was the outrage among the Egyptian people stemming from the torture and killing of 27-year-old Khaled Mohamed Saeed by the Egyptian State Security Investigations Service (*Dawlat Min Mabahth*). A few months before the eventual revolution of 2011, pictures of Saeed's disfigured corpse were circulated within Egypt and among activists and sympathizers internationally. This growing outrage combined with long-standing grievances over politics and economics but came to a sharp focus when Egyptian political activist and techie Wael Ghonim launched a Facebook entitled "We are Khaled Said" which drew more than a million subscribers. Somewhat similarly, simmering economic and political tensions in Tunisia spilled over into demonstrations and revolt after Mo-

hamed Bouazizi, a street vendor, set himself on fire after being harassed by police. Despite heavy state censorship and information control, news of Bouazizi's action and the protests in its wake spread through Facebook and Twitter—but also equally through the use of mobile phones and satellite television coverage. Political, economic and social tensions therefore combined with various media strategies to achieve the will of protestors, and social media was one of many tools used in their struggles.

Bearing in mind that one of the central figures was a Western tech worker and that the promotion of Facebook as a central tool was a positive promotional tool, the discourse and coverage of what has more recently been termed "the Arab Spring" also reveals a strong bias of Western instrumentality. In an opinion for Al Jazeera English, Tarak Barkawi (2011) of the Centre of International Studies, University of Cambridge reminded us that revolutions are human events, caused not by telecommunications technologies, but by the people who live them:

> To listen to the hype about social networking websites and the Egyptian revolution, one would think it was Silicon Valley and not the Egyptian people who overthrew Mubarak... Via its technologies, the West imagines itself to have been the real agent in the uprising. Since the Internet developed out of a U.S. Defense Department research project, it could be said the Pentagon did it, along with Egyptian youth imitating wired hipsters from London and Los Angeles... Most narratives of globalisation are fantastically Eurocentric, stories of Western white men burdened with responsibility for interconnecting the world, by colonising it, providing it with economic theories and finance, and inventing communications technologies.

Mozorov (2011a) noted the further irony in the fact that Western companies are responsible for much of the surveillance and information control technologies frequently brought into the service of repressive regimes and Western governments are often complicit in the deals that make these available:

> The Egyptian government had the ability to monitor and intercept traffic passing through their networks thanks to "deep packet inspection" technology sold to state-owned Telecom Egypt by the American firm Narus (owned by Boeing). The Iranian government appears to have used similar equipment sold to them by western companies to spy on its opponents: last year the European parliament condemned Nokia Siemens for providing Iran's authorities with "censorship and surveillance technolgy." Some fear that the oppressive regime in Belarus used technology supplied by Ericsson to suppress political dissent...

The overall triumphalism of discourse regarding the so-called Arab Spring also reflects the continuing traditions of ignorance and attendant deep divisions between the West and the Arab world we have explored above. To return to the comparison with traditional mass media, social media may more properly be cast as a new coinage for a new context in which to extend processes that have been associated with media since the earliest mass audiences. Despite their enhanced interactivity, immediacy and capacity for group delineation, Internet Age social media processes may conceivably be described as extensions of the social properties of the mass audience. Members of the listening audience for the October 1938 Orson Welles radio adaptation of *War of the Worlds* were engaged in a social response to the community's shared experience of an imagined event. Elsewhere, I have demonstrated (Mohammed S. N., 2001) that a radio listening experience may be partly a social event that involves not just mass media content but also the discussions and response among audience members who participate in meaning-making processes.

This broader perspective on the social context of media leads to questions about how media in the Information Age can be used for negative social action or disinformation and ignorance outside of the specific context of the Arab Spring. The most extreme example of this may perhaps be found in Pauli's (2010) exploration of the role of radio in the Rwandan genocide of 1994 and the extent to which mass participation was prompted by the social use of radio. Pauli (2010, p. 674) noted that several factors affect the potential for a mass media message to precipitate effects:

> A message is strengthened when the media environment is limited and competing messages are weak or absent... when it is repeated over time... when it is echoed in a variety of media. Messages in the mass media may have heightened influence in a political context of instability... during large-scale social disruption... Relationships among social groups and individuals can magnify the effect of a message.

The murderous uses of radio in Rwanda resulted in the death of almost a million people, in part through a kind of social mobilization via mass media. Such disinformation and ignorance occurred while other parts of the world were experiencing the rollout of Internet technologies and celebrating new ways to communicate. Here Pauli's (2010) emphasis on the availability of alternative sources is important. The modern manifestations of social media have been characterized by a flexibility of information sources that generally provide a variety of information options. However, as the "face-mobs" of Egypt have demonstrated, multiply repeated and widely distributed information and opinions can also form waves of motivation. Where these work in the service

of democratic reform and peaceful protests, we are apt to applaud them. However, we are less likely to savor the possibility that these same mechanisms can work in the opposite direction. This may manifest itself in the mobilization of ethnic or other sectarian hate as in Rwanda, or in the use of social media (or the social uses of mass media) by oppressive political regimes.

Even outside of the politically charged crises of Egypt, Tunisia, or Iran, social media in its modern forms can contribute to political disinformation. Howard Kurtz (2010), writing in the Washington Post, noted a Pew Research Center survey that identified some 18 percent of Americans who mistakenly identified President Barack Obama as a Muslim. Furthermore, the survey found that the percentage of persons who said they did not know whether the president was Muslim or Christian had increased since his election. Kurtz (2010) associated this ignorance and disinformation in part with e-mails and websites that circulated the falsehoods which became so integrated into the public discourse as to take on the qualities of fact for many of those interviewed.

Social media, like all the media of the Information Age—including television and radio, are capable of generating laudable as well as deplorable consequences. They are, like other tools, quite dependent on the intentions of the users. What distinguishes social media is the joint and collective nature of the tool reflected in the mass movements and trends that the world has witnessed in recent years. However, the lesson of Rwanda is that collective and social uses of media are not devoid of the threat of negative consequences.

10

Reasons for Hope

In this so-called "Information Age" or "Communication Age," ironically, the missing components are reliable information and meaningful communication. Perhaps the terms "Disinformation Age" or "Babble Age" would more accurately describe this gloomy period in history.

(Kamalipour, 2010, p. 93).

If the preceding arguments paint a dismal picture of the Information Age and the persistence of both ignorance and disinformation, they necessarily beg the question of whether the Information Age can in fact serve to alleviate ignorance and disinformation, or if ignorance and disinformation can ever provide positive social effects. The use of modern information technologies such as Facebook and Twitter have enabled opposition groups in places like Iran and Egypt to mobilize information resources against rampant government propaganda and information repression and other forms of oppression. The infrastructure and conventions of the Information Age have also made it easier to spread socially valuable messages. From HIV/AIDS support groups online to literacy programs via new communication technologies in several developing countries, there are several undeniable benefits of Information Age technology and thinking. The Information Age has made information more plentiful and the myriad of information relationships more complex.

As discussed earlier, more information does not automatically mean more knowledge. Greater availability or volume of information does not lead to greater knowledge, social benefits, understanding or peace—but simply to more information. However, the very notion that increased information should necessarily be a social good is simply a social bias of the age itself. Divested of the assumption that more information should automatically result in benefits to the individual or society, sober analysis can more clearly estimate the potential of information as a tool. Like other tools, information can be used to destroy, exploit and oppress, or it can be used creatively and conscientiously, to build greater social equity, progress and peace among other edifices of prosperity.

The previous chapters have repeatedly noted that the wide availability of information creates new challenges of discrimination and evaluation. Though information is increasingly easy to obtain, determining both the veracity and the value of the knowledge is often increasingly difficult. The other side of this coin is a certain democratization of information politics in which users are free to create their own novel, often diverse, interpretations of information. Much like printing started a process of democratization of the written word, the Information Age may mark a phase of information democratization on a much larger scale. While a certain amount of ignorance and disinformation must emerge from this process, there is also the potential for innovative thinking and re-visioning of various long-held beliefs and biases. To the extent that information is freely available and despite the widespread political and commercial manipulations outlined previously, the processes of making meaning still largely rest with the information consumer who increasingly becomes the information producer as well.

Religious ideas have guided humankind's ideas about morality and provided both social order and personal solace for many generations. Some authors have suggested that religion and the need to observe and practice faith are an essential part of the human condition. Regardless of the strength of this assertion, powerful currents of religious faith-practice almost universally pervade modern society despite the widespread value placed on science and rationalism. The widespread use of new media for religious proselytizing noted above is also accompanied by the widespread ability to explore and interrogate religious ideas. Much in the same way that mass printing is thought to have reformed the dominance of the church over religious thought and practice in Europe, new media forms may enable the reformation of modern-day religious practices and beliefs through greater individual freedoms to examine and explore the founding bases of such practices and beliefs over time and in various contexts. Modern explorations of the bases of faith include access to previously suppressed texts and voice to previously suppressed dissent. Such information may result in meaningful changes to bodies of faith-practice that may be more coherent with modern science, knowledge and the evolution of ideas about social justice and human rights (including for many faith-traditions—gender equality).

Religious skepticism has traditionally been discouraged with rules against heresy and blasphemy (some of which still exist in many countries) which have served to preserve numerous anachronistic beliefs and practices. Several religious traditions and sub-groupings, for example, persist in denial of equal rights to women, advocacy of violence against others for religious purposes, denunciation of alternative sexualities, racism and numerous other ills. The

modern Information Age has fostered social dialogue in many (though not all) societies that gives voice to those marginalized under religious tradition and paves the way for reform.

ASSANGE'S WIKILEAKS AND THE EROSION OF INFORMATION PRIVILEGE

In 2010 the website WikiLeaks made international news when it released a large number of sensitive documents relating to both U.S. diplomacy and military efforts in Iraq. This was not the first set of documents or information released by the site, as it had, in preceding months, also released a wide range of documents including some pertaining to the Afghanistan war and video of a U.S. helicopter killing Iraqi civilians and Reuters journalists (Barber, 2010; Leigh & Harding, 2011).

Coverage of the largest rounds of what were termed "document dumps" provided a curious set of Information Age dynamics wherein the Internet technologies most fervently upheld as democratizing and egalitarian were suddenly being cast as threatening and dangerous on every kind of national security grounds including troop safety in battle–zones. Both traditional and new media outlets echoed calls for WikiLeaks founder Julian Assange to be tried on charges of treason. Michael Reagan, for example, writing for News-max.com (2010) argued that Assange and his co-conspirator U.S. Army soldier Bradley Manning, should be tried for treason with the following rationale:

> Julian Assange and his fellow conspirator Pvt. Bradley Manning allegedly betrayed the United States, gave aid and comfort to the terrorists who seek to destroy the United States, and if found guilty they deserve nothing less than death sentences for their unspeakable crimes... Their pitifully lame excuse that they were merely trying to provide information to the American people that was being improperly withheld from them by the government is on a par with Benedict Arnold's claim that he was merely trying to inform the British on information the American people believed they deserved to have.

While even the charge of treason against Manning faces its own particular difficulties, the assertion that Assange, an Australian citizen who owed no allegiance to the U.S. could be charged for treason against the United States was a popular assertion widely spread and widely believed but not necessarily clear in legal terms. It is perhaps possible that the vast majority of media outlets were not inclined to investigate the legal implications and requirements of treason charges. However, it is equally likely that many in the media also simply assumed that U.S. law is powerful enough to automatically cover citizens of other nations operating outside of the U.S. in any circumstance.

More important here is the relevance of the WikiLeaks dumps to the previous discussions of information privilege. The release of closely guarded information to the public evokes the polemic of free democratic speech against claims of national security, imbued as those are with notions of the "war on terror" and troop security. WikiLeaks and its mission, however, provide reason to question the absolute power of information privilege in practice if not in law. It is important to note that several laws were indeed broken by the WikiLeaks operatives and little of real consequence emerged from the large numbers of cables and other documents that were leaked. It is also not likely that information privilege will be eradicated by simple actions of law breaking and subterfuge—requiring much more complex challenges in law and changes in information culture to counteract the abuses of this and previous ages while also balancing the needs of national security against the public's right to know. Morozov (2011a) argued:

> The biggest challenge to Internet freedom lies in western democracies themselves, where law enforcement and intelligence agencies want to assert greater control over our networks. The rapid securitisation of cyberspace is particularly severe in the U.S., where the government, spooked by the WikiLeaks saga, is opting for a more aggressive watch over the Internet... The fact that the U.S. government is trying to export Internet freedom abroad while limiting it at home is not lost on its adversaries, who skillfully exploit such hypocrisy for propaganda. The push to promote Internet freedom should aim as much inward as it does outward.

SKEPTICISM

While the Information Age and its attendant (perceived) information overloads may be complicit in the persistence and creation of ignorance, new information and communication technologies have also created the means for informed skepticism. Monolithic mass media, characteristic of the start of the Information Age now exist alongside diverse and nimble forms of social and other media that can foster information skepticism. The well-informed information consumer can independently search and verify (or falsify) information in mass, new and social media using the technologies of the Information Age. Though such exploration is increasingly technically feasible, other barriers persist, including barriers of language (quickly diminishing as online translators become more popular and more efficient) and official or corporate information control. Perhaps the main barrier, however, is the lack of impetus to be skeptical. Information, provided in large quantities with little effort is taken at face value most times unless some threat or benefit is perceived. Skepticism, then, may be subject to limitations imposed by other factors of information and ignorance power.

Foucault's work warned of the social implications of social surveillance and information control while Antonio Gramsci warned of the establishment of "hegemony" through the exertion of power by dominant classes to the extent that the views of those classes came to be seen as normal and natural. These two perspectives may converge as the overwhelming power of large information corporations and governments to control information makes the act of skeptical inquiry less and less likely. Bearing in mind that surveillance enables those with information power to analyze and even predict the skeptical response (often creating ready strategies to counter oppositional thinking), it becomes evident that the dual power of information provision and information surveillance taken together may enable the creation of what might be termed "information hegemony" among information consumers. Information hegemony manifests itself in the notion that the information they consume and the perspectives they receive from powerful information players are not only correct, but also reasonable and natural.

The new technologies of communication provide the means, though not necessarily the motivation, to challenge prevailing and traditional hegemonies. Notions of new information and communication technologies as a sufficient condition for democratization or social change continue to emerge. Whether in opposition movements in Iran or revolutions in Egypt and Tunisia, excitement about the technologies eventually gives way to the realization that the human element is always necessary for change. It is in the persistence of human aspirations that we may find hope for the future of communications technologies in the service of enlightenment rather than ignorance.

THE GLOBAL PUBLIC SPHERE

While McLuhan's Global Village may not have materialized, something equally important has—a global sphere of public discourse—or at least the potential for one. Stichweh has argued (2003) that the genesis of a global public sphere may be traced back to the *respublica Christiana* and its importance in medieval Europe. However, several developments were needed—including secularization and the spread of the notion of global to include those outside of both Europe and Christendom for development of the broader ideas of the public sphere. Today, the public sphere is most commonly conceptualized in terms delineated by Jürgen Habermas (1962). From the early spread of the networked computer communications systems the notion of a global public sphere was limited to small groups, often of elites or specific interest communities who were geographically scattered. The emergence of broader new media use, the reduced costs of access and the popularity of social media have enabled global discourse in theory. In practice, many of the global

discussions feature persistent tropes of distrust and ignorance but recent events have pointed to the possibilities that exist within the technologies.

While the role of social media has been, perhaps overemphasized as a driving force in the Middle East's popular uprisings of early 2011, the reality did include use of such media for communication between and among diverse populations. Despite language barriers, users from diverse countries were drawn to the Facebook pages and groups supporting the movement to express solidarity and support. This kind of involvement was one of the key factors that Pappacharisi (2002) identified as being necessary for revitalization of the public sphere. Pappacharisi (2002, p. 16) characterized as "Utopian" the perspectives that speculated that "computer-mediated political communication will facilitate grassroots democracy and bring people all across the world closer together." Yet, it might be argued that, on an admittedly limited scale, something just like that occurred in the case of Egypt's popular political uprising.

Further, outside of the purely political, there are several other areas of global discourse that may benefit from global media and the Information Age ability to transcend borders. Important among these is the facilitation of religious and cultural dialogue. While many websites and online systems (as well as traditional mass media) still enable traditions of division, exclusion and conflict among cultures and religions, the ability to communicate across traditional boundaries may in itself provide the means for understanding. A common error in this regard is to assume that organized efforts at mutual discourse are the only appropriate approach to dialogue. Yet, the ability to communicate brings with it the notion of community in the sense of coming together much more powerfully than staged or organized efforts. Turner (2008, p. 233) reflected that

> perhaps the real effect of globalization is the triumph of heterodox, commercial, hybrid popular religion over orthodox, authoritative, professional versions of the spiritual life. Their ideological effects cannot be controlled by religious authorities, and they have a greater impact than official messages.

THE LOCAL CONTEXT

The global scope of new information technologies tends to invite analyses that are themselves global in scope. Yet even in the relatively new manifestations of the networks such as Facebook, certain local uses suggest that communities can make use of the technologies for developing and supporting local ties. According to Macnamara (2010, p. 264), for example, "while the Internet facilitates globalization of information and culture, particularly when used by large media organizations, it also opens up opportunities for new levels of

micro-local communication." Stewart (2007, p. 548) similarly drew attention to what he terms the "domestication" of Information and Communication Technologies in their evolution within various local contexts. Davies and Crabtree (2004) have suggested that modern digital communication networks do not primarily feature simple metropolitan-centered networks with marginal external communities but rather, a complex mix of diasporic, local and transnational conversations on the networks that are not easily separated into distinct domains.

As we have considered earlier, the digital networks of the Information Age have provided the means and the opportunity for local communities to communicate more effectively despite their global scope. In terms of human and social development, the means to more effectively build strong local communities through global media provides reason for hope that communities could become more cohesive and engage in meaningful and productive debates leading to economic and social well-being. At a much more mundane level, community activities and business stand to benefit from such communications.

TACIT KNOWLEDGE

Sociologists have used the term "tacit knowledge" to refer to the set of general assumptions that people in a given society share on particular issues (Husserl, 1962; Schütz, 1967). Intercultural communications sometimes refers to a similar idea as "cultural assumptions." Whichever terms might be used, scholars of human societies have argued for the existence of common assumed knowledge upon which societies and social understandings are constructed. Cropf and Casaregola (1996), for example, argued that even our very assumptions about knowledge and information are culture bound. These terms are similar to (but not interchangeable with) some of the business literature that concerns itself with the distinction between tacit and explicit knowledge in organizations, particularly since the broader sociological scope considers the tacit (and often foundational) social and cultural assumptions of entire societies.

When fundamental social and cultural assumptions are often discovered to be flawed, questioning them may lead to social change. However, questioning these assumptions can be a difficult process if only for their assumed naturalness and the consequent self-fulfilling logic of their necessity and functions. In the Information Age, most media (old and new) portrayals are still primarily guided by such assumptions, although the opening of the mediascape to all voices has also led to a greater ability to step outside of these

assumptions—particularly by giving voice to those "othered" by these assumptions.

Traditional assumptions in the modern West, for example, about the superiority of heterosexual unions and the presumed deviance of homosexuality have changed over recent decades with the aid of mass media and new media information providing exposure to alternative perspectives. The Information Age, for all its disinforming potential and its promotion of hate, can also be the means of questioning biased and unjust tacit assumptions about others and about the world.

Older media forms have traditionally been controlled by gatekeepers who would operate under and replicate the tacit assumptions of their communities and audiences. The existence of relatively few media outlets allowed for this replication to continue for several decades. The coming of global media and de-massified media forms including the World Wide Web and social media removed not only the gatekeepers but also the tacit assumptions that guided their casting of both news and program content. The Information Age has seen the development of myriad channels even of traditional media where varieties of social expressions may be found—among them various ethnic and cultural groups; gay, lesbian and transgendered communities; and various political groups. It is in this free marketplace of ideas that the Information Age provides the means for challenging traditional and tacit assumptions about social realities.

By way of a caveat, however, the mainstream media are still largely controlled by dominant elites in most countries. In such contexts, alternative viewpoints may find the means of expression but the commercial and social dominance of traditional mass media forms may continue foster the marginalization of alternative information communities unless their ideas can also inhabit the public sphere.

OBSCENITY, CENSORSHIP AND IGNORANCE

A prevailing tacit assumption that has been made explicit as law in the United States is the so-called community standard. This principle governs the determination of what constitutes obscenity in the United States and is predicated on the tacit assumption that communities possess uniform standards of morality—particularly with regard to sexual expression. The globalized media environment has, for some time, made this assertion largely irrelevant in a globalized media environment where users share materials not just across communities but also across state, national and cultural boundaries. Nair (2007, p. 19) commented on the problem of the community standard when applied to the Internet, writing:

Something that may be perfectly legal in New York may be offensive and illegal in Tennessee. Regulation in the traditional forms of media did not pose much of a problem as, if in the case of print, all the publisher needed to ensure was that the material is not disseminated to any state where the content would be illegal. However, the Internet changed this scenario as "publication" on the Internet was not geographically constrained and if the same rules that apply to the offline world were extended to the Internet, any publication should confirm to the strictest community standard within the U.S.A.

While the use of the community standard remains constitutional in the United States, Nair (2007) noted the many difficulties of enforcing such a standard on a national and international medium such as the Internet. The Information Age brings, for some, the specter of uncensored sexual expression and discussion. For others, the same technologies bring promises of freedom of speech to many who have hitherto not enjoyed that luxury. On an international scale, users can and do use the technologies of the modern Information Age to challenge the imposed ignorance of information restrictions such as censorship. Whether the content might be of a sexual, political or religious nature, Information Age communication technologies have created a dynamic of governmental censorship imposition and user censorship avoidance in many nations.

Censorship has often been predicated on the moral and philosophical taboos surrounding sexual expression in many (including Western) cultures and the perceptions of obscenity associated with such expressions. In places such as Saudi Arabia and Kuwait, religious pretexts are used to enforce censorship that serves political needs. Samin (2008, p. 199) for example, characterized the Saudi government's information control efforts as "one of the most extensive Internet monitoring and censorship regimes in existence" explaining that

> twenty-five Internet service providers are authorized to compete for business and all are answerable to a central Internet oversight and censorship body, the Internet Services Unit of the King Abd Al-Aziz City for Science and Technology.

While censorship was feasible and successful in the age of traditional mass media, the emerging media forms of the modern Information Age including the Internet, social media and even mobile phone multimedia technologies have enabled users to seriously challenge government censorship efforts. Despite being illegal in both countries, for example, the use of proxy servers to bypass government restrictions is both easy and widespread, though there is something of a cat and mouse game in which the government seeks to block proxy-enabling sites and users scramble to continually find new ones. These

conservative governments have also been largely impotent to stem the flow of sexual content, discussions and even "illicit" liaisons that proliferate via mobile phone and Bluetooth technologies. As Braude (2006) described it:

> In patriarchal societies like Saudi Arabia and Kuwait or hard-line regimes like Iran, methods for preventing unchaperoned dating range from legal restrictions on non-familial mixing between the sexes to tough social taboos... Mobile phones, now widely in use by teens and young adults throughout the Middle East, enable swinging singles to tiptoe around these roadblocks... And thanks to Bluetooth technology, which renders phone numbers unnecessary by enabling short-range, anonymous signaling, it's even possible for a boy and a girl to meet and mingle without any prior arrangement... Small wonder some Muslim clerics in the gulf region and elsewhere have called for a Bluetooth ban... (n.p.)

As titillating as these accounts may be, it is more than access to casual encounters and pornography that drives the information dynamic. Users also spar with government forces on the free expression of political ideas—one instance of this may be found in the case of Mohammad Abdul-Kader Al-Jassem, a Kuwaiti blogger jailed by that country's government in May of 2010 for daring to criticize the king (emir) and other members of the hereditary and permanent ruling family. The evolving media forms of the Information Age pit users and creative applications of the technologies against these governments and their traditional bias towards the imposition of ignorance. Foucault's power-information relationship and the role of surveillance are implied in Morozov's (2011) observation that the governments in the region have themselves been evolving in their efforts at suppression:

> It used to be that authoritarian regimes could tame the web simply by filtering or blocking "harmful" websites. Anyone who wanted to gain access to them would then need to use proxies and tools to get round censorship... Now authoritarian governments rely on a rapidly expanding panoply of tools and tactics that range from distributed denial-of-service attacks to make websites temporarily unavailable, to spreading malware that helps them to spy on dissidents remotely.

To return to the popular uprisings in Egypt, Tunisia and elsewhere in the Middle East and North Africa, the dynamic of ignorance (as information suppression, isolation, or surveillance) and information has also been evident. Despite widespread exultation in the role of Facebook, Twitter and other social media in those movements, government shutdowns of Internet service and even mobile phone service remind us of this continuing dynamic. Disinformation and ignorance as a part of the policy of repressive governments remain a reality in today's world. New media forms—coupled with the aspirations of vast portions of humanity to resist the yoke of information control

enable movements to overthrow not just old governments, but also old ideas and old ignorance.

Epilogue: The End of the World

The apocalypse, a Christian conceptualization (related to earlier Judaic ideas) of the conclusion of life on earth has persisted throughout modern times. Collins (2000, p. 41) defined apocalypse as "a genre of revelatory literature with a narrative framework in which a revelation is mediated by an otherworldly being to a human recipient, disclosing a transcendent reality which is both temporal, insofar as it envisages eschatological salvation, and spatial, insofar as it involves another, supernatural world." Stewart and Harding (1999, p. 286) explained:

> The term apocalypse (derived from the Greek apokalupis, meaning uncover or disclose) refers most narrowly to the revelation of John recorded in the New Testament Book of Revelation. During the Middle Ages, it came also to refer to any revelation, prophecy, or vision of the end of history and the current world order, or to the end-time events themselves.

More commonly, the apocalypse is understood as a set of beliefs related to the end of times or life on earth as we know it. O'Leary (1994, p. 7) writes:

> Apocalypse has been a dominant theme in Christian culture for over two thousand years... In addition to the importance of apocalyptic myth in Judaism and the early Christian church, the rhetoric of apocalypse has been used by such diverse communities as the imperial and papal parties struggling for power in thirteenth-century Europe, by Luther and the German Protestants in their battle against the papacy, by the English Puritans as they fought against the Anglican church and the royalists, and by modern evangelists arguing against ecumenism, pacifism, and the nuclear freeze movement.

THE MILLERITES AND OTHER GREAT DISAPPOINTMENTS

Though certainly not the only instance, the case of the Millerites remains one of the most famous examples of apocalyptic prediction and preparation. Corfield (2007, p. 39) described their experience as follows:

> When William Miller, a Vermont farmer, declared October 22nd, 1844 to be the date of doomsday an estimated 100,000 Protestants in the U.S.A and Britain stopped work and made ready. There followed the "Great Disappointment." "Still in the cold world! No deliverance—the Lord not come!" sighed one disillusioned believer on October 23rd. Nevertheless, the keenest Millerites were not deterred. They argued that the

1844 debacle was but a stage in a greater scenario and re-founded the church as the Seventh-Day Adventists.

History is replete with apocalyptic visions in several different religious and cultural traditions, all of which have turned out to be untrue in any global sense—though particular societies may have seen the end of their way of life for reasons other than divine termination. Stewart and Harding (1999, p. 289) described the scale and frequency of apocalyptic visions in the following terms:

> Since the colonial period, hundreds of movements, revivals, communities, and insti-tutions—short-lived and long-lasting, violent and pacific, prosaic and bizarre—have been fashioned, in part, after biblical texts and visions pertaining to endtime, immi-nent cataclysm, judgment, and redemption: the Shakers, the Oneida community, the Burned-Over District, the Millerite movement, Mormonism, the Jehovah's Witness, the Disciples of Christ, Seventh-Day Adventism, dispensationalism and the Bible prophecy movement, the Social Gospel, the Nation of Islam, the Garveyites, the Ras-tafarians, Jonestown, the Branch Davidians, Heaven's Gate, and visions of Mary, to name a few.

In most cases, apocalyptic predictions have simply turned out to be unful-filled—with followers having to recast their ideas in the best cases. In other cases, adherents have found themselves in much more dire circumstances. One such case (which Stewart and Harding referred to above simply as "Jonestown") was the death of almost a thousand people under the leadership of Jim Jones at the Jonestown settlement in Guyana in 1978.

APOCALYPSE IN THE INFORMATION AGE

The repeated failure of prophecies of the apocalypse has not diminished the popularity of apocalyptic discourse and fascination among both true believers and the merely curious. Michael (1999), for example, referred to the resurgence of interest in apocalyptic ideas and literature during the latter half of the twentieth century, citing several influential academic studies such as Klaus Koch's *Rediscovery of Apocalyptic* (1972) and Ernst Käsemann's "The Beginnings of Christian Theology" (1969).

These relatively esoteric academic and theological excursions were accom-panied by a popular resurgence of apocalyptic ideas in the broader modern information era. The popularity of Hal Lindsey's repeated (failed) apocalyptic pronouncements such as *The Late Great Planet Earth* (1970) and Lindsey's continuing popularity bear testimony to this phenomenon. Lindsey continues to appear in books, magazines, on television and even on his own website making not just apocalyptic pronouncements, but also commentaries on a wide range of geopolitical issues. *Time* magazine (Sullivan, 2008) quoted

Lindsey from an online essay he wrote associating then candidate Barack Obama with the mythical Anti-Christ:

> Obama is correct in saying that the world is ready for someone like him—a messiah-like figure, charismatic and glib... The Bible calls that leader the Antichrist. And it seems apparent that the world is now ready to make his acquaintance.

O'Leary (1994, p. 7) made particular note of the role of mass media in the popularity of such ideas, writing, "the apocalyptic messages of preachers such as Jimmy Swaggart and Jerry Falwell have found increasingly wider audiences through the media of radio, television, and film." O'Leary (1994) nuanced his emphasis on the role of mass media, however, with the argument that the emergence of nuclear warfare in the modern age played into apocalyptic discourse by presenting a situation in which the threat of planetary destruction was made far more real to a broader range of people than strictly evangelical or fundamentalist believers.

Yet surely in our modern Information Age, post-television and deep into the era of the Internet, the World Wide Web, social media and global news networks, one would think that these ideas have faded away. But they have not. As I write this epilogue, I am forced to contemplate the most important event of this day—and perhaps any day—the end of the world. Despite the availability of copious sources of information—including religious information that clearly states (as in the Biblical book of Matthew, 24:36), that the end of time is not known to any except God the father, a small, fringe group of biblical interpreters has been able to launch a highly visible campaign insisting that May 21, 2011 marks the end of days (which, if you are reading this, turned out to be untrue). According to Time.com (Gibson, 2011):

> The movement, led by Harold Camping, who runs the Evangelical network Family Radio, is predicting that mid-May of this year will bring about Judgment Day—the time when, according to some, the earth will be destroyed because of mankind's sins and all Christian believers will ascend to heaven... Apparently Camping believes this will occur on May 21 on the basis of a mathematical system he created to interpret prophecies hidden in the Bible... It's worth noting that this isn't the first time that Camping has predicted the end of the world... He originally used his mathematical system to predict that Sept. 6, 1994, would be Judgment Day.

While most people do not take such pronouncements seriously (perhaps a boon of the Information Age), the very fact of the widespread popularity of this idea and the fact that the movement raised 80 million dollars in contributions bears some testimony to the persistence of ignorance and its global scale,

summed up in the British newspaper, *The Telegraph* which noted in an early report on the morning of May 21, 2011 (The Telegraph, 2011):

> Inhabitants of New Zealand, scheduled to be among the first to meet the apocalypse according to a U.S. fundamentalist preacher, this morning confirmed they were still in existence as the appointed time was reached in their time zone... Eighty-nine-year-old tele-evangelist Harold Camping had prophesied that the "Rapture" would begin with powerful earthquakes at 6pm in each of the world's regions, after which the good would be beamed up to heaven... This morning, Kiwis confirmed there were no signs of the dead rising from the grave, nor of the living ascending into the clouds to meet Jesus Christ... Twitter users were disappointed by the absence of Armaggedon.

Both internationally and in towns across the United States, the issue garnered attention—which though mostly sardonic, was pervasive all the same. In Grand Rapids, Michigan, Reimink (2011) wrote that Judgement Day in the digital age included the following:

> Facebook users are promoting worldwide post–Rapture looting today, followed by a massive party for the left-behind masses... Atheists have set up websites offering to care for pets whose owners are Raptured away. A service called You've Been Left Behind offers to manage the online identities of those who ascend to heaven. Online stores are full of Judgment Day memorabilia.

More instructive, however, was this journalist's observations on the larger implications of the end-of-days story when he noted that "dismissible as Camping's teachings might be, more than 40 percent of Americans do believe Jesus will return before 2050, according to the Pew Research Center," and cited Jennifer Beahan, assistant director of the Center for Inquiry of Michigan, who described that percentage as "a sad state of affairs" saying that "I think the takeaway is we need to stop basing our beliefs on superstition and numerolgy."

I would tend to agree.

Bibliography

ABC News. (2010, January 14). Haiti swore a pact to the devil; Pat Robertson's shocking statement (Transcript). *Good Morning America*.

Abelman, R. (1990). News on the "700 Club" after Pat Robertson's political fall. *Journalism Quarterly, 67*(1), 157-162.

Abelman, R., & Neuendorf, K. (1985). How religious is religious television programming? *Journal of Communication, 35*(1), 98-110.

Abelman, R., & Pettey, G. R. (1988). How religious is religious television? *Journalism Quarterly, 65*(2), 313-319.

Acquisti, A., & Gross, R. (2006). Imagined communities: Awareness, information sharing, and privacy on the Facebook. *Lecture Notes in Computer Science, 4258*, 36-58.

Addams, J. (1909). *The spirit of youth and the city streets*. New York: Macmillan Company.

Afshari, R. (2009). A historic moment in Iran. *Human Rights Quarterly, 31*(4), 839-856.

Aguolu, I. E. (1997). Accessibility of information: a myth for developing countries? *New Library World, 98*(1132), 25.

Allison, K., & Van Duyn, A. (2007, November 7). Facebook seeks "Holy Grail" of online advertising. *Financial Times*, p. 15.

Altheide, D. L., & Grimes, J. N. (2005). War programming: The propaganda project and the Iraq War. *The Sociological Quarterly, 46*(4), 617-643.

Anderson, B. (1983). *Imagined communities: Reflections on the origin and spread of nationalism*. London: Verso.

Anderson, L. (2011). Demystifying the Arab spring: Parsing the differences between Tunisia, Egypt, and Libya. *Foreign Affairs, 90*(3), 2-7.

Androutsopoulos, J. (2006). Multilingualism, diaspora, and the Internet: Codes and identities on German-based diaspora websites. *Journal of Sociolinguistics, 10*(4), 520-547.

Anonymous. (2009). Rush Limbaugh: The master of racial poison. *The Journal of Blacks in Higher Education, 64*(1), 15.

Anyefru, E. (2008). Cyber-nationalism: The imagined Anglophone Cameroon community in cyberspace. *African Identities, 6*(3), 253-274.

Atay, A. (2009). How Facebook is changing student-teacher relationships. *Rocky Mountain Communication Review, 6*(1), 71-74.

Austin, S. (1987). The paradox of Socratic ignorance (how to know that you don't know). *Philosophical Topics, 15*(2), 23-34.

Ayoob, K. T., Duyff, R. L., & Quagliani, D. (2002). Position of the American Dietetic Association: Food and nutrition misinformation. *Journal of the American Dietetic Association, 102*(2), 260–266.

Bagdikian, B. (2004). *The new media monopoly*. Boston, MA: Beacon Press.

Barber, L., & Pearce, K. (2008). The effects of instructor Facebook participation on student perceptions of teacher credibility and teacher attractiveness. Paper presented at the annual meeting of the International Communication Association, TBA, Montreal, Quebec, Canada Online. Retrieved from http://www.allacademic.com/meta/p231890_index.html.

Barber, M. (2010, November 28). A WikiLeaks timeline. *The National Post*. Retrieved from http://news.nationalpost.com/2010/11/28/a-wikileaks-timeline/.

Barkawi, T. (2011, March 21). The globalisation of revolution: Revolutions are caused by human agency; not telecommunications technologies, scholar argues. Retrieved from http://english.aljazeera.net/indepth/opinion/2011/03/2011320131934568573.html.

Barns, G. (2009, February Monday). Virtual world's darker side. *Hobart Mercury (Australia)*, p. 26.

Barstow, D., Stein, R., & Kornblut, A. E. (2005, March 13). Under Bush, a new age of prepackaged news. *The New York Times*, p. 1.

Barthes, R. (1957). *Mythologies*. Paris: Seuil.

Bartlett, C. J., & Green, C. G. (1966). Clinical prediction: Does one sometimes know too much? *Journal of Counseling Psychology, 13*(3), 267–270.

Bauer, M. (1996). Socio-demographic correlates of DK-responses in knowledge surveys: Self-attributed ignorance of science. *Social Science Information, 35*(1), 39–68.

Baumann, M. (2009, Oct). A political revolution goes viral... not so fast. *Information Today, 26*(9), 1–3.

Bawden, D., & Robinson, L. (2009). The dark side of information: Overload, anxiety and other paradoxes and pathologies. *Journal of Information Science, 35*(2), 180–191.

BBC News. (2007, May 22). Breastfeeding fatwa causes stir. Retrieved from http://news.bbc.co.uk/go/pr/fr/-/2/hi/middle_east/6681511.stm.

BBC News. (2009, January 5). Scientists dismiss "detox myth." Retrieved from http://news.bbc.co.uk/2/hi/7808348.stm

Beck, G. L. (2009). *Arguing with idiots: How to stop small minds and big government*. New York: Simon and Shuster.

Beelman, M. S. (2001). The dangers of disinformation in the war on terrorism. *Nieman Reports, 55*(4), 16–18.

Bell, D. (1973). *The coming of post-industrial society*. New York: Basic Books.

Berne, P., Condry, J., & Scheibe, C. (1988). Nonprogram content of children's television. *Journal of Broadcasting and Electronic Media, 32*(3), 255–270.

Bishop, R., & Phillips, J. (2006). Ignorance. *Theory, Culture & Society, 23*(2–3), 180–182.

Boyd, D. M., & Ellison, N. B. (2007). Social network sites: Definition, history, and scholarship. *Journal of Computer-Mediated Communication, 13*(1), Article 11.

Braude, J. (2006, October 15). Bluetooth is for lovers in Kuwait / Wireless becomes the mating call of choice in Muslim countries. Retrieved from http://articles.sfgate.com/2006-10-15/opinion/17314737_1_gulf-region -text-messages-bluetooth.

Brenner, S. (2010). *Cybercrime: Criminal threats from cyberspace.* Santa Barbara, CA: ABC-CLIO.

Briggle, A., & Mitcham, C. (2009). From the philosophy of information to the philosophy of information culture. *The Information Society, 25,* 169–174.

Briggs, A., & Burke, P. (2002). *A social history of the media: From Gutenberg to the Internet.* Hoboken, NJ: Wiley-Blackwell.

Britto, S., & Dabney, D. (2010). Fair and balanced? Justice issues on political talk shows. *American Journal of Criminal Justice,* 1–21.

Broderick, J. F., & Miller, D. W. (2007). *Consider the source: A critical guide to 100 prominent news and information site on the Web.* Medford, NJ: Information Today Inc/CyberAge Books.

Brown, D. (2003). *The Da Vinci code.* New York: Doubleday.

Brown, G. (2001, October 16). Mutual misperceptions: The historical context of Muslim-Western relations. Retrieved from http://www.aph.gov.au/ library/pubs/cib/2001-02/02cib07.htm.

Brown, P. G. (2008). Choosing ignorance within a learning universe. In B. Vitek, & W. Jackson (Eds.), *The virtues of ignorance: Complexity, sustainability, and the limits of knowledge* (pp. 165–188). Lexington: The University Press of Kentucky.

Brummett, B. (1988). The homology hypothesis: Pornography on the VCR. *Critical Studies in Media Communication, 5*(3), 202–216.

Brunvand, J. H. (1981). *The vanishing hitchhiker: American urban legends and their meanings.* New York: W. W. Norton and Company Inc.

Bryan, C., Tsagarousianou, R., & Tambini, D. (1998). Electronic democracy and the civic networking movement in context. In C. Bryan, R. Tsagarousianou, & D. Tambini (Eds.), *Cyberdemocracy: Technology, cities and civic networks.* (pp. 1–17). London: Routledge.

Bryant Bell. (2010). Comment: The curious case of Kevin Trudeau, king of catch me if you can. *Mississippi Law Journal, 79*(4), 1043-1072.

Buhler, S. M. (2002). Reviving Juliet, repacking Romeo: Transformations of character in pop and post-pop music. In R. Burt (Ed.), *Shakespeare after mass media* (pp. 243-264). New York: Palgrave.

Burgess, J. (2008). "All your chocolate rain are belong to us?" Viral Video, YouTube and the dynamics of participatory culture. In G. Lovink, & S. Niederer(Eds.), *Video vortex reader: Responses to YouTube* (pp. 101-109). Amsterdam: Institute of Network Cultures.

Burke, P. (2000). *A social history of knowledge: From Gutenberg to Diderot.* Cambridge, UK: Polity Press.

Burton, E. K. (2010, May-Jun). Teaching evolution in Muslim states: Iran and Saudi Arabia compared. *National Center for Science Education Reports*, pp. 25-29.

Cairncross, F. (1997). *The death of distance: How the communications revolution will change our lives.* Boston, MA: Harvard Business School Press.

Campbell, H. (2010). *When religion meets new media.* Oxon, UK: Routledge.

Carey, J. W. (2005). Historical pragmatism and the Internet. *New Media & Society, 7*(4), 443-455.

Carvalho, A. (2007). Ideological cultures and media discourses on scientific knowledge: Re-reading news on climate change. *Public Understanding of Science 16*(2), 223-243.

Carver, R. P. (1973). Effect of increasing the rate of speech presentation upon comprehension. *Journal of Educational Psychology, 65*(1), 118-126.

Castells, M. (2000). *The rise of the network society, The Information Age: Economy, society and culture* (2nd ed., Vol. 1). Cambridge, MA: Blackwell.

Cavalli-Sforza, L., Menozzi, P., & Piazza, A. (1994). *The history and geography of human genes.* Princeton, NJ: Princeton University Press.

Center for the Renewal of Science and Culture. (1999). *The wedge.* Seattle, WA: The Discovery Institute.

Chew, W. L. (2001). "Literature, history and the social sciences: An historical-imagological approach to Franco-American stereotypes." In W. L. Chew (Ed.), *National stereotypes in perspective: Americans in France, Frenchmen in America* (pp. 1-54). Amsterdam: Editions Rodopi B.V.

Chopoidalo, C. (2009). The possible worlds of Hamlet: Shakespeare as adaptor, adaptations of Shakespeare. *PhD Thesis.* Edmonton: University of Alberta.

Christensen, C. (2006). God save us from the Islam clichés. *British Journalism Review, 17*(1), 65-70.

Clarke, R. (1988). Information technology and dataveillance. *Communications of the ACM, 31*(5), 498–512.

Clarke, S. (2002). Conspiracy theories and conspiracy theorizing. *Philosophy of the Social Sciences, 32*(2), 131–150.

Cleveland, H. (1985). The twilight of hierarchy: Speculations on the global information society. *Public Administration Review, 45*(1), 185–195.

CNN World. (2005, August 23). Former aide: Powell WMD speech "lowest point in my life." Retrieved from http://articles.cnn.com/2005-08-19/world/powell.un_1_colin-powell-lawrence-wilkerson-wmd-intelligence?_s=PM:WORLD.

Cohen, F. (2003, April). Internet fraud: Mythical online scams. *Computer Fraud & Security, 2003*(4), 19.

Cohen, S. (1972). *Folk devils and moral panics.* Oxford: Basil Blackwell.

Coleridge, S. T. (2006[1798], March 11). *The rime of the ancient mariner.* Retrieved from http://www.gutenberg.org/files/151/151-h/151-h.htm

Collins, J. J. (2000). Apocalyptic literature. In C. A. Evans, & S. Porter (Eds.), *Dictionary of New Testament backgrounds* (p. 41). Downers Grove, IL: Inter-Varsity Press.

Collins, S. (2010). Digital Fair: Prosumption and the fair use defence. *Journal of Consumer Culture, 10*(1), 37–55.

Comfort, R. (2008). *Evolution: A fairy tale for grownups: 101 questions to shake believers.* Alachua, FL: Bridge-Logos.

Cook, S. D. (1995). The structure of technological revolutions and the Gutenberg myth. In J. C. Pitt (Ed.), *New directions in the philosophy of technology* (pp. 63–84). Dordrecht, The Netherlands: Kluwer Academic Publishers.

Corfield, P. J. (2007). The end is nigh. *History Today, 57*(3), 37–39.

Cortese, A. (2006). *Opposing hate speech.* Westport, CT: Praeger.

Cranor, L. F., & La Macchia, B. A. (1998). Spam! *Communications of the ACM, 41*(8), 74–83.

Cronin, C. (2003). Kant's politics of enlightenment. *Journal of the History of Philosophy, 41*(1), 51–80.

Cropf, R. A., & Casaregola, V. (1996). Community and information networks in hypermedia culture: Constructing a new social epistemology. *Bulletin of Science, Techology and Society, 16*(3), 157–166.

Cross-Tab Inc. (2010). *Online reputation in a connected world.* New York: Cross-Tab Inc.

Croteau, D., & Hoynes, W. (2003). *Media society: Industries, images and audiences.* Thousand Oaks, CA: Pine Forge Press.

Dalsgaard, S. (2008). Facework on Facebook: The presentation of self in virtual life and its role in the US elections. *Anthropology Today, 24*(6), 8–12.

Daniels, J. (2009). Cloaked websites: Propaganda, cyber-racism and epistemology in the digital era. *New Media & Society, 11*(5), 659–683 .

Davies, W., & Crabtree, J. (2004). Invisible villages: Technolocalism and community renewal. *Renewal 12*(1). Retrieved from http://www.renewal.org.uk/issues/2004%20Voulme%2012/Invisible%20Villages.htm.

Davis, A. (2009, December 17). Social media sees breakthrough year. *Media*, p. 12.

Day, K. (1991, February 15). Discovery channel to buy educational cable network. *Washington Post*, p. F3.

De Landa, M. (1991). *War in the age of intelligent machines*. Cambridge, MA: MIT Press.

Deleuze, G. (1995). *Negotiations: 1972–1990*. New York: Columbia University Press.

Don Stewart Association. (2010). Green prosperity prayer handkerchief. Retrieved from http://www.donstewartassociation.org/page.aspx?pid=253.

Donovan, P. (2002). Crime legends in a new medium: Fact, fiction and loss of authority. *Theoretical Criminology, 6*(2), 189–215.

Donovan, P. (2007). How idle is idle talk? One hundred years of rumor research. *Diogenes, 54*(1), 59–82.

Douglas, K. M., & Sutton, R. M. (2008). The hidden impact of conspiracy theories: Perceived and actual influence of theories surrounding the death of Princess Diana. *The Journal of Social Psychology, 148*(2), 210–221.

Douthwaite, R. (1999). *The growth illu$ion: How economic growth has enriched the few, impoverished the many and endangered the planet* (Revised and Updated Edition). Gabriola Island, BC: New Society Publishers.

Drucker, P. F. (1999). Beyond the information revolution. *Atlantic Monthly, 284*(4), 47–57 .

Dugger, R. (2000). The corporate domination of journalism. In W. Serrin (Ed.), *The business of journalism* (pp. 27–56). New York: The New Press.

Durham, W. H. (1990). Advances in evolutionary culture theory. *Annual Review of Anthropology, 19*(1), 187–210.

Dvorak, J., Pirillo, C., & Taylor, W. (2003). *Online! The book*. Upper Saddle River, NJ: Prentice Hall.

Dysart, J. (2010, October 11). Social media sites can hurt job seekers. *Transport Topics, 3916*, p. A18.

Echchaibi, N. (2008). Hyper-Islamism? Mediating Islam from the halal website to the Islamic talk show. *Journal of Arab and Muslim Media Research, 1*(3), 199–214.

Edgecliffe-Johnson, A., & Fenton, B. (2010, March 3). Discovery plans expansion of TLC channel into 75 markets. *Financial Times,* p. 17.

Ehrlich, P. R., & Ehrlich, A. H. (1996). *Betrayal of science and reason: How anti-environmental rhetoric threatens our future.* Washington, DC/Covelo, CA: Island Press/Shearwater Books.

Einstein, A. (1949). Why socialism? *Monthly Review, 1*(1), 1–13.

Elgin, S. H. (1995). A feminist is a what? *Women and Language, 13*(2), 46.

Ellison, N. B., Steinfeld, C., & Lampe, C. (2007). The benefits of Facebook "friends": Social capital and college students' use of online social network sites. *Journal of Computer-Mediated Communication, 12*(4), 1134–1168.

Elmer-Dewitt, P., & Dowell, W. (1995, July 24). Fire storm on the computer nets. *Time, 146*(4), p. 57.

Elmer-DeWitt, P., Bloch, H., Cole, W., & Epperson, S. E. (1995, July 3). Online erotica: on a screen near you. *Time, 146*(1), pp. 38–45.

Entman, R. M. (1993). Framing: Toward clarification of a fractured paradigm. *Journal of Communication, 43*(4), 51–58.

Ernst, E. (1997). Colonic irrigation and the theory of autointoxication: A triumph of ignorance over science. *Journal of Clinical Gastroenterology, 24*(4), 196–198.

Featherly, K. (2003). Communications Decency Act. In S. Jones, *Encyclopedia of new media: An essential reference to communication and technology* (pp. 76–79). Thousand Oaks, CA: Sage.

Feder, K. L. (1984). Irrationality and popular archaeology. *American Antiquity, 49*(3), 525–541.

Federal Trade Commission (FTC) Office of Public Affairs. (2007a, June 25). Kevin Trudeau banned from infomercials. Retrieved from http://www.ftc.gov/opa/2004/09/trudeaucoral.shtm.

Federal Trade Commission (FTC) Office of Public Affairs. (2007b, September 14). FTC: Marketer Kevin Trudeau violated prior court order. Retrieved from http://www.ftc.gov/opa/2007/09/trudeau.shtm

Federal Trade Commission (FTC) Office of Public Affairs. (2009, January 28). FTC charges marketers of kinoki foot pads with deceptive advertising; seeks funds for consumer redress. Retrieved from http://www.ftc.gov/opa/2009/01/xacta.shtm

Federal Trade Commission (FTC) Office of Public Affairs. (2010, August 12). FTC to announce action against Internet marketers of açai berry weight-

loss pills and "colon cleansers." Retrieved from http://www.ftc.gov/opa/2010/08/açaicolon_ma.shtm.

Feldstein, M. (2004). Kissing cousins: Journalism and oral history. *The Oral History Review, 31*(1), 1-22.

Fernback, J. (2003). Legends on the net: An examination of computer-mediated communication as a locus of oral culture. *New Media & Society, 5*(1), 29-45.

Fine, G. A. (1985). The Goliath effect: Corporate dominance and mercantile legends. *The Journal of American Folklore, 98*(387), 63-84.

Flicker, E. (2003). Between brains and breasts—women scientists in fiction film: On the marginalization and sexualization of scientific competence. *Public Understanding of Science, 12*(3), 307-318.

Floridi, L. (2009). The information society and its philosophy: Introduction to the special issue on "The philosophy of information, its nature, and future developments." *The Information Society, 25*, 153-158.

Forsythe-Brown, I. (2006). Maintaining a transnational family: A Caribbean case study. Paper presented at the annual meeting of the American Sociological Association, Montreal Convention Center, Montreal, Quebec, Canada.

Fost, D. (2003, February 6). Savage talk: A former herbalist has remade himself into the vitriol-spewing king of the Bay Area's afternoon drive time. *The San Francisco Chronicle*, p. E1.

Foster, J. B., & McChesney, R. W. (2011). The Internet's unholy marriage to capitalism. *Monthly Review: An Independent Socialist Magazine, 62*(10), 1-30.

Foucault, M. (1977). *Discipline & punish.* New York: Vintage.

Fuchs, C. (2011). Web 2.0, prosumption, and surveillance. *Surveillance & Society, 8*(3), 288-309.

Fukuyama, F. (1989). The end of history? *The National Interest, 16*(2), 3-18.

Furst, G. (Director). (2007). *I am Omega* [Motion Picture].

Gardner, A. (2011, January 20). Nearly half of Americans still suspect vaccine-autism link. *Bloomberg Businessweek*. Retrieved from http://www.businessweek.com/lifestyle/content/healthday/649031.html.

Gibson, M. (2011, January 3). Judgement day: Will May 21, 2011 be the end of the world? *Time Newsfeed*. Retrieved from http://newsfeed.time.com/2011/01/03/judgment-day-will-may-21-2011-be-the-end-of-the-world/#ixzz1MzyOKG9Y.

Giglio, M. (2011, April 3). The republic of fear: Recent protests in Syria have brought brutal government crackdown—and renewed paranoia among dissidents. *Newsweek.com*. Retrieved from http://www.newsweek.com/2011/04/03/the-republic-of-fear.html.

Gilliam, R. (1982). The perils of postindustrialism. *American Quarterly*, *34*(1), 77–82.

Giroux, H. A. (2006). Dirty democracy and state terrorism: The politics of the new authoritarianism in the United States. *Comparative Studies of South Asia, Africa and the Middle East*, *26*(2), 163–177.

Goffman, E. (1959). *The presentation of self in everyday life*. Garden City, NY: Doubleday & Company, Inc.

Gonzalez, J. (2005, September 6). Disaster used as political payoff. *Daily News (New York)*, p. 22.

Gorrindo, T., Gorrindo, P. C., & Groves, J. E. (2008). Intersection of online social networking with medical professionalism: Can medicine police the Facebook boom? *Journal of General Internal Medicine*, *23*(12), 2155.

Graham, P. (2006). *Hypercapitalism: New media, language, and social perceptions of value*. New York: Peter Lang Publishing.

Granovetter, M. (1973). The strength of weak ties. *The American Journal of Sociology*, *78*(6), 1360–1380.

Green, T., & Bailey, B. (2010). Academic uses of Facebook: Endless possibilities or endless perils? *TechTrends*, *54*(3), 20–22.

Greenway, F. L., & Bray, G. A. (1977). Human chorionic gonadotropin (hCG) in the treatment of obesity: A critical assessment of the Simeons method. *Western Journal of Medicine*, *127*(6), 461–463.

Gregory, M. (2007). Real teaching and real learning vs narrative myths about education. *Arts & Humanities in Higher Education*, *6*(1), 7–27 .

Griffin, S. (2000). *Internet pioneers: J.C.R. Licklider*. Retrieved from http://www.ibiblio.org/pioneers/licklider.html.

Grimmelmann, J. (2009). Saving Facebook. *Iowa Law Review*, *94*(4), 1137–1206.

Groeling, T. (2008). Who's the fairest of them all? An empirical test for partisan bias on ABC, CBS, NBC, and Fox News. *Presidential Studies Quarterly*, *38*(4), 631–658.

Guardian Media Limited. (2011, February 15). hCG injection illegal and could be harmful. *Guardian Media–Trinidad and Tobago Guardian Online*. Retrieved from http://guardian.co.tt/letters/2011/02/15/hcg-injection-illegal-and-could-be-harmful.

Gutterman, B., Rahman, S., Supelano, J., Thies, L., & Yang, M. (2009). *White paper: Information & communication technologies (ICT) in education for development*. Global Alliance for ICT and Development, Economic and Social Affairs. New York: United Nations.

Habermas, J. (1962). *Strukturwandel der Öffentlichkeit: Untersuchungen zu einer kategorie der bürgerlichen gesellschaft (The structural transformation of the public sphere).* Neuwied/Berlin: Luchterhand.

Haddon, L., & Paul, G. (2001). Design in the IT industry: The role of users. In R. Coombs, K. Green, A. Richards, & V. Walsh (Eds.), *Technology and the market: demands, users and innovation* (pp. 201–215). Northhampton, MA: Edward Elgar Publishing, Inc.

Hafez, K. (2008). European-Middle Eastern relations in the media age. *Middle East Journal of Culture and Communication, 1*(1), 30–48.

Hafez, K. (2007). *The myth of media globalization.* (A. Skinner, Trans.) Cambridge: Polity Press.

Halavais, A. (2000). National borders on the World Wide Web. *New Media & Society, 2*(7), 7–28.

Hardaker, D. (2006, January 4). Amr Khaled: Islam's Billy Graham. *The Independent.* Retrieved from http://www.independent.co.uk/news/world/middle-east/amr-khaled-islams-billy-graham-521561.html.

Harding, S. (2006). Two influential theories of ignorance and philosophy's interests in ignoring them. *Hypatia, 21*(3).

Haynes, R. D. (1994). *From Faust to Strangelove: Representation of the scientist in Western literature.* Baltimore and London: Johns Hopkins University Press.

Haynes, R. (2003). From alchemy to artificial intelligence: Stereotypes of the scientist in Western literature. *Public Understanding of Science, 12*(3), 243–253.

Hedges, W. L. (1956). Irving's Columbus: The problem of romantic biography. *The Americas, 13*(2), 127–140.

Heslam, J. (2011, May 5). Dems blast Brown over fake bin Laden photo. *Boston Herald.com.* Retrieved from http://www.bostonherald.com/news/politics/view.bg?articleid=1335790.

Hill, C. E., Loch, K. D., Straub, D. W., & El-Sheshai, K. (1998). A qualitative assessment of Arab culture and information technology transfer. *Journal of Global Information Management, 6*(3), 29–38.

Hitlin, P. (2003). False reporting on the Internet and the spread of rumors: Three case studies. *Gnovis, 4.* Retrieved from http://gnovisjournal.org: http://gnovisjournal.org/files/Paul-Hitlin-False-Reporting-on-the-Internet.pdf.

Hofstetter, C. R., Barker, D., Smith, J. T., Zari, G. M., & Ingrassia, T. A. (1999). Information, misinformation, and political talk radio. *Political Research Quarterly, 52*(2), 353–369.

Holzner, S. (2008). *Facebook marketing: Leverage social media to grow your business.* Indianapolis, IN: Que Corp.

Hughey, M. W. (1990). Internal contradictions of televangelism: Ethical quandaries of that old time religion in a brave new world. *International Journal of Politics, Culture, and Society, 4*(1), 31–47.

Huntington, S. P. (1996). *The clash of civilizations and the remaking of world order.* New York: Simon and Schuster.

Hussain, A. J. (2007). The media's role in a clash of misconceptions: The case of the Danish Muhammad cartoons. *The Harvard International Journal of Press/Politics, 12*(4), 112–130.

Husserl, E. (1962). *Ideas: General introduction to pure phenomenology.* London: Collier.

Hutson, J. H. (2002, May). The founding fathers and Islam: Library papers show early tolerance for Muslim faith. *Library of Congress information bulletin, 61*(5). Retrieved from http://www.loc.gov/loc/lcib/0205/tolerance.html

Ingram-Waters, M. C. (2009). Public fiction as knowledge production: The case of the Raëlians' cloning claims. *Public Understanding of Science, 18*(3), 292–308.

Internet World Stats. (2011, May 18). Internet usage statistics: The Internet big picture. Retrieved from http://www.Internetworldstats.com/stats.htm

Irving, W. (1828). *History of the life of Christopher Columbus.* New York: G. & C. Carvill.

Jacoby, S. (2008). *The age of American unreason.* New York: Pantheon.

Johansen, M. S., & Joslyn, M. R. (2008). Political persuasion during times of crisis: The effects of education and news media on citizens' factual information about Iraq. *Journalism and Mass Communication Quarterly, 85*(3), 591–608.

Johns Hopkins Bloomberg School of Public Health. (2008, January 15). Myths about dioxin and freezing plastic bottles. Retrieved from http://www.jhsph.edu/dioxins.

Johnson, P. (2003, July 8). On MSNBC: One Savage attack too many; Controversial conservative fired after "get AIDS and die" remark. *USA Today*, p. D.05.

Jones, S. E. (2006). *Against technology: From the Luddites to Neo-Luddism.* New York: Routledge.

Kamalipour, Y. R. (2010). Language, media and war: Manipulating public perceptions. *Journal of Global Mass Communication, 3*(1–4), 87–94.

Kamalipour, Y. R., & Snow, N. (2004). *War, media, and propaganda: A global perspective.* Lanham, MD : Rowman and Littlefield.

Kampfner, J. (2003, May 15). The truth about Jessica: Her Iraqi guards had long fled, she was being well cared for—and doctors had already tried to free her. *The Guardian*, p. 2.

Käsemann, E. (1969). The beginnings of Christian theology. In *New Testament questions of today* (W. J. Montague, Trans.) pp. 82–107. London: SCM Press.

Keefe, J. (2007). James Ferrier and the theory of ignorance. *The Monisi*, 90(2), 297–309.

Keeley, B. L. (1999). Of conspiracy theories. *The Journal of Philosophy*, 96(3), 109–126.

Kelly, E. L., & Fiske, D. W. (1951). *The prediction of performance in clinical psychology*. Ann Arbor, MI: University of Michigan Press.

Keohane, R. O., & Nye, J. S. (1998). Power and interdependence in the information age. *Foreign Affairs*, 77(5), pp. 81–94.

Khouri, R. G. (2004, November 10). Why is the legacy of confrontation so strong? Retrieved from http://www.commongroundnews.org/article.php?id=2586&lan=en&sid=1&sp=1.

Kime, R., & Gillespie, D. (1967). Oblique educational television. *Journal of School Health*, 37(3), 153–156.

King, K. P. (2000). Educational television: "Let's explore science." *Journal of Science Education and Technology*, 9(3), 227–246.

King, P. E., & Behnke, R. R. (2000). Effects of communication load, affect, and anxiety on the performance of information processing tasks. *Communication Quarterly*, 48(1), 74–84.

King, P. E., & Behnke, R. R. (1989). The effect of time-compressed speech on comprehensive, interpretive, and short-term listening. *Human Communication Research*, 15(3), 428–443.

Kirkpatrick, D. (2010). *The Facebook effect: The inside story of the company that is connecting the world*. New York: Simon & Schuster.

Kitty, A., & Greenwald, R. (2005). *Outfoxed: Rupert Murdoch's war on journalism*. New York: The Disinformation Company.

Klapp, O. E. (1986). *Essays on the quality of life in the information age*. New York: Greenwood Press.

Kleingeld, P. (2007). Kant's second thoughts on race. *The Philosophical Quarterly*, 57(229), 573–592.

Knickmeyer, E. (2008, May 18). Fledgling rebellion on Facebook is struck down by force in Egypt. *The Washington Post*, p. 1.

Koch, K. (1972). *Rediscovery of apocalyptic*. London: SCM Press.

Kraidy, M. (2005). *Hybridity, or the cultural logic of globalization*. Philadelphia, PA: Temple University Press.

Kuhn, T. S. (1962). *The structure of scientific revolutions, 1ˢᵗ ed.* Chicago: University of Chicago Press.

Kunkel, D. (1998). Policy battles over defining children's educational television. *Annals of the American Academy of Political and Social Science,* 557(1), 39-53.

Kurtz, H. (2010, August 25). The ignorance factor: Obama, religion and the media. *The Washington Post.* Retrieved from http://www.washingtonpost.com/wp-dyn/content/article/2010/08/25/AR2010082502493.html.

Lacey, C., & Longman, D. (1997). *The press as public educator: Cultures of understanding, cultures of ignorance.* Bedforshire, UK: John Libbey Media.

Lanier, D. (2010). Recent Shakespeare adaptation and the mutations of cultural capital. *Shakespeare Studies,* 38(1), 104-113.

Lasswell, H. D. (1927a). *Propaganda technique in the World War.* London: Kegan Paul, Trench, Trubner & Co.

Lasswell, H. D. (1927b). The theory of political propaganda. *The American Political Science Review,* 21(3), 627-631.

Latzer, M. (2009). Information and communication technology innovations: Radical and disruptive? *New Media & Society,* 11(4), 599-619.

Lawrence, F. (Director). (2007). *I am legend* [Motion Picture].

Leaning, M. (2009). *The Internet, power and society: Rethinking the power of the Internet to change lives.* Oxford, UK: Chandos Publishing.

Lee, G., & Capella, J. N. (2001). The effects of political talk radio on political attitude formation: Exposure versus knowledge. *Political Commun-ication,* 18(4), 369-394.

Lefebvre, O. (2008). Is disinformation easier than in the past? In M. Schrenk, V. V. Popovich, D. Engelke, & P. Elisie (Ed.), *REAL CORP 2008 Proceedings: Mobility Nodes as Innovation Hubs* (pp. 603-607). Vienna: REAL CORP.

Leigh, D., & Harding, L. (2011). *WikiLeaks: The inside story of Julian Assange and Wikileaks.* New York: Public Affairs.

Leitch, T. (2002). Twice told tales: Disavowal and the rhetoric of the remake. In J. Forrest, & L. R. Koos (Eds.), *Dead ringers: The remake in theory and practice* (pp. 37-62). Albany: State University of New York Press.

Levin, B. (2003). Cyberhate: A legal and historical analysis of extremists' use of computer networks in America. In B. Perry (Ed.), *Hate and bias crime: A reader* (pp. 363-382). New York: Routledge.

Levi-Strauss, C. (1963). *Structural anthropology.* (C. Jacobson, & B. G. Schoepf, Trans.) New York: Basic Books.

Levy, M. R. (1989). *The VCR age.* London: Sage.

Levy, M. R. (1987). VCR use and the concept of audience activity. *Communication Quarterly, 35*(3), 267–275.

Lewis, J. A. (2005). The Internet and terrorism. *Proceedings of the Annual Meeting (American Society of International Law), 99,* 112–115. Washington, DC: American Society of International Law.

Lewis, M. W. (2000). Global Ignorance. *Geographical Review, 90*(4), 603–628.

Licklider, J., & Taylor, R. W. (1968). The computer as a communication device. *Science and Technology, 76*(2), 21–31.

Lin, C. (2001). The VCR, home video culture, and new video technologies. In J. Bryant, & J. A. Bryant (Eds.), *Television and the American family* (pp. 91–110). Mahwah, NJ: Lawrence Erlbaum Associates.

Lindsey, H. (1970). *The late great planet earth.* Grand Rapids, MI: Zondervan.

Ling, R. (2009). What would Durkheim have thought? Living in (and with) the information society. In E. Alampay, *Living in the information society in Asia* (pp. 1–23). Singapore: Institute of Southeast Asian Studies.

Litman, B., & Komiya, M. (1990). The economics of the prerecorder video-casssete industry. In J. R. Dobrow (Ed.), *Social and cultural aspects of VCR Use* (pp. 25–44). Hillsdale, NJ: Lawrence Erlbaum Associates.

Llewellyn, J. (1996–97). Understanding urban legends: A peculiar public relations challenge. *Public Relations Quarterly, 41*(4), 17–22.

Loeb, J. (1914, December 1). Science and race. *The Crisis,* pp. 92–93.

Losh, S. C. (2010). Stereotypes about scientists over time among US adults: 1983 and 2001. *Public Understanding of Science, 19*(3), 372–382.

Lukasiewicz, J. (1994). *The ignorance explosion: Understanding industrial civilization.* Ottawa, ON: Carleton University Press.

MacFarquhar, N. (2001, October 19). A nation challenged: Education—anti-Western and extremist views pervade Saudi schools. *The New York Times,* p. B3.

Machlup, F. (1962). *The production and distribution of knowledge in the United States.* Princeton, NJ: Princeton University Press.

Macnamara, J. (2010). *The 21st century media (r)evolution: Emergent communication practices.* New York: Peter Lang.

Malhotra, N. K. (1982). Information load and consumer decision making. *Journal of Consumer Research, 8*(4), 419–430.

Malhotra, N. K., Jain, A. K., & Lagakos, S. W. (1982). The information overload controversy: An alternative viewpoint. *The Journal of Marketing, 46*(2), 27–37.

Manovich, L. (2009). The practice of everyday (media) life: From mass consumption to mass cultural production? *Critical Inquiry, 35*(2), 319–331.

Manuel, F. E. (1938). The Luddite movement in France. *The Journal of Modern History*, *10*(2), 180–211.

Manzerolle, V., & Smeltzer, S. (2011). Consumer databases and the commercial mediation of identity: A medium theory analysis. *Surveillance & Society*, *8*(3), 323–337.

Marley, R. N. (Composer). (1976). Rat race. [R. N. Marley, Performer] On *Rastaman vibration*. Kingston, Jamaica: Tuff Gong.

Matheson, R. (1954). *The omega man*. New York: Walker and Company.

Mazer, J. P., Murphy, R. E., & Simonds, C. J. (2007). I'll see you on "Facebook": The effects of computer-mediated teacher self-disclosure on student motivation, affective learning, and classroom climate. *Communication Education*, *56*(1), 1–17.

Mccann-Mortimer, P., Augoustinos, M., & Lecouteur, A. (2004). "Race" and the Human Genome Project: Constructions of scientific legitimacy. *Discourse and Society*, *15*(4), 409–432.

McCauley, C., & Jacques, S. (1979). The popularity of conspiracy theories of presidential assassination: A Bayesian analysis. *Journal of Personality and Social Psychology*, *37*(5), 637–644.

McLuhan, M. (1964). *Understanding media: The extensions of man*. New York: McGraw Hill.

McLuhan, M., & Fiore, Q. (1967). *The medium is the massage*. New York: Bantam.

McMorris, F. A., & Geyelin, M. (1994, August 11). Nigerian fraud scheme. *The Wall Street Journal*, p. B6.

McMurdo, G. (1997). Cyberporn and communication. *Journal of Information Science*, *23*(1), 81–90.

Media Matters for America. (2006, June 9). Savage called Iraqi witnesses of alleged Haditha massacre "vermin" and "scum," proclaimed detained Marines are American "POWs." Retrieved from http://mediamatters. org/research/200606090010.

Media Matters for America. (2004, April 30). Unsubstantiated Drudge rumor echoed through the media. Retrieved from http://mediamatters.org/ research/200405020004.

Meraz, S. (2009). Is there an elite hold? Traditional media to social media agenda setting influence in blog networks. *Journal of Computer-Mediated Communication*, *14*(3), 682–707.

Metz, A. M. (2008). A fantasy made real: The evolution of the subjunctive documentary on U.S. cable science channels. *Television & New Media*, *9*(4), 333–348.

Michael, M. G. (1999). Genre of the apocalypse: What are they saying now? *Bulletin of Bibllical Studies, 18*(2), 115–126.

Mikkelson, B., & Mikkelson, D. P. (2006, March 1). Bread and media circuses. Retrieved from http://www.snopes.com/photos/gruesome/crush boy.asp.

Mikkelson, B., & Mikkelson, D. P. (2010a, February 1). Nigerian scam. Retrieved from http://www.snopes.com/fraud/advancefee/nigeria.asp.

Mikkelson, B., & Mikkelson, D. P. (2010b, April 5). National day of prayer. Retrieved from http://www.snopes.com/politics/obama/prayerday.asp.

Millbank, D. (2010). *Tears of a clown: Glenn Beck and the tea bagging of America.* New York: Doubleday.

Miller, D. (2004). Information dominance: The philosophy of total propaganda control. In Y. R. Kamalipour, & N. Snow (Eds.), *War, media, and propaganda: A global perspective* (pp. 7–17). Lanham, MD: Rowman & Littlefield Publishers, Inc.

Miller, G. A. (1956). The magical number seven, plus or minus two: Some limits on our capacity for processing information. *Psychological Review, 63*(2), 81–97.

Miller, H. (1995, June). The presentation of self in electronic life: Goffman on the Internet. A paper presented at the Embodied Knowledge and Virtual Space Conference Goldsmiths' College, University of London.

Mills, C. (1997). *The racial contract.* Ithaca, NY: Cornell University Press.

Mirza, Y. (2005). Abraham as an iconoclast: Understanding the destruction of images through Qur'anic exegesis. *Islam and Christian-Muslim Relations, 16*(4), 413–428.

Mitroff, I. I., & Silvers, A. (2008). Sociopathic capitalism: Tricked to solve the wrong problems. *Fellowship, 74*(4–9), 26–30.

Mohammed, S. N. (2001). Personal communication networks and the effects of an entertainment-education radio soap opera in Tanzania. *Journal of Health Communication, 6*(2), 137–154.

Mohammed, S. N. (2007). Cable modems. In H. Bidgoli, *The handbook of computer networks* (Vol. 2, pp. 221–229). Hoboken, NJ: John Wiley and Sons.

Mohammed, S. N. (2011). *Communication and the globalization of culture: Beyond tradition and borders.* Lanham, MD: Lexington Books.

Moisy, C. (1997). Myths of the global information village. *Foreign Policy, 107,* 78–87.

Moll, Y. (2010). Islamic Televangelism: Religion, media and visuality in contemporary Egypt. *Arab Media & Society, 10,* 1–27.

Moore, W. E., & Tumin, M. M. (1949). Some social functions of ignorance. *American Sociological Review, 14*(6), 787–795.

Morozov, E. (2009, March/April). Texting toward utopia: Does the Internet spread democracy? *Boston Review.* Retrieved from http://bostonreview. net/BR34.2/morozov.php.

Morozov, E. (2011a, March 8). The Internet is a tyrant's friend. *New Scientist.* Retrieved from http://www.newscientist.com/article/mg20928026.100-the-Internet-is-a-tyrants-friend.html.

Morozov, E. (2011b). *The net delusion: How not to liberate the world.* London: Allen Lane.

Morrow, L. (1989, May 29). Essay: Welcome to the global village. *Time,* p. 41.

Mosco, V. (2004). *The digital sublime: Myth, power, and cyberspace.* Cambridge, MA: MIT Press.

MSNBC.com. (2010, July 29). Details of 100 million Facebook users published online. Retrieved from http://www.msnbc.msn.com/id/3846 3013/ns/technology_and_science-security/.

Murray, C., & Herrnstein, R. (1994). *The bell curve.* New York: The Free Press.

Nair, A. (2007). Internet content regulation: Is a global community standard a fallacy or the only way out? *International Review of Law, Computers & Technology, 21*(1), 15–25.

Navickas, K. (2005). The search for "General Ludd": The mythology of Luddism. *Social History, 30*(3), 281–295.

New Orleans Police Department. (1997, January 30). Internet Subscribers. Retrieved from http://www.mardigrasday.com/police1.html.

Newsletter on Intellectual Freedom. (2010, March). Facebook founder: Online privacy not a "social norm." *Newsletter on Intellectual Freedom,* pp. 48–49.

Nicola, N. (2010). Black face, white voice: Rush Limbaugh and the "message" of race. *Journal of Language and Politics, 9*(2), 281–309.

Nora, S., & Minc, A. (1978). *L'informatisation de la société: Industrie et services informatiques.* Paris: Documentation Française.

O'Boyle, L. (1968). The Image of the journalist in France, Germany, and England, 1815–1848. *Comparative Studies in Society and History, 10*(3), 290–317.

O'Leary, S. D. (1994). *Arguing the apocalypse: A theory of millenial rhetoric.* New York: Oxford University Press.

Orwell, G. (1949). *Nineteen eighty–four.* London: Secker and Warburg.

Ouellette, L. (1995). Camcorder dos and don'ts: Popular discourses on amateur video and participatory television. *Velvet Light Trap, 36*(3), 33–45.

Pacanowskya, M. E., & O'Donnell-Trujillo, N. (1983). Organizational communication as cultural performance. *Communication Monographs, 50*(2), 126-147.

Palfreman, J. (2006). A tale of two fears: Exploring media depictions of nuclear power and global warming. *Review of Policy Research, 23*(1), 23-43.

Palmås, K. (2011). Predicting what you'll do tomorrow: Panspectric surveillance and the contemporary. *Surveillance & Society, 8*(3), 338-354.

Palser, B. (2004, October 1). Checking it out. *American Journalism Review,* p. 100.

Papacharissi, Z. (2002). The virtual sphere: The Internet as a public sphere. *New Media & Society, 4*(1), 19-27.

Pariser, E. (2011). *The Filter Bubble: What the Internet is hiding from you.* New York: The Penguin Press HC.

Parker, K. (2010, January 17). The devil in Pat Robertson. *The Washington Post: Regional Edition,* p. A23.

Parsons, S., Simmons, W., Shinhoster, F., & Kilburn, J. (1999). Test of the grapevine: An empirical examination of conspiracy theories among African Americans. *Sociological Spectrum, 19*(2), 201-222.

Pattir, D. (2006, February 16). A picture of hate: Graphic anti-Semitism in Muslim media. *Jewish Exponent, 219*(21), p. 20.

Pauli, C. (2010). Killing the microphone: When broadcast freedom should yield to genocide prevention. *Alabama Law Review, 61*(4), 665-700.

Pempeka, T. A., Yermolayeva, Y. A., & Calvert, S. L. (2009). College students' social networking experiences on Facebook. *Journal of Applied Developmental Psychology, 30*(3), 227-238.

People for the American Way. (2001, September 17). Transcript of entire Robertson-Falwell interview available. Retrieved from http://www.com mondreams.org/news2001/0917-03.htm.

Peters, B. (2009). And lead us not into thinking the new is new: A bibliographic case for new media history. *New Media & Society, 11*(1&2), 13-30.

Pillar, P. R. (2006). Intelligence, policy, and the war in Iraq. *Foreign Affairs, 85*(2), 15.

Pillsbury, B., & Mayer, D. (2005). Women connect! Strengthening communications to meet sexual and reproductive health challenges. *Journal of Health Communication, 10*(4), 361-371.

Piltz, R. (2008). The denial machine. *Index on Censorship, 37*(4), 72-81.

Pleitgen, F. (2008, October 10). Source of Iraq WMD intelligence tells his story. Retrieved from http://articles.cnn.com/2008-10-10/world/iraq. curveball_1_germ-labs-german-intelligencebnd?_s=PM:WORLD.

Polgreen, L. (2006, February 24). Nigeria counts 100 deaths over Danish caricatures. *New York Times Friday, February 24, 2006*, p. 8.

Pool, I. d. (1981). Review. *Technology and Culture, 22*(2), 352–354.

Poster, M. (1990). *The mode of information: Poststructuralism and social context.* Oxford: Polity.

PR Newswire. (2008, July 21). "Talk radio network should fire Michael Savage," says disability rights coalition. *PR Newswire.* New York: PR Newswire Association LLC.

Prados, A. B. (2001). *CRS report for Congress–Middle East: Attitudes toward the United States.* Washington, DC: Congressional Research Service: The Library of Congress.

Proctor, R. N. (2008). Agnotology: A missing term to describe the cultural production of ignorance (and its study). In R. N. Proctor, & L. Schiebinger (Eds.), *Agnotology: The making and unmaking of ignorance* (pp. 1–33). Stanford, CA: Stanford University Press.

Quastler, H. (1956). Studies of human channel capacity. In C. Cherry (Ed.), *Information theory, proceedings* (pp. 361–371). New York: Academic Press.

Radford, B. (2003). *Media mythmakers.* Amherst, NY: Prometheus.

Radsch, C. C. (2009, May 12). Economy, Internet top Arab media forum agenda: Dubai media forum awards top Arab journalists. *Al–Arabiyya.* Retrieved from http://www.alarabiya.net/articles/2009/05/12/72694 .html.

Ragona, U., & Salkow, S. (Directors). (1964). *The last man on Earth* [Motion Picture].

Ravetz, J. R. (1993). The sin of science: Ignorance of ignorance. *Knowledge: Creation, Diffusion, Utilization, 15*(2), 157–165.

Reagan, M. (2010, December 1). WikiLeaks' Assange and Pvt. Manning should be tried for treason. *Newsmax.com.* Retrieved from http:// www.newsmax.com/Reagan/Reagan-Assange-Manning-WikiLeaks/2010/1 2/01/id/378596.

Redbook. (2009, February). 10 hottest health trends. *Redbook.* Retrieved from: http://www.redbookmag.com/health-wellness/advice/health/hottest -health-trends

Reid, T. (2002, September 17). America plans PR blitz on Saddam. *The Times of London.* Retrieved from http://www.timesonline.co.uk/article/0,,3-418110,00.html

Reimink, T. (2011, May 21). Group claiming today is Judgment Day awaits Rapture, others gear up for celebration. *The Grand Rapids Press.* Retrieved May 21, 2011, from http://www.mlive.com/news/grand-rapids/index.ssf/ 2011/05/group_claiming_today_as_judgme.html.

Rescher, N. (2009). *Ignorance: On the wider implications of deficient knowledge.* Pittsburg, PA: University of Pittsburg Press.

Reynolds, C. B. (2010, June 10–16). Beck's attack must be confronted. *Sacramento Observer.*, 47(26), p. B4.

Rheingold, H. (1993). *The virtual community: Homesteading on the electronic frontier.* New York: Perseus Books.

Rigdon, J. E. (1995, December 8). Advertising: Web sites find niche in budgets ruled by TV, print campaigns. *Wall Street Journal*, p. B14.

Roberts, J., & Armitage, J. (2008). The ignorance economy. *Prometheus, 26*(4), 335–354.

Robinson, M. (2002). *Mobocracy: How the media's obsession with polling twists the news, alters elections and undermines democracy.* Roseville, CA: Forum.

Romey, K. M. (2003). Seductions of pseudoarchaeology: Pseudoscience in cyberspace. *Archaeology, 56*(3), online.

Roston, M. (2010, March 9). Why are the Drudge Report's exclusives so often completely false? Retrieved from http://trueslant.com/level/2010/03/09/why-are-the-drudge-reports-exclusives-so-often-completely-false/.

Rubin, A. M., & Bantz, C. (1987). Utility of videocassette recorders. *American Behavioral Scientist, 30*(5), 471–485.

Russell, J. B. (1991). *Inventing the flat earth: Columbus and modern historians.* New York: Praeger.

Sachs, S. (2003, April 4). Arab media portray war as killing field. *The New York Times*, p. B1.

Sagal, B. (Director). (1971). *The omega man* [Motion Picture].

Said, E. W. (2001, October 22). The clash of ignorance. *The Nation, 12*(11), p. 273.

Sale, K. (2006). The achievements of "General Ludd": A brief history of the Luddites. *Tailoring Biotechnologies, 2*(1), 69–78.

Samin, N. (2008). Dynamics of Internet use: Saudi youth, religious minorities and tribal communities. *Middle East Journal of Culture and Communi-cation, 1*(2), 197–215.

Sarukkai, S. (2008). Culture of technology and ICTs. In A. Saith, M. Vijayabaskar, & V. Gayathri (Eds.), *ICTs and Indian social change: Diffusion, poverty, governance* (pp. 34–58). New Delhi, India: Sage.

Scheer, R. (1999, January 14). More sludge from Drudge: The story that Clinton fathered an illegitimate son turns out to be a hoax. *Pittsburgh Post-Gazette*, p. A15.

Schmidt, C. W. (2010). A closer look at climate change skepticism. *Environmental Health Perspectives, 118*(12), A537–A540.

Schroeder, G. (1997). *The science of God: The convergence of scientific and biblical wisdom.* New York and London: The Free Press.

Schütz, A. (1967). *The phenomenology of the social world.* (G. Walsh, & L. F.J, Trans.) Evanston, IL: Northwestern University Press.

Schwartz, S. (2006, February 20). Muhammad caricatured. *The Weekly Standard, 11*(22), pp. 29–31.

Scott, E. C., & Branch, G. (2002, August 13). "Intelligent Design" not accepted by most scientists. Retrieved from http://www.ncseweb.org/resources/articles/996_intelligent_design_not_accep_9_10_2002.asp

Segev, E., & Ahituv, N. (2010). Popular searches in Google and Yahoo! A "digital divide" in information uses? *The Information Society, 26,* 17–37.

Seib, P. (2005). The news media and the "clash of civilizations." *Paramaters: US Army War College, 34*(4), 71–85.

Selwyn, N. (2009). Faceworking: Exploring students' education-related use of Facebook. *Learning, Media, & Technology, 34*(2), 157–174.

Serin, D., & Marti, P. (2010). Le cancer sur Facebook. *OncoMagazine, 4*(3), 1.

Shachtman, N. (2009, December 13). Social networks as foreign policy. *The New York Times Magazine,* p. 62.

Shapiro, A. L. (1999). The Internet. *Foreign Policy, 115,* 14–27.

Sharp, D. (2008). Advances in conspiracy theory. *The Lancet, 372*(9647), 1371–1372.

Shenk, D. (1997). *Data smog.* New York: Harper Collins.

Sheppard, K. (2011, May/June). The hackers and the hockey stick. *Mother Jones, 36*(3), pp. 33–39.

Shibutani, T. (1966). *Improvised news: A sociological study of rumor.* Indianapolis, IN: Bobbs–Merrill.

Sholle, D. (2002). Disorganizing the new technologies. In G. Elmer (Ed.), *Critical perspectives on the Internet* (pp. 3–26). Lanham, MD: Rowman and Littlefield.

Siddique, H. (2010, August 11). JetBlue flight attendant Steven Slater becomes overnight folk hero. *The Guardian.* Retrieved from http://www.guardian.co.uk/world/2010/aug/11/jetblue-steven-slater-facebook-hero#history-link-box.

Simms, N. (1978). Ned Ludd's mummers play. *Folklore, 89*(2), 166–178.

Sinclair, J., & Cunningham, S. (2000). Go with the flow: Diasporas and the media. *Television & New Media, 1,* 11–31.

Sisler, V. (2008). Digital Arabs: Representation in video games. *European Journal of Cultural Studies, 11*(2), 203–219.

Smithson, M. (1993). Ignorance and science: Dilemmas, perspectives, and prospects. *Knowledge: Creation, Diffusion, Utilization, 15*(2), 133–156.

Smithson, M. (1989). *Ignorance and uncertainty: Emerging paradigms.* New York: Springer.

Smithson, M. (1985). Toward a social theory of ignorance. *Journal for the Theory of Social Behaviour, 15*(2), 151–172.

Softky, M. (2000, October 11). Building the Internet: Bob Taylor won the national medal of technology "for visionary leadership in the development of modern computing technology." Retrieved from http://www.almanac news.com/morgue/2000/2000_10_11.taylor.html?

SONY Corporation of America et al. v. Universal City Studios, Inc., et al., 81–1687. (The Supreme Court of the United States January 17, 1984).

Squire, J. E. (2006). *The movie business book.* New York: Simon and Schuster.

Stahl, R. (2006). Have you played the war on terror? *Critical Studies in Media Communication, 23*(2), 112–130.

Stam, M. (2010). Newspapers, radio, and the business of media in the United States. *OAH Magazine of History, 24*(1), 25–28.

Starr, L. R., & Davila, J. (2009). Clarifying co-rumination: Association with internalizing symptoms and romantic involvement among adolescent girls. *Journal of Adolescence, 32*(1), 19–37 .

Stauber, J., & Rampton, S. (2002). *Toxic sludge is good for you: Lies, damn lies and the public relations industry.* Monroe, ME: Common Courage Press.

Steuter, E., & Wills, D. (2009). Discourses of dehumanization: Enemy construction and Canadian media complicity in the framing of the war on terror. *Global Media Journal–Canadian Edition, 2*(2), 7–24.

Stewart, J. (2007). Local experts in the domestication of information and communication technologies. *Information, Communication & Society, 10*(4), 547–569.

Stewart, K., & Harding, S. (1999). Bad endings: American apocalypsis. *Annual Review of Anthropology, 28*(1), 285–310.

Stichweh, R. (2003). The genesis of a global public sphere. *Development, supplement: Mediating Citizenship in The Global Network Society, 46*(1), 26–29.

Stowell, F. (2007). The knowledge age or the age of ignorance and the decline of freedom? *Systemic Practice and Action Research, 20*(5), 413–427.

Strategic Direction. (2008). My Space or yours: Advertising and social networks. *Strategic Direction, 24*(8), pp. 15–18.

Stross, R. (2009, March 8). When everyone's a friend, is anything private? *The New York Times,* p. BU3.

Subramanian, S. (1995, January 16). The story in our genes. *TIME.com.* Retrieved from http://www.time.com/time/magazine/article/0,9171,982 346,00.html.

Sullivan, A. (2008, August 08). An antichrist Obama in McCain ad? *TIME.com.* Retrieved from http://www.time.com/time/politics/article/ 0,8599,1830590,00.html#ixzz1MzpNxGNb.

Sullivan, P. (2001, August 21). Internet a prime venue for snake-oil sales of "health products." *Canadian Medical Association Journal, 165*(4), 465.

Sunstein, C. R. (1986). Government control of information. *California Law Review, 74*(3), 889–921.

Sunstein, C. R., & Vermeule, A. (2009). Conspiracy theories: Causes and cures. *The Journal of Political Philosophy, 17*(2), 202–227.

Svennevig, M., & Firmstone, J. (2000). Putting the new into context: A backwards look at new information technologies. *International Journal of Advertising, 19*(5), 581–597.

Szalavitz, M. (2011, February 25). The hCG diet myth: Why would a pregnancy hormone make you skinny? *TIME Healthland.* Retrieved from http://healthland.time.com/2011/02/25/debunking-the-hcg-diet-myth-why-would-a-pregnancy-hormone-make-you-skinny/.

Terzian, S. G., & Grunzke, A. L. (2007). Scrambled eggheads: Ambivalent representations of scientists in six Hollywood film comedies from 1961 to 1965. *Public Understanding of Science, 16*(4), 407–418.

The CNN wire staff. (2011, January 5). Retracted autism study an "elaborate fraud," British journal finds. *CNN.com* Retrieved from http://www.cnn.com/2011/HEALTH/01/05/autism.vaccines/index.html.

The New York Times. (1892, August 29). Progress of the cholera. *The New York Times*, p. 2.

The New York Times. (1999, August 15). The hateful agenda of ignorance. *The New York Times*, p. 14.

The Pew Research Centerfor the People and the Press. (2007). *What Americans know: 1989–2007: Public knowledge of current affairs changed little by news and information revolutions.* Washington DC: Pew Research Center for The People & The Press.

The Telegraph. (2011, May 21). Apocalypse not right now: "Rapture" end of world fails to materialise: Reports of the end of the world appeared to have been exaggerated today. *The Telegraph (UK)* Retrieved from http://www.telegraph.co.uk/news/religion/8527582/Apocalypse-not-right-now-Rapture-end-of-world-fails-to-materialise.html.

The Washington Times. (2010, December 28). Ho-ho-hoax: Twas a bleak Christmas for global-warming alarmism. *The Washington Times*, p. B02.

Thomas, S., & Holderman, L. (2008). The social construction of modern intelligence. In L. Holderman (Ed.), *Common sense: Intelligence as presented on popular television* (pp. 7–106). Lanaham, MD: Lexington Books.

Tidline, T. J. (1999). The mythology of information overload. *Library Trends*, 47(3), 485–506.

Time Magazine. (1950, July 31). Science: All human beings. *TIME.com* Retrieved from http://www.time.com/time/magazine/article/0,9171,82127 0,00.html#ixzz1LRWvfttl.

Toffler, A. (1970). *Future shock*. New York: Random House.

Toffler, A. (1980). *The third wave*. New York: William Morrow & Co. Inc.

Tolbert, C. J., & McNeal, R. S. (2003). Unraveling the effects of the Internet on political participation. *Political Research Quarterly*, 56(2), 175–185.

Tomaselli, K. G., & Shepperson, A. (2010). All the world's a brothel: Metaphysics of the text and cultural economy in the information age. *Critical Arts: A South-North Journal of Cultural & Media Studies*, 24(1), 51–74.

Toosi, N. (2005, February 20). An Egyptian view of reality: Still not a whole lot of understanding about the United States—and vice versa. *Milwaukee Journal Sentinel*, p. 1.

Townley, C. (2009). Toward a revaluation of ignorance. *Hypatia*, 21(3), 37–55.

Tuana, N. (2004). Coming to understand: Orgasm and the epistemology of ignorance. *Hypatia*, 19(1), 194–232.

Tuana, N. (2006). The speculum of ignorance: The women's health movement and epistemologies of ignorance. *Hypatia*, 21(3), 1–19.

Turner, B. S. (2008). Religious speech: The ineffable nature of religious communication in the information age. *Theory Culture Society*, 25(7–8), 219–235.

Turner, J. (2007). The messenger overwhelming the message: Ideological cues and perceptions of bias in television news. *Political Behavior*, 29(4), 441–464.

Tynes, R. (2007). Nation-building and the diaspora on Leonenet: A case of Sierra Leone in cyberspace. *New Media & Society*, 9(3), 497–518.

Ungar, S. (2008). Ignorance as an under-identified social problem. *The British Journal of Sociology*, 59(2), 301–326.

Urista, M. A., Dong, Q., & Day, K. D. (2009). Explaining why young adults use Myspace and Facebook through uses and gratifications theory. *Human Communication*, 12(2), 215–229.

Veysey, L. (1982). A postmortem on Daniel Bell's postindustrialism. *American Quarterly*, 34(1), 49–69.

Wallis, W. D. (1929). The prejudices of men. *The American Journal of Sociology*, 34(5), 804–821.

Warren, M. J. (2007). Terrorism and the Internet. In L. J. Janczewski, & A. M. Colarik(Eds.), *Cyber warfare and cyber terrorism information* (pp. 42–49). Hershey, NY: Science Reference.

Webster, F. (2002). The information society revisited. In S. L. Livingstone (Ed.), *Handbook of new media: Social shaping and consequences of ICTs* (pp. 22–33). London: Sage.

Wellman, B. (1997). An electronic group is virtually a social network. In S. Kiesler (Ed.), *Culture of the Internet* (pp. 179–205). Mahwah, NJ: Lawrence Erlbaum.

Wherry, R. J. (1931). A new formula for predicting the shrinkage of the coefficient of multiple correlations. *Annals of Mathematical Statistics, 2*(1), 440–451.

Wherry, R. J. (1940). The Wherry-Doolittle test selection method. In W. H. Stead, & L. L. Shartle (Eds.), *Occupational counseling techniques* (pp. 245–252). New York: American Book Company.

Wilkerson, M. M. (1967). *Public opinion and the Spanish-American war: A study in war propaganda.* New York: Russell & Russell.

Willcocks, L. P. (2006). Michel Foucault in the social study of ICTs: Critique and reappraisal. *Social Science Computer Review, 24*(3), 274–295.

Wilson, S. M., & Peterson, L. C. (2002). The anthropology of online communities. *Annual Review of Anthropolgy, 31,* 449–467.

Wilson, T. (1995). Trends and issues in information science: A general survey. In O. Boyd-Barrett, & P. Braham, *Media, knowledge and power: A reader* (pp. 407–422). London: Routledge.

Winston, B. (1998). *Media technology and society: A history from the telegraph to the Internet.* London: Routledge.

Winter, J. P. (1992). *Common cents: Media portrayal of the Gulf War and other events.* Cheektowaga, NY: Black Rose Books.

Wodak, R. (2006). Mediating ideology in text and image: Ten critical studies. In I. Lassen, J. Strunck, & T. Vestergaard (Eds.), *Images in/and news in a globalised world: Introductory thoughts* (pp. 1–18). Philadelphia, PA: John Benjamins North America.

Wootan, G. D., & Phillips, M. B. (2010). *Detox diets for dummies.* Hoboken, NJ: Wiley Publishing.

Wresch, W. B. (1996). *Disconnected: Haves and have nots in the Information-Age.* Piscataway, NJ: Rugters University Press.

Wurman, R. S., Leifer, L., Sume, D., & Whitehouse, K. (2001). *Information anxiety 2.* Indianapolis, IN : Pearson Education, Inc.

Wyckoff, D. (1993). Why a legend? Contemporary legends as community ritual. *Contemporary Legend, 3,* 1–36.

Yiannopoulos, M. (2010, July 30). First Wikileaks, now Facebook. Is this the death of privacy? The parallels between the Wikileaks saga and the openness of Facebook's user data are striking. *The Telegraph (UK).*

Retrieved from http://www.telegraph.co.uk/technology/facebook/7919 103/First-Wikileaks-now-Facebook.-Is-this-the-death-of-privacy.html.

Index

100, 103, 109, 110, 112-113,
117, 132, 135, 145, 161-162,
167
economy, 109, 113
Kuwait, 16, 92-93, 169-170

L

Limbaugh, Rush, 119-121
Ludd, Ned, 39-41

M

Machlup, Fritz, 28-29
Marx, Karl, 5, 41
McLuhan, Marshall, 46-47, 52,
148, 165
medical, health, 37, 50, 61, 63,
65-66, 77-80, 82, 123-126,
129-131, 140, 149
Middle East, 13, 55, 56, 94, 96,
100-101, 147, 157, 166, 170
misinformation, 2, 63-64, 67, 69,
82, 84, 88-89, 93, 119, 120,
130, 137, 144
myth, 15, 41, 51, 72, 74, 75, 77-
80, 102, 173

N

networks, 29-31, 53, 57, 127, 131,
132, 148, 149, 150-151, 152,
154, 175
Nigerian 419 scheme, 133-134

O

Obama, Barack, 59-60, 78-79, 84,
121, 139, 160, 175

P

Panopticon, 47

pornography, 61, 107-108, 170
post-industrialism, 32
propaganda, 2, 5, 61, 71, 86-91,
93-94, 122, 144, 152, 156,
161, 164

R

race, 4, 103-105, 120-121, 141,
145
Raëlians, 63
recycling, cultural, 114
religion, 13, 14, 17, 63-66, 68, 79,
85, 95-96, 98, 100, 162, 166
revolution, 1, 12-13, 25-26, 33-
34, 37-38, 41, 51, 53, 60,
156-158
Rwanda, 45, 159-160

S

satellite, 29, 47, 52, 67, 69, 102-
103, 118-120, 158
Saudi Arabia, 16-17, 70, 96, 99-
100, 169-170
Savage, Michael, 121-122
science, 15, 17, 21, 30, 62, 123,
124, 169
scientist, 10, 23-24, 29, 105
social media. See social networking
social networking, 59-60, 114,
142, 147-149, 152-155, 158
spam, 66, 132
supremacists, 106

T

talk radio, 119-122
technology, 1, 12-13, 26-27, 29,
32, 34, 36, 38, 39, 41-43, 45-
46, 48, 56-57, 60-61, 70, 89,
102, 110-112, 114, 117, 128,

General Editor: **Steve Jones**

Digital Formations is the best source for critical, well-written books about digital technologies and modern life. Books in the series break new ground by emphasizing multiple methodological and theoretical approaches to deeply probe the formation and reformation of lived experience as it is refracted through digital interaction. Each volume in **Digital Formations** pushes forward our understanding of the intersections, and corresponding implications, between digital technologies and everyday life. The series examines broad issues in realms such as digital culture, electronic commerce, law, politics and governance, gender, the Internet, race, art, health and medicine, and education. The series emphasizes critical studies in the context of emergent and existing digital technologies.

Other recent titles include:

Felicia Wu Song
 Virtual Communities: Bowling Alone, Online Together

Edited by Sharon Kleinman
 The Culture of Efficiency: Technology in Everyday Life

Edward Lee Lamoureux, Steven L. Baron, & Claire Stewart
 Intellectual Property Law and Interactive Media: Free for a Fee

Edited by Adrienne Russell & Nabil Echchaibi
 International Blogging: Identity, Politics and Networked Publics

Edited by Don Heider
 Living Virtually: Researching New Worlds

Edited by Judith Burnett, Peter Senker & Kathy Walker
 The Myths of Technology: Innovation and Inequality

Edited by Knut Lundby
 Digital Storytelling, Mediatized Stories: Self-representations in New Media

Theresa M. Senft
 Camgirls: Celebrity and Community in the Age of Social Networks

Edited by Chris Paterson & David Domingo
 Making Online News: The Ethnography of New Media Production

To order other books in this series please contact our Customer Service Department:

(800) 770-LANG (within the US)

(212) 647-7706 (outside the US)

(212) 647-7707 FAX

To find out more about the series or browse a full list of titles, please visit our website:

WWW.PETERLANG.COM